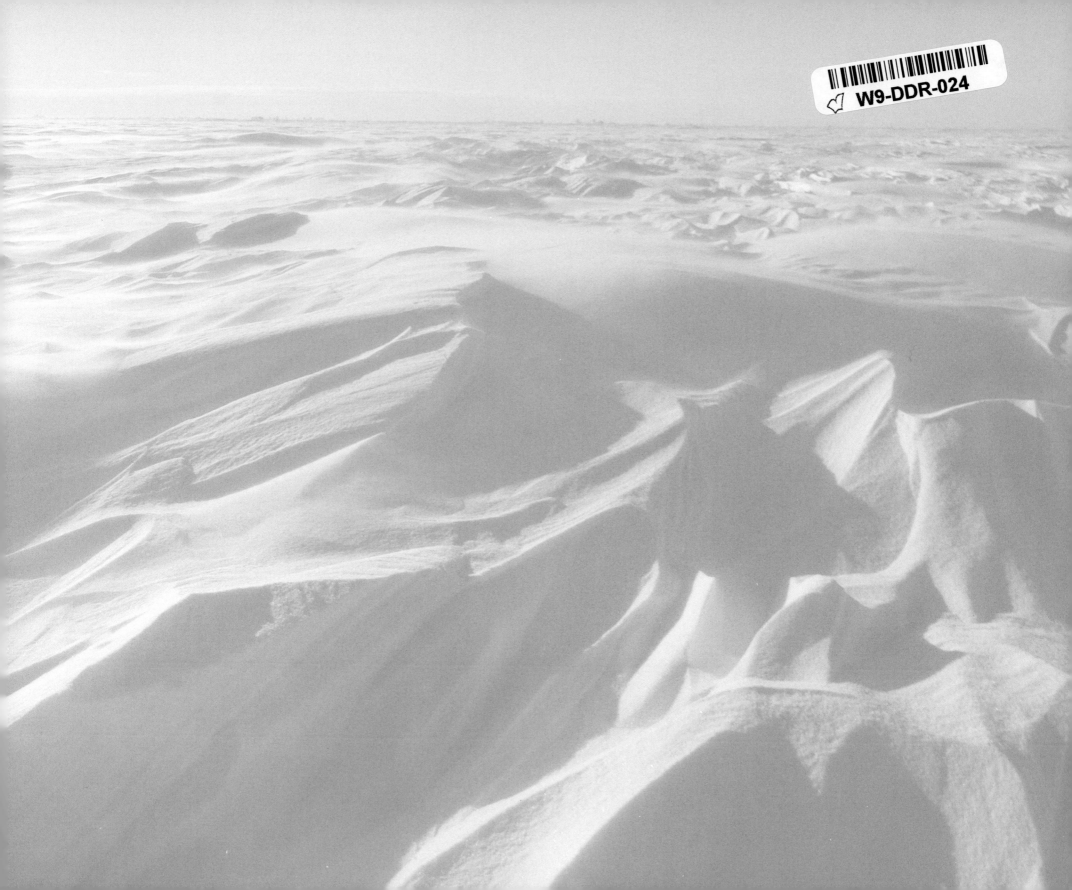

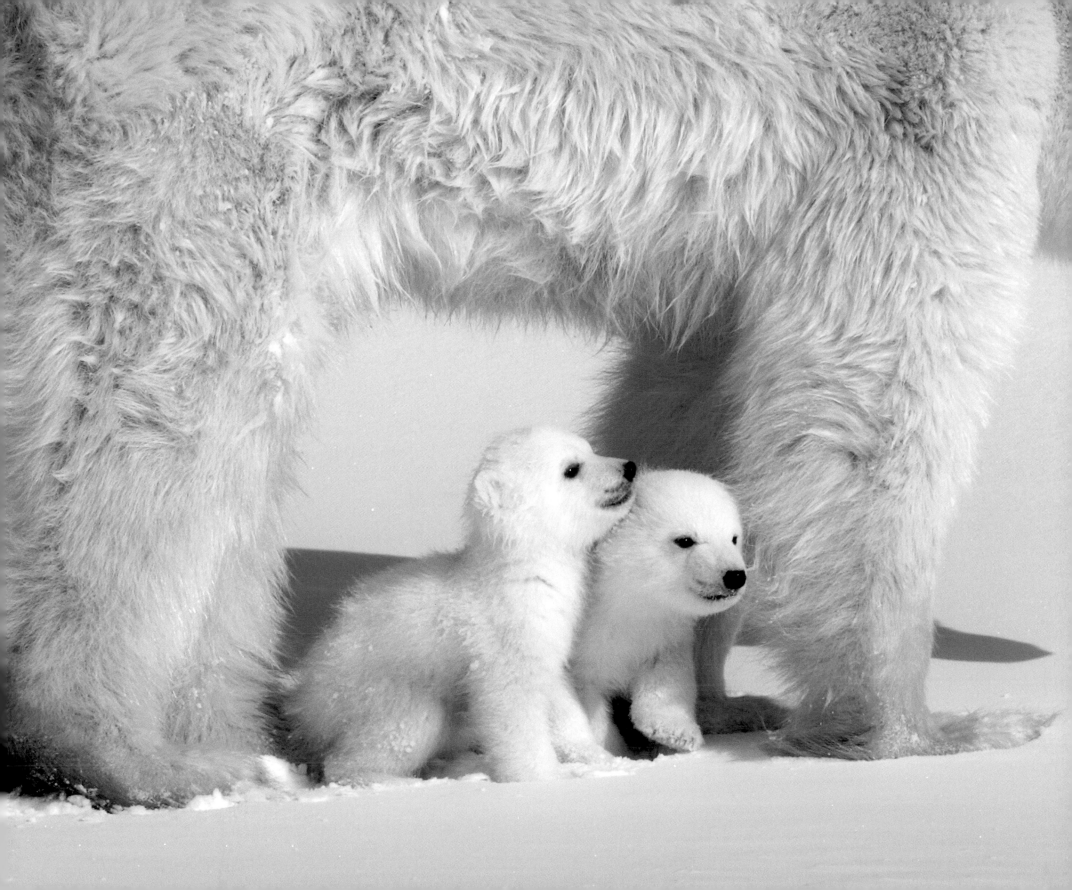

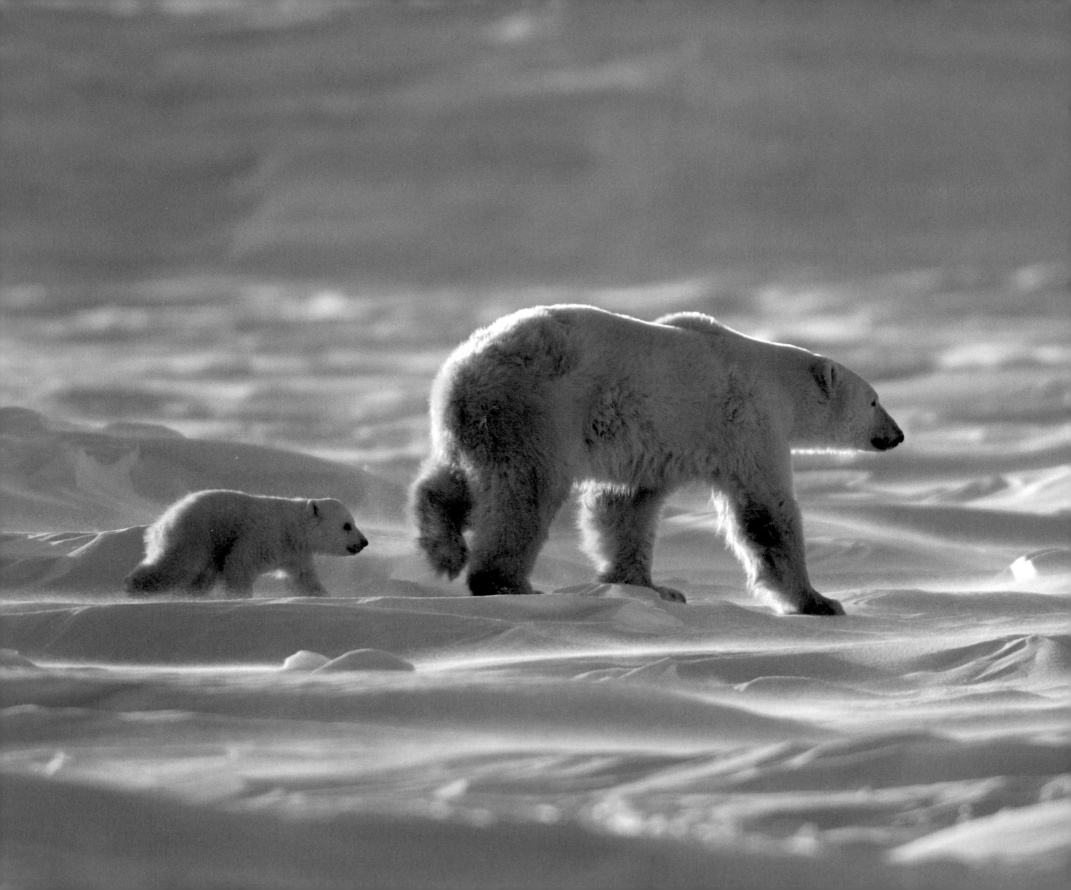

Little POLAR BEARS

Photography and Text by Thorsten Milse

Imprint

Photographer and author
Thorsten Milse, internationally renowned nature and wildlife photographer, can't get enough of the polar bear cubs of Wapusk National Park in northern Canada. This series of photographs has enjoyed great international acclaim: Milse won the Grand Prize of the photography competition held by the esteemed American magazine Nature's Best, and was named BBC Wildlife Photographer of the Year. His photographs have appeared in magazines such as GEO, BBC Wildlife, Nature's Best, and Illustreret Videnskab.

Photo credits
pp. 28, 162: © Norbert Rosing
Jacket flap: © Christina Karliczek

All others: © Thorsten Milse
www.wildlifephotography.de

Text sources
Dr. Ian Stirling, Polar Bears, 1998
Dr. Ian Stirling, Bären, 2002
Dr. Robert Wrigley, Polar Bear Encounters, 2001
www.polarbearsinternational.org
www.pc.gc.ca/pn-np/mb/wapusk/index_e.asp
www.watchee.com

Drawings: Stephanie Weber

With the friendly support of Canon Deutschland GmbH

This work has been carefully researched by the author and kept up to date as well as checked by the publisher for coherence. However, the publishing house can assume no liability for the accuracy of the data contained herein.

We are always thankful for suggestions and advice.
Please write to:
C. J. Bucher Publishing, Product Management
Innsbrucker Ring 15
81673 Munich
Germany
e-mail: info@bucher-publishing.com
Homepage: www.bucher-publishing.com

Project Director: Gerhard Grubbe
Project Management: Dr. Birgit Kneip
Translation: Elizabeth Schwaiger, Toronto
Proof-reading: Toby Skingsley, Munich
Design and DTP: Alexandra Finke, Lemgo
Cartography: Astrid Fischer-Leitl, Munich
Production: Bettina Schippel
Printed in Germany by Passavia Druckservice, Passau

ISBN 978-3-7658-1586-7

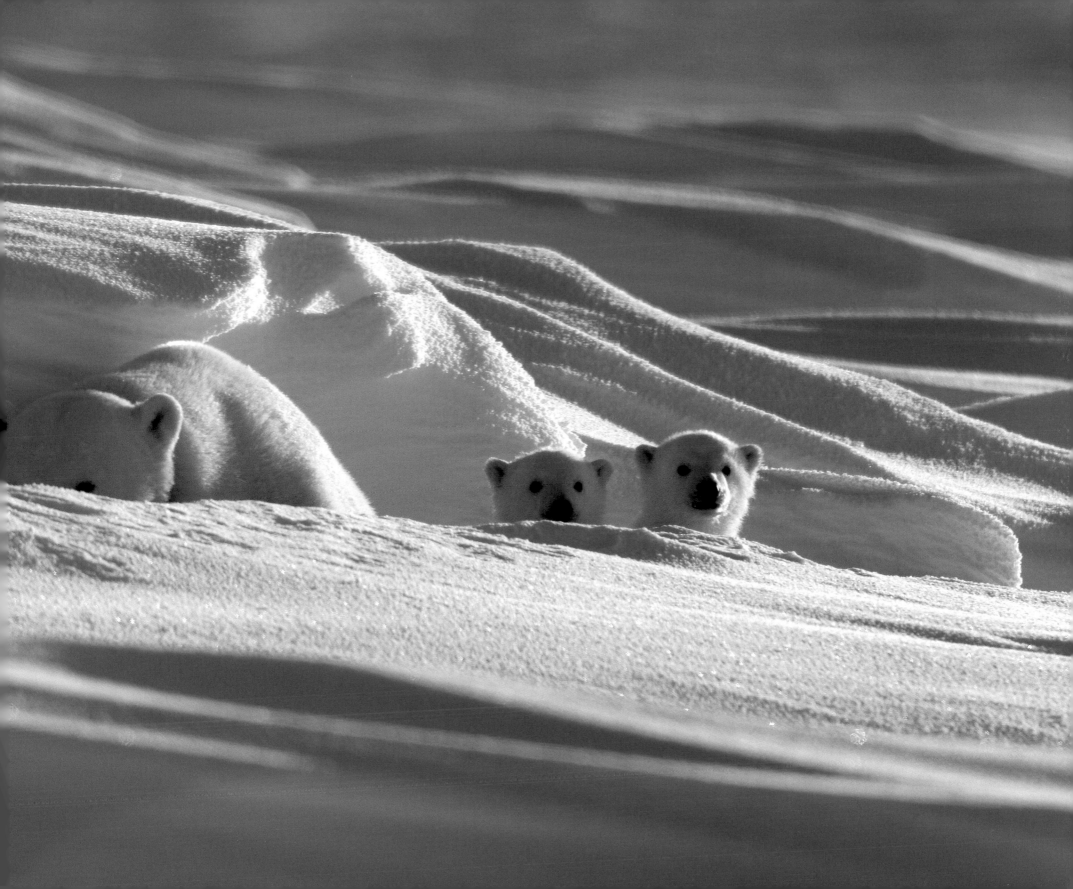

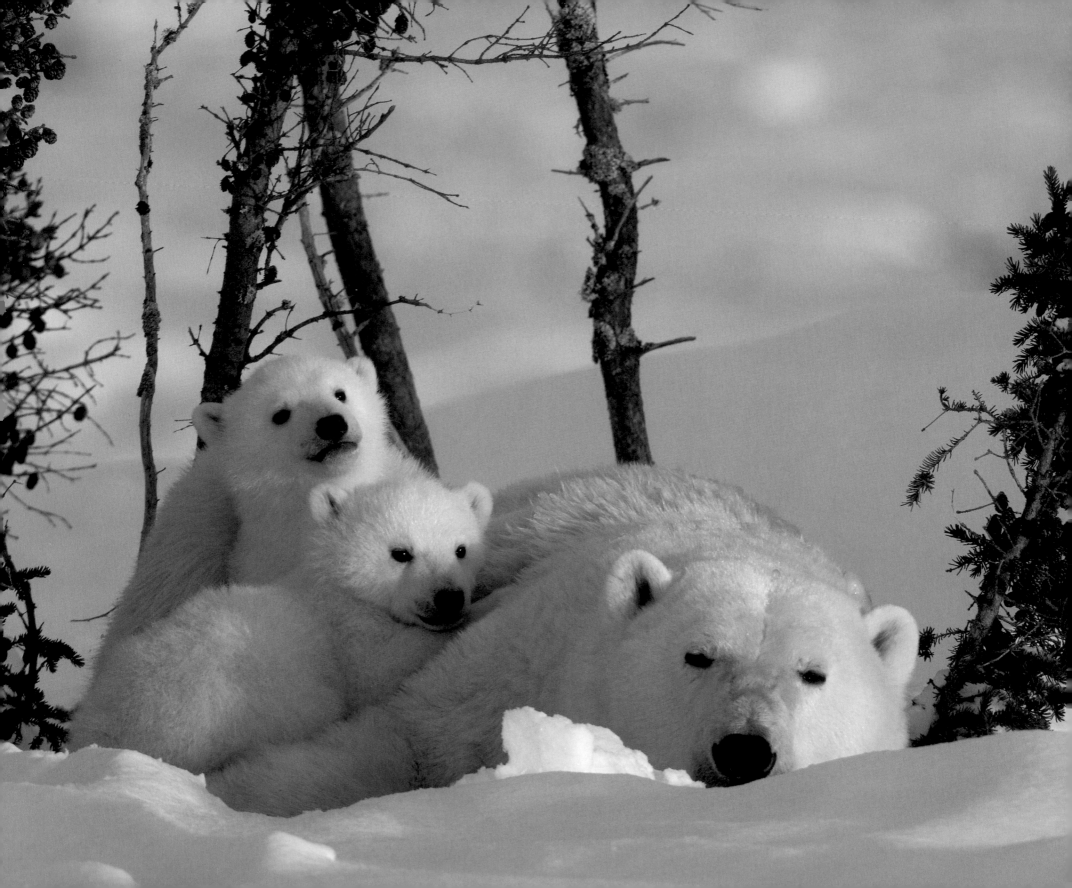

Table of Contents

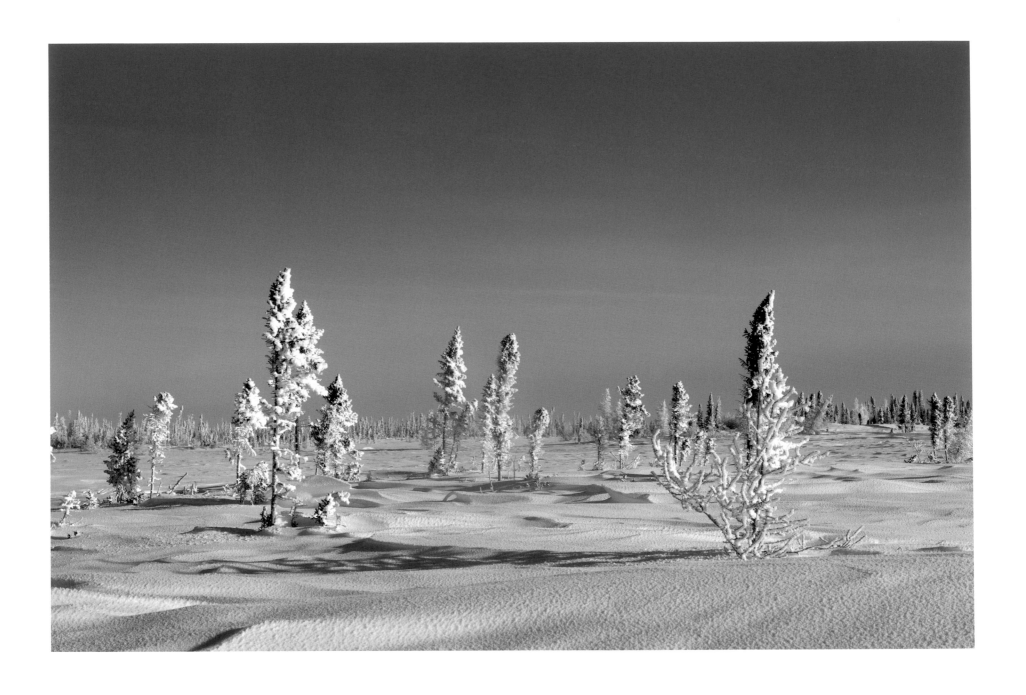

8

9

Wapusk National Park

The Cree word for the great bears of the western Hudson Bay area is "Wapusk". This is the origin of the name of Canada's 37th national park.

Parks Canada's mandate is to establish a national park in each of Canada's natural regions. Wapusk National Park represents the Hudson-James Lowlands natural region. While the area is rich in variety and abundance of wildlife species, it is the polar bear which captures people's imagination and is the symbolic species of the region. Seeing this magnificent creature in the wild is an event to be remembered for a lifetime. In Wapusk National Park, visitors are able to experience a small part of the world inhabited by polar bears.

Parks Canada is a world leader in the protection and preservation of nature. It is Parks Canada's mandate to protect and present our natural heritage in order to foster public understanding, appreciation and enjoyment in ways that ensure these places remain intact for future generations.

Maintaining ecological integrity in Canada's national parks is the first priority for park managers. Wapusk National Park encompasses most of the maternity denning area of the western Hudson Bay population of polar bears. Park management restricts human activities in the denning area to ensure that the pregnant female bears are not disturbed while still allowing for controlled visits to the area.

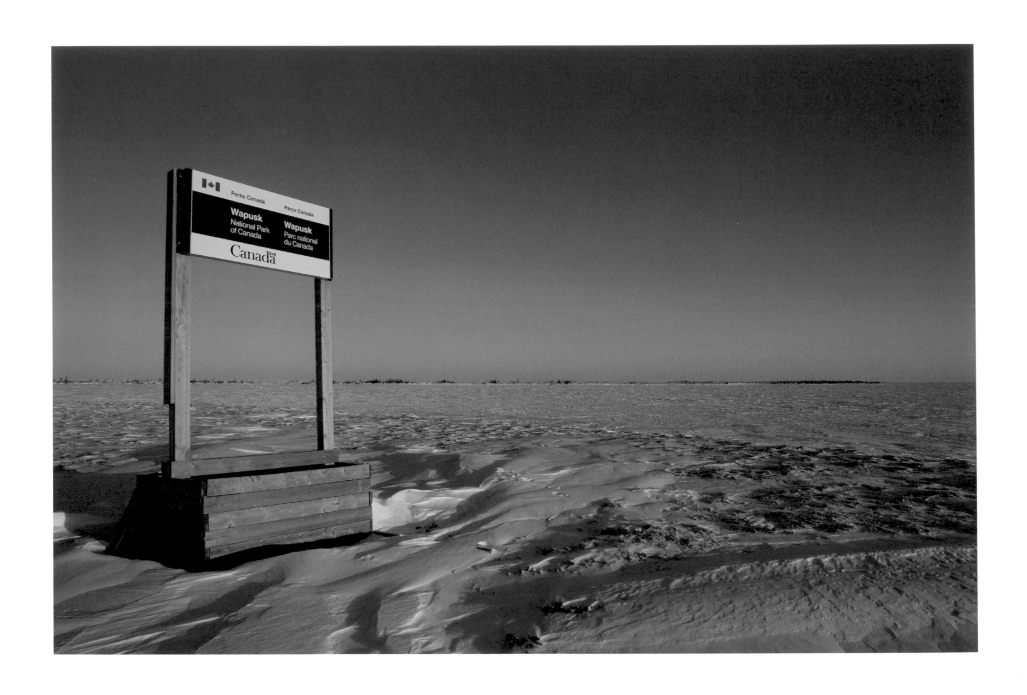

12

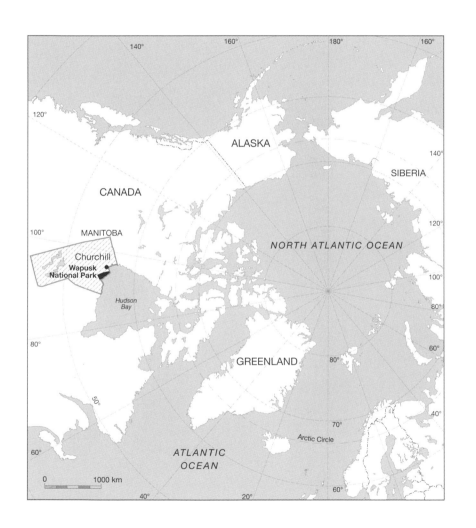

While Wapusk National Park can protect the polar bear habitat and ensure the polar bears are not disturbed in the park, there are global forces, that the park cannot control. Climate change is the most significant factor threatening polar bears. With warming climates and reduced ice cover on the Arctic seas, polar bears face an uncertain future. Regardless of where a person lives, everyone can assist in ensuring polar bears have a future by reducing greenhouse gas emissions.

Cam Elliott
Superintendent at Wapusk National Park of Canada

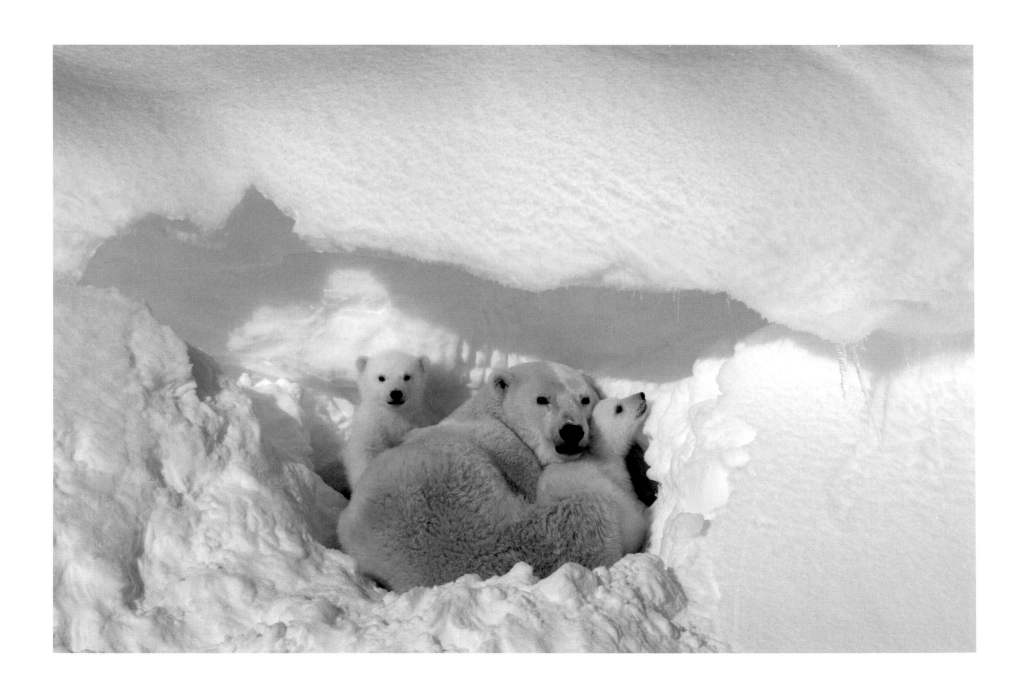

14

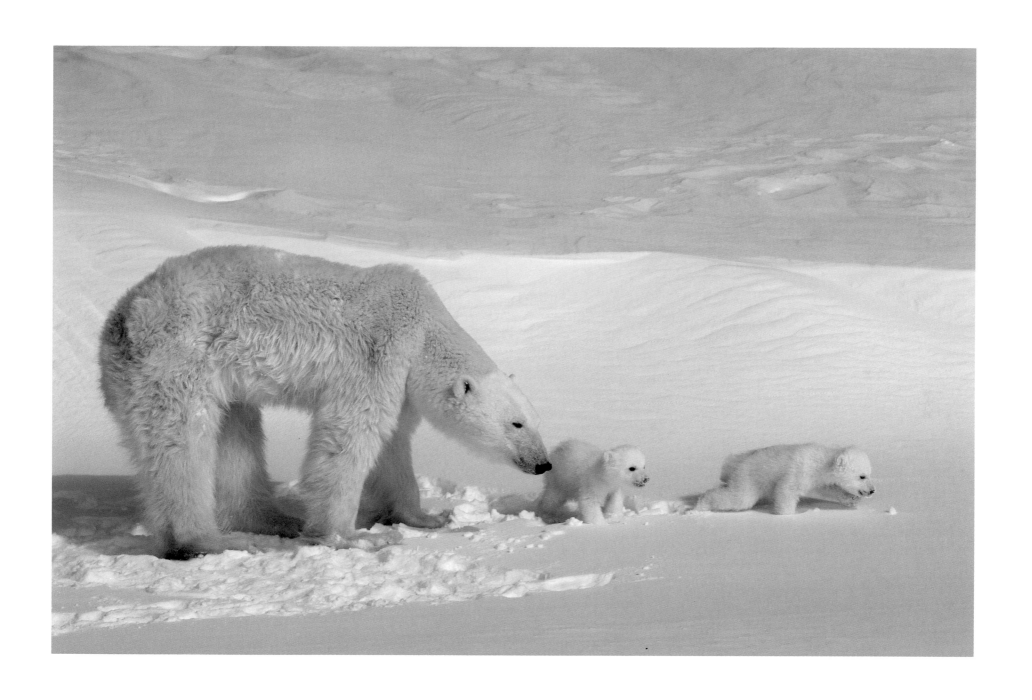

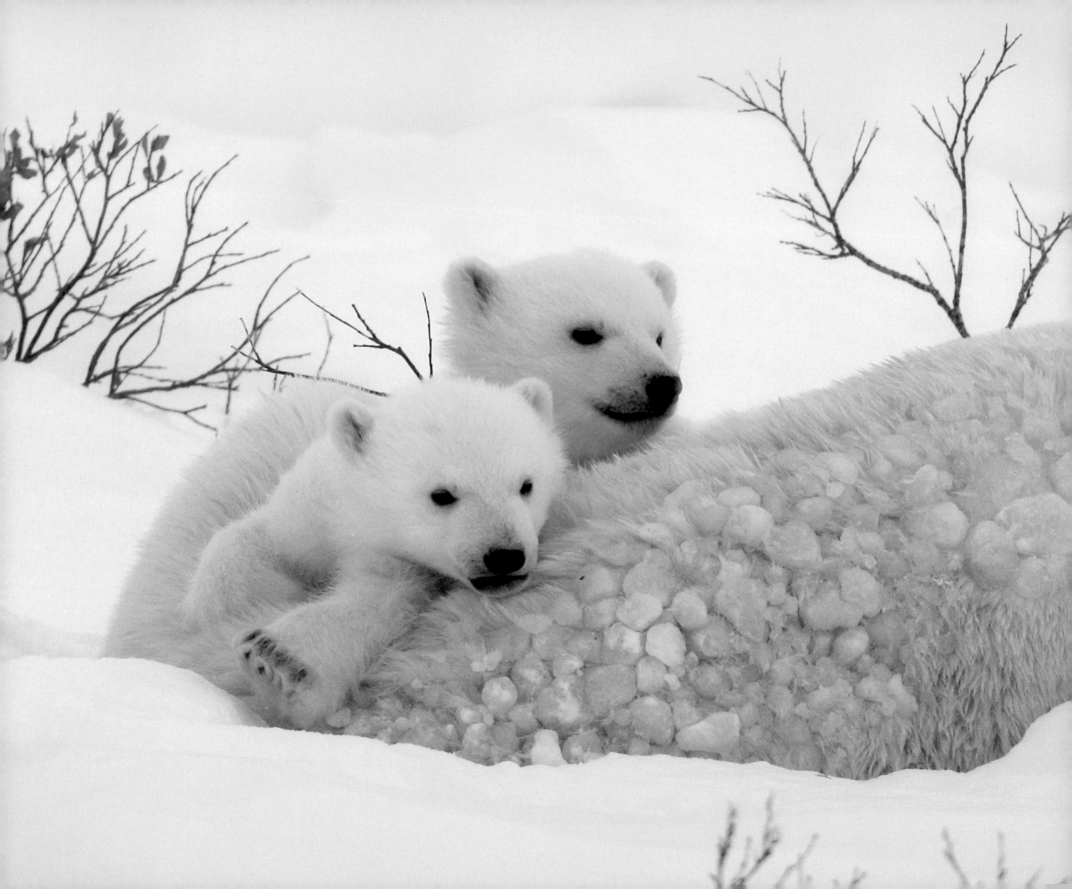

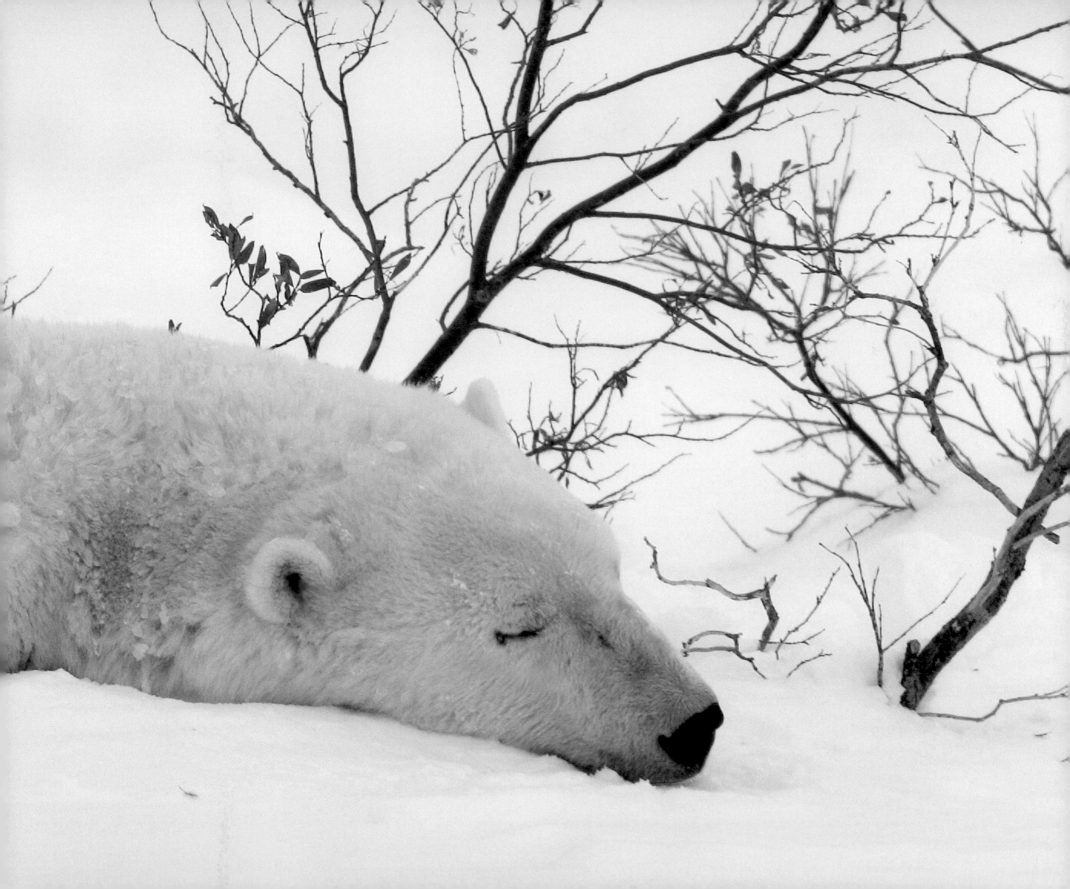

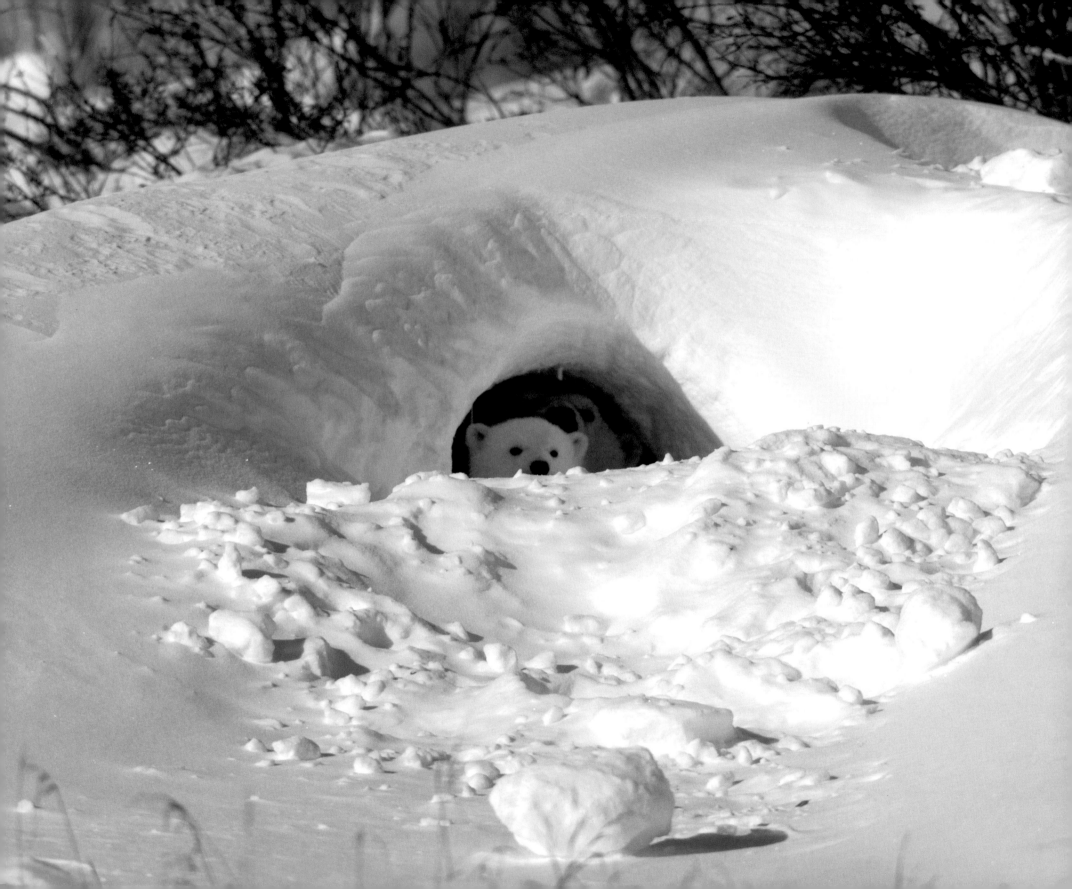

Motivation

Why did I choose polar bear cubs as my subject for wildlife photography? After all, it requires me to fly to Canada's far north, to the province of Manitoba, where I have to lie in the snow for hours, sometimes even for days, to be able to shoot pictures. Temperatures frequently drop to below 40 °C in the Canadian Arctic. Hands and feet are frozen stiff, the icy wind hits your face like thousands of pinpricks and also whirls up the snow, reducing visibility and creating snowdrifts that turn the search for little polar bears into a highly arduous undertaking. The long and expensive journey, the physical effort and the cold: these are hardly arguments in favor of polar bear photography. And yet, to my eyes, there are few sights more beautiful than to observe polar bear cubs with their mother, as they play, tussle and cuddle, until they finally embark on their long journey to Hudson Bay.

During my sojourns in the Canadian Arctic I have gained many insights into the life of the bears. It is never the same, the scenery and the situations are ever changing. I'm always in a state of suspension until our trackers have found the bears – sometimes only after days of searching. When the moment finally arrives, I'm always gripped by excitement: a den in the middle of the snow … a small black nose … you hold your breath … and then a white face appears. Cautiously and with some curiosity, a polar bear cub peaks out. Behind the cub, the mother's head gradually appears. For that one moment, I forget about everything else around me; as if in a trance, I press the shutter release of the camera. The endless wait has been worthwhile, the many hardships are forgotten – and I am suffused with a feeling of indescribable happiness. Moments like these are among the most exciting and beautiful in the life of a wildlife photographer.

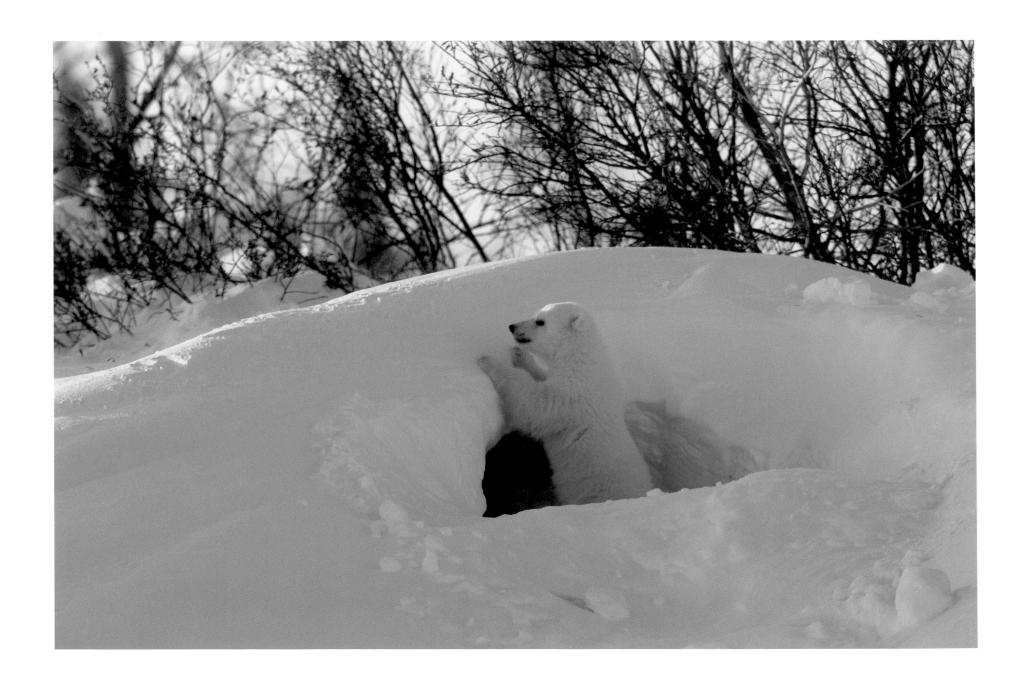

20

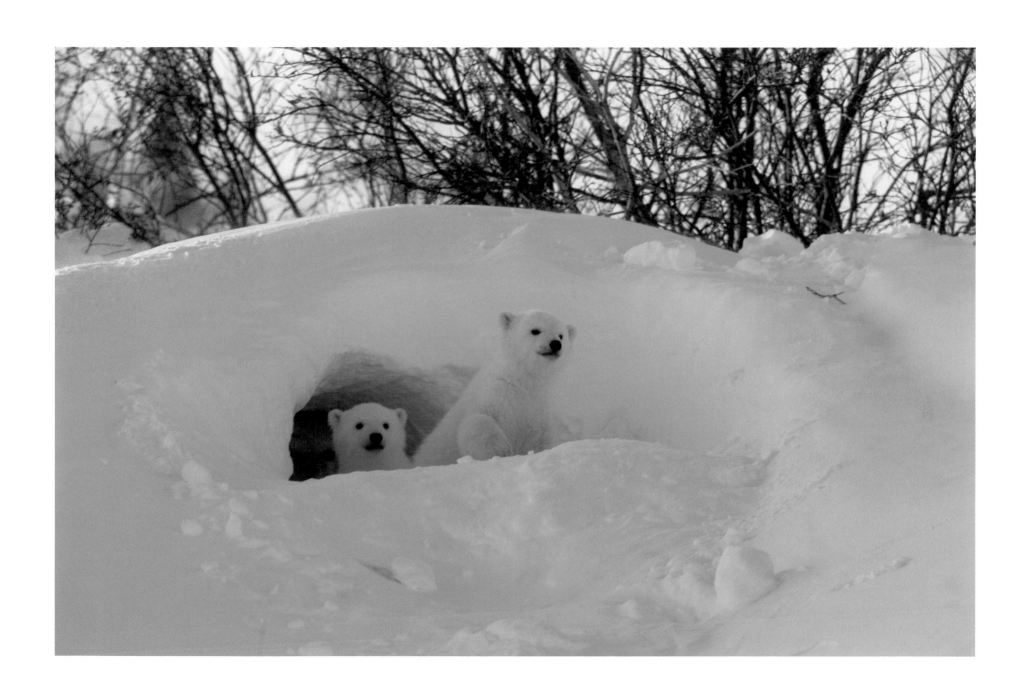

21

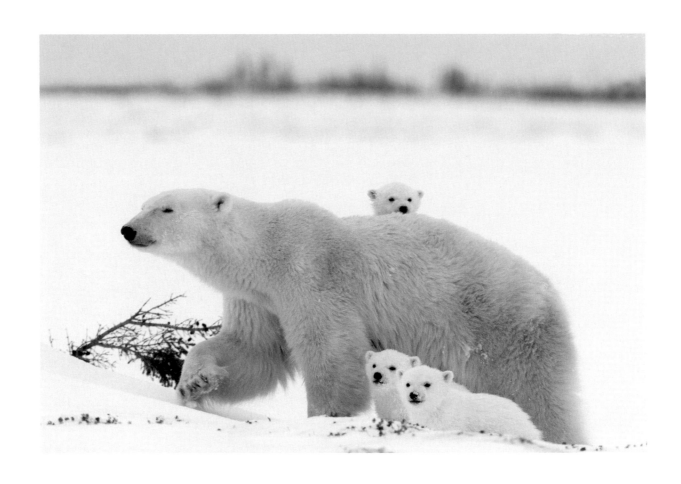

With determination, the polar bear mother sets out with her triplets on her migration toward Hudson Bay.
Right: This bear mother simply let herself and her cubs be covered in a layer of snow to catch some rest.

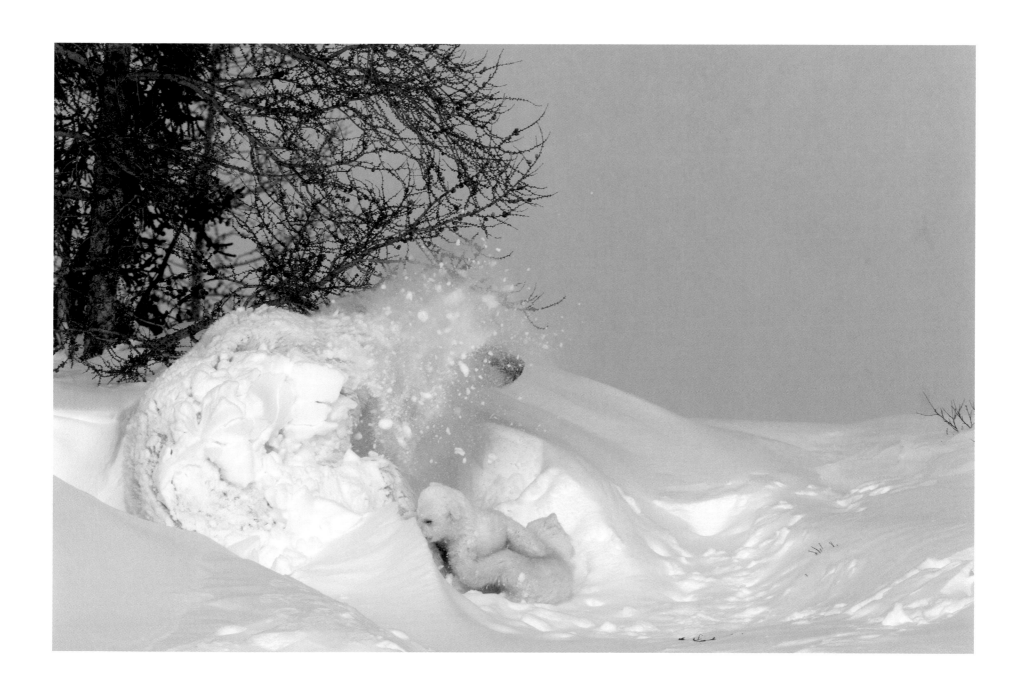

23

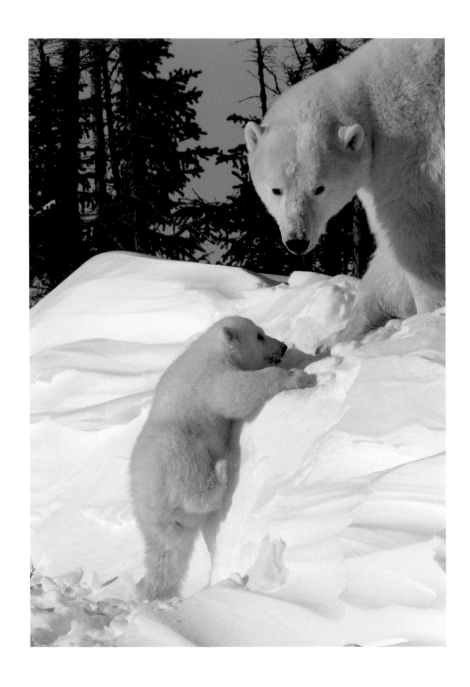 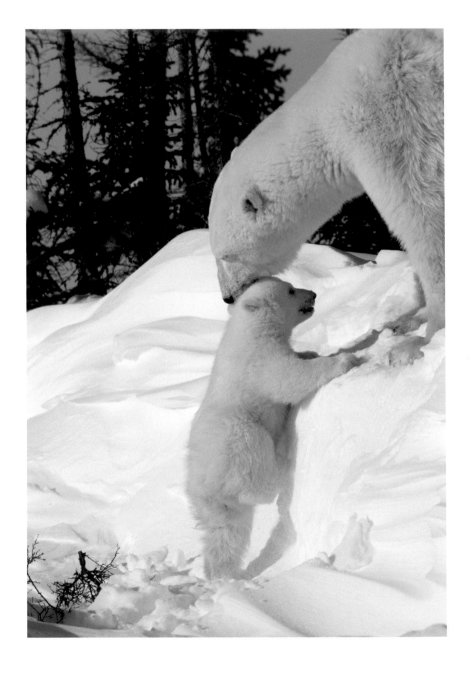

2中

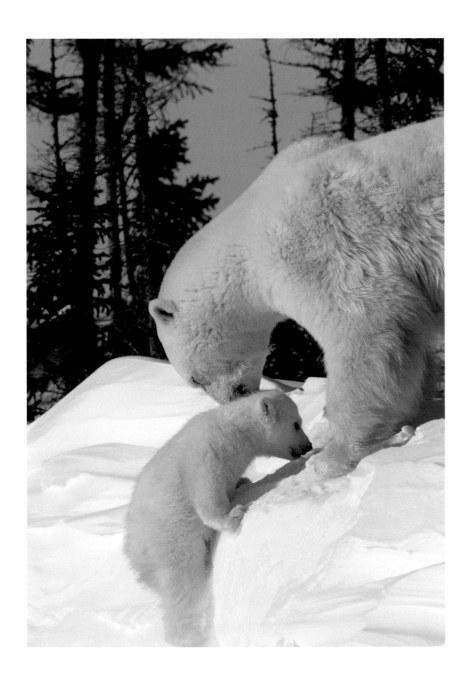

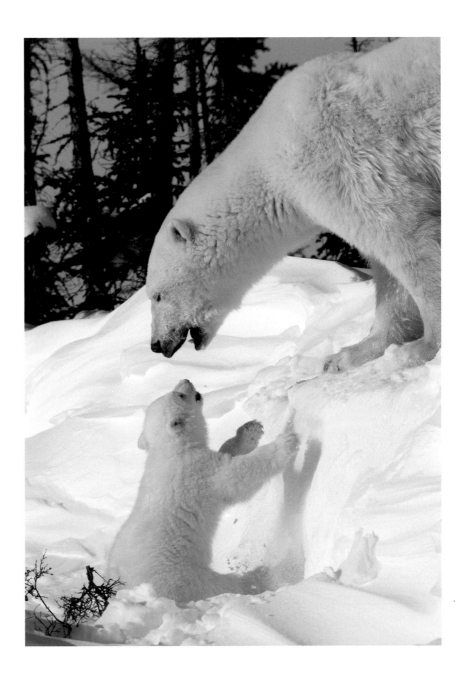

25

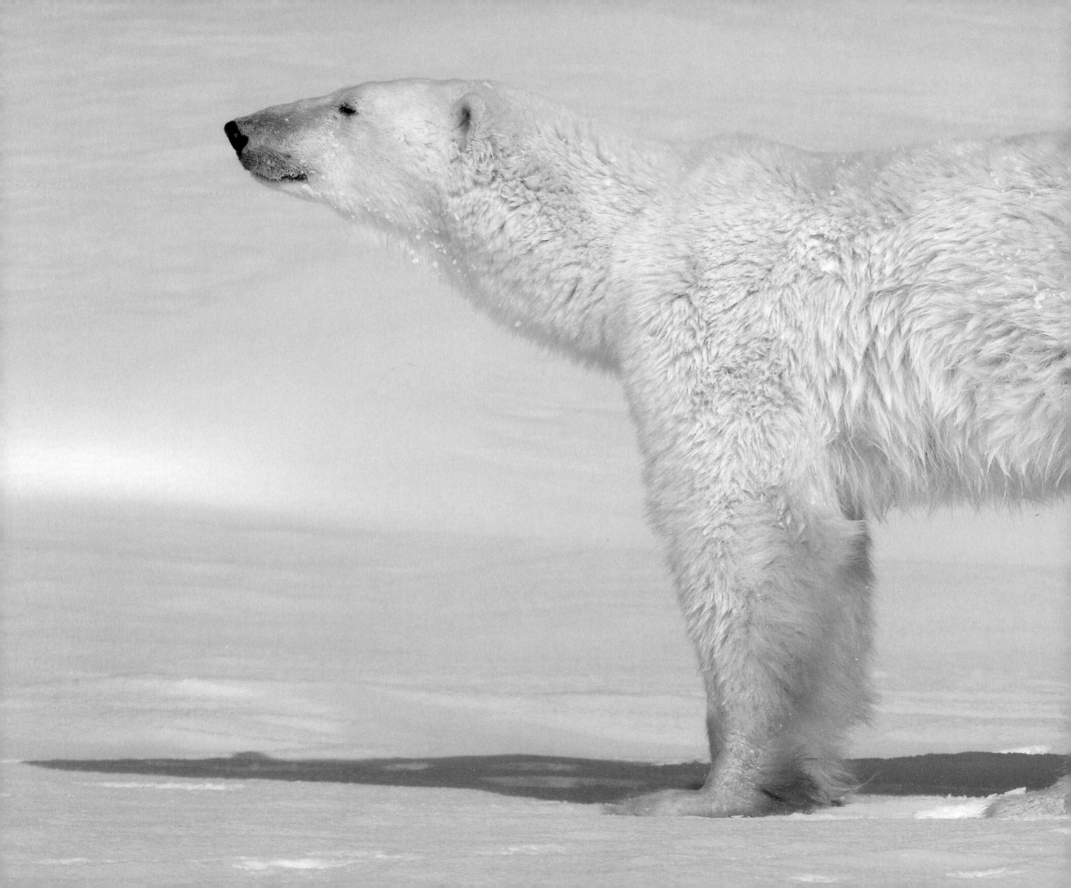

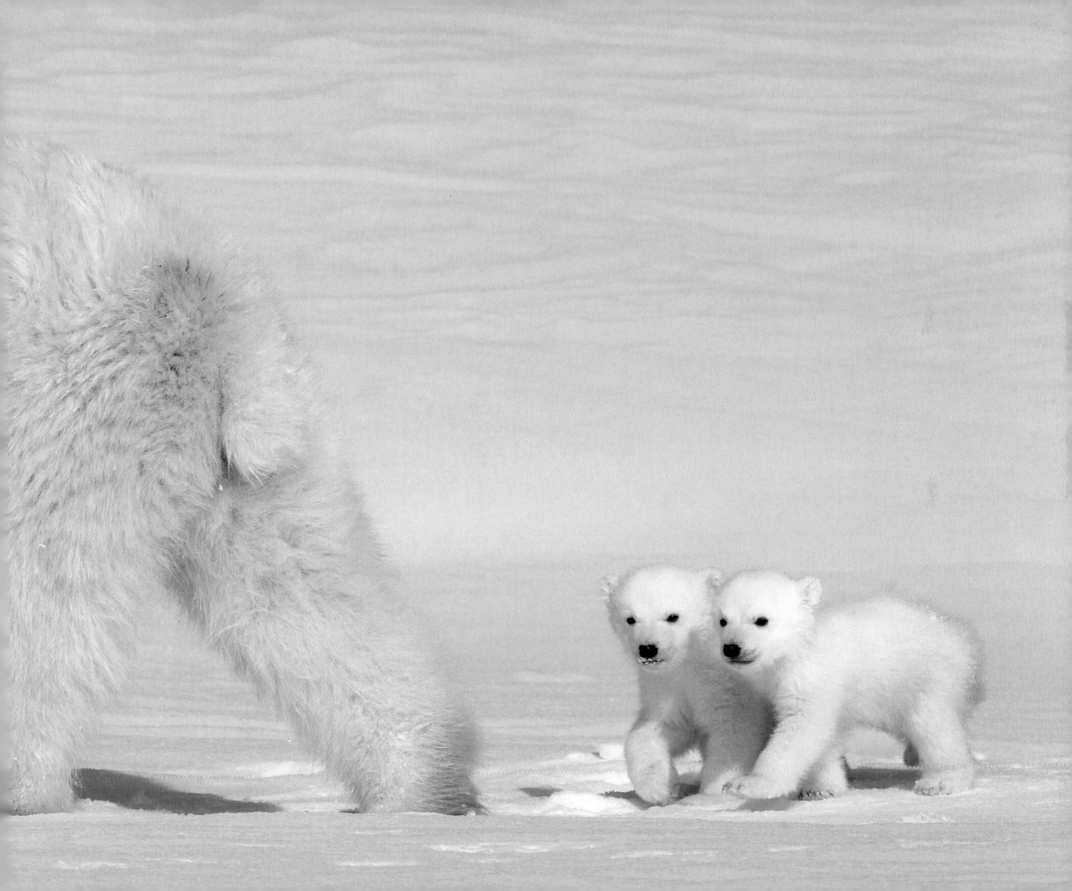

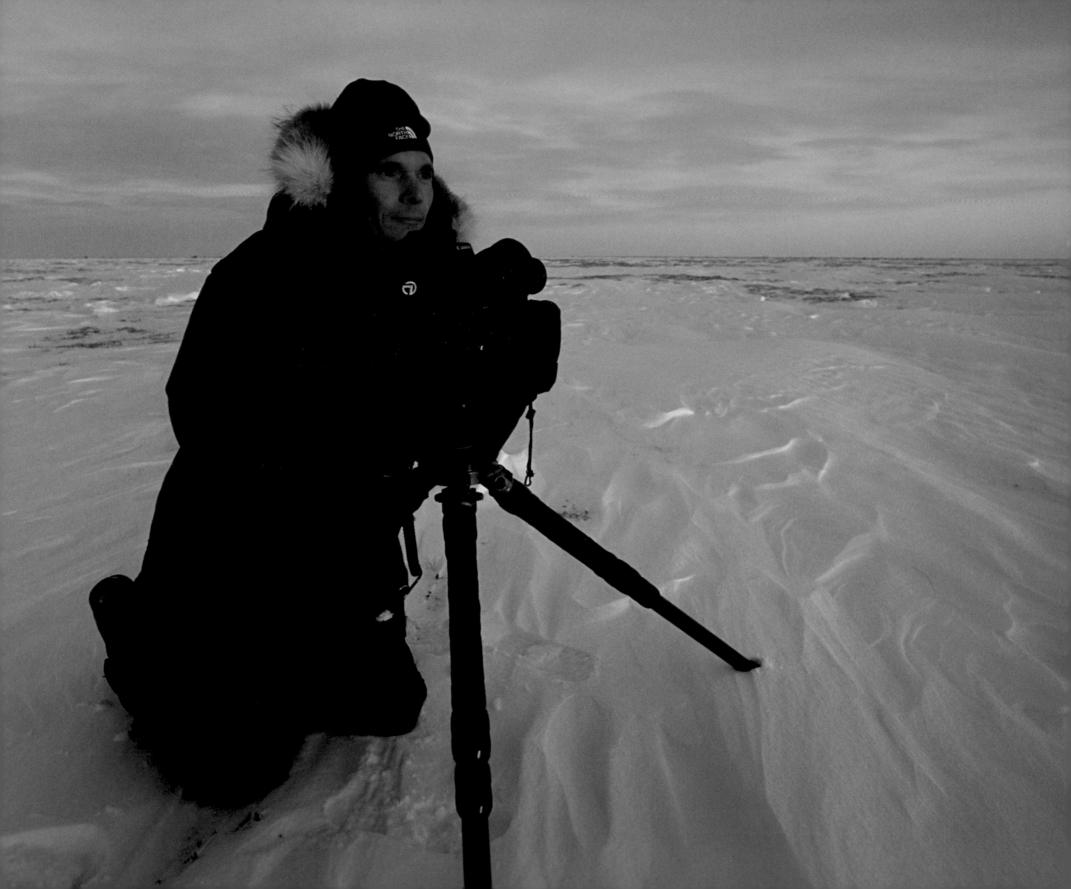

Reaching the Goal

For an endeavor of this kind, the costs and the effort, a passionate enthusiasm and deep affection for the white giants of the Arctic and for their offspring are absolutely essential. Reaching the goal, however, also requires good organization. This involves, first and foremost, permission for a photographic excursion from the authorities at Wapusk National Park. Located in Manitoba, Wapusk National Park is one of the few places worldwide where polar bear cubs can be observed up close from a distance of roughly 100 meters. Permission is granted only to a limited number of visitors, who are required to adhere to a strict set of rules.

Wapusk National Park was named after the white giants. In the Cree language "Wapusk" means "white bear." The park covers an area of 11,475 square kilometers. Among other mandates, it was created to protect some 1,200 dens where the females give birth to their cubs. During the birthing season, roughly 150 to 200 females reside in this range. Thus, by comparison to other polar bear habitats worldwide, the park is home to a very high density of dens, and this is why the area is also referred to as the "denning area."

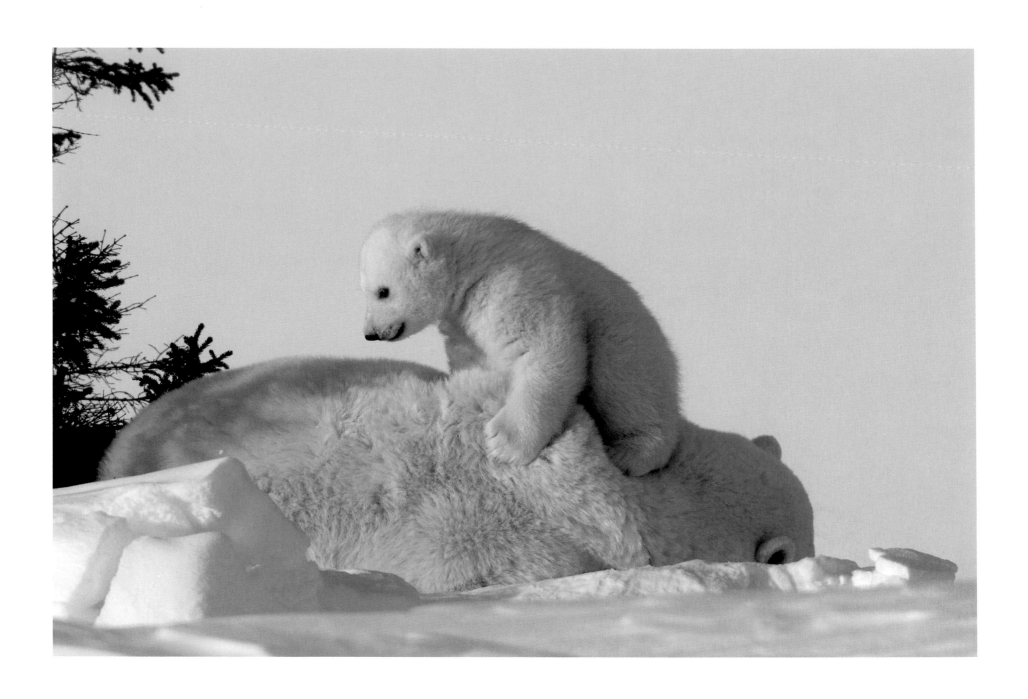

30

The Churchill polar bear denning area lies some 70 kilometers south of Churchill and is one of 17 such areas worldwide. Other large denning areas are found on Wrangel Island, off the coast of north-east Russia, and on Kong Karls Land in Spitsbergen, which is part of Norway.

Wat'chee Lodge plays an important role in the success of an undertaking such as mine. The Canadian Indian owners and associates do not only offer accommodation and provisions, snowmobiles, drivers and guides to park visitors. They also look after the most important aspect of all – that is, tracking down the bears in the white expanse of the Arctic.

"Wat'chee" is another Cree word that can be roughly translated as "a hill covered with trees in the middle of the tundra." Wat'chee Lodge, which affords a magnificent view over the plains on Hudson Bay, is perched on just such a hill, located some 60 kilometers south of Churchill and directly at the boundary of Wapusk National Park. Morris and Michael Spence are the owners of the lodge and one chapter is dedicated entirely to them in recognition of their love for these bears.

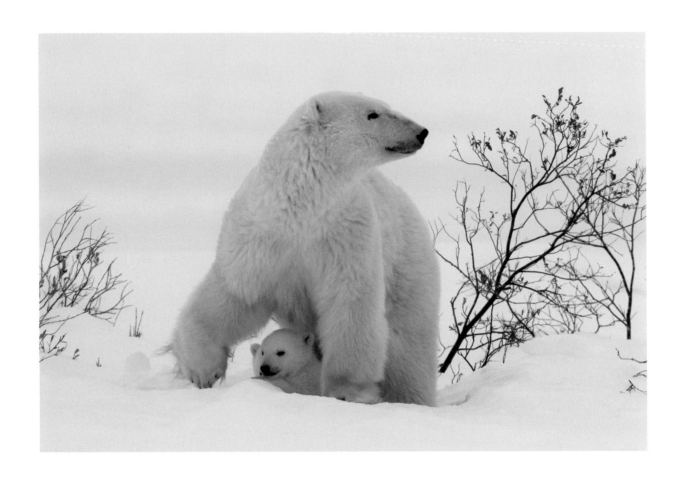

The bear mother looks around anxiously for her second cub.
She does not like it when the little ones stray beyond her reach; polar bear families need body contact.

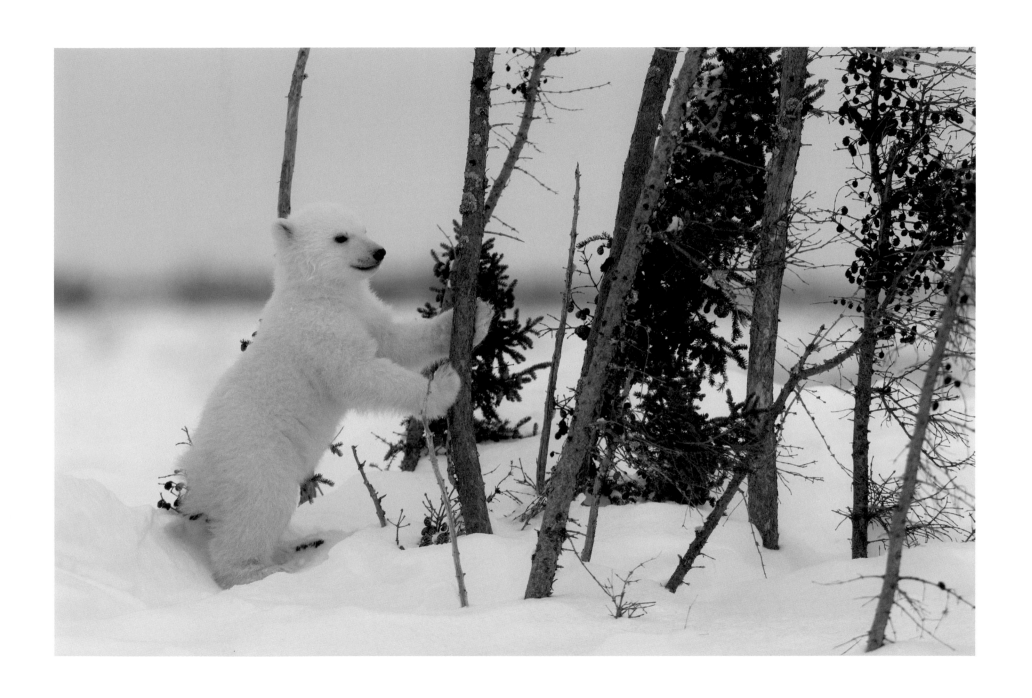

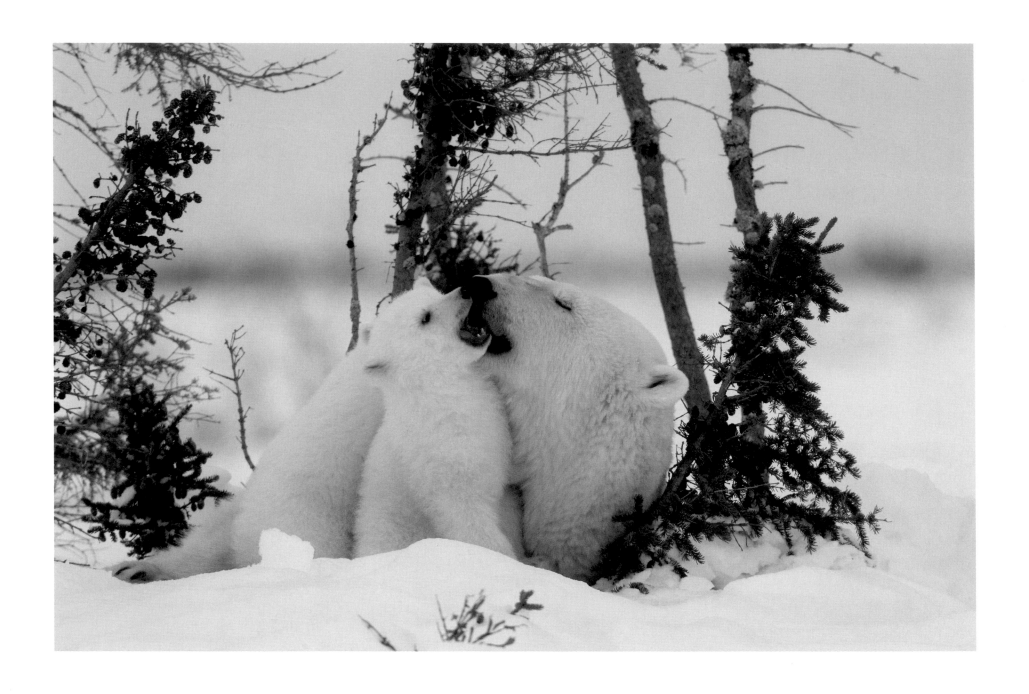

3中

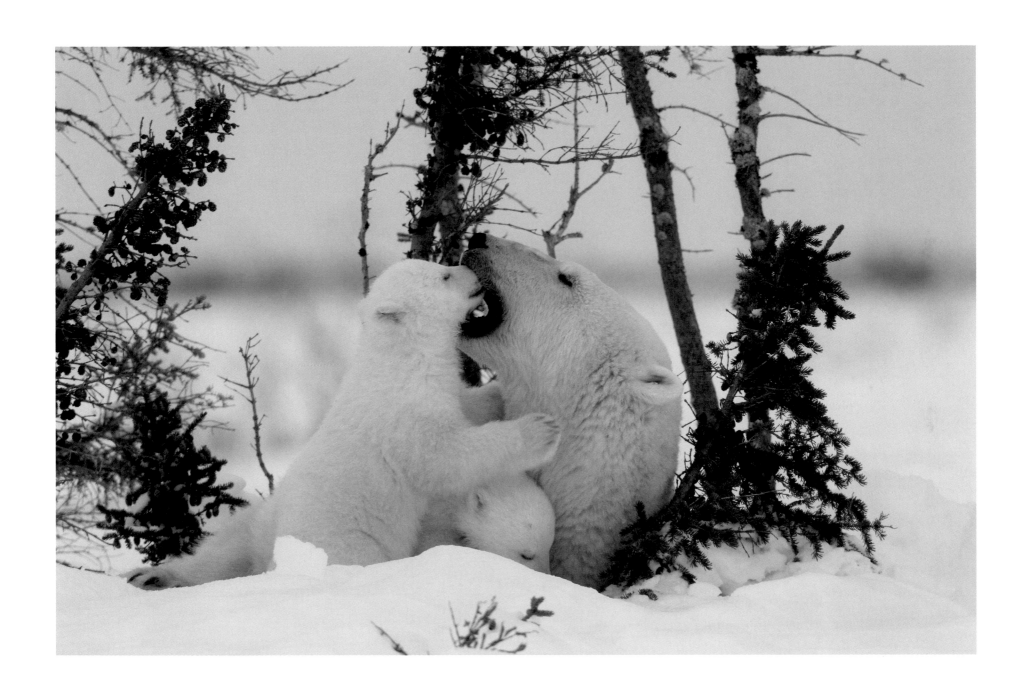

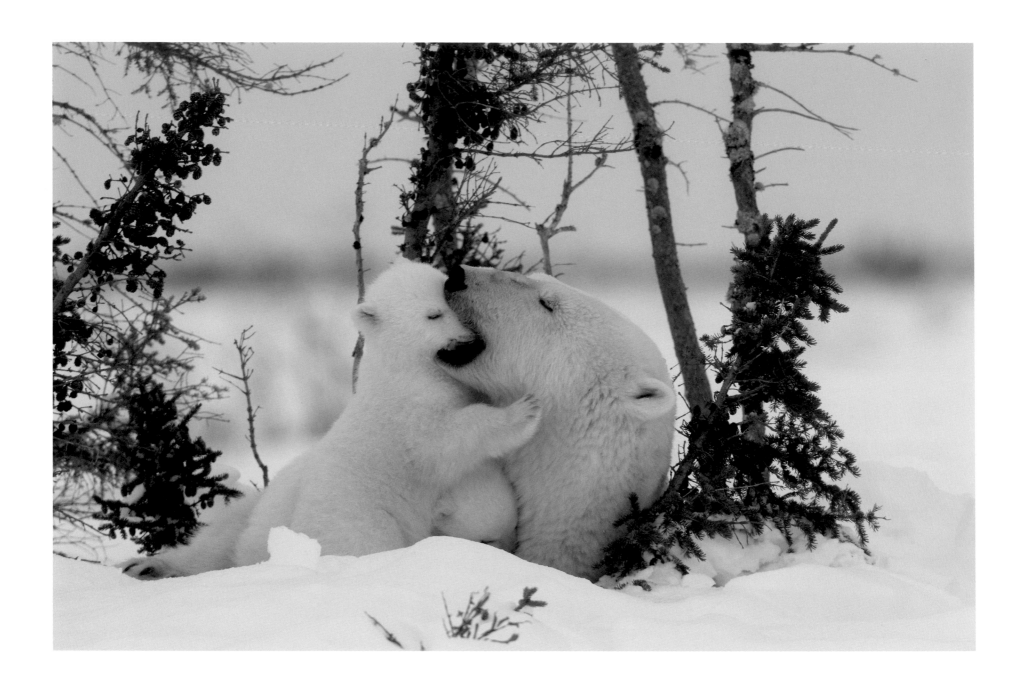

36

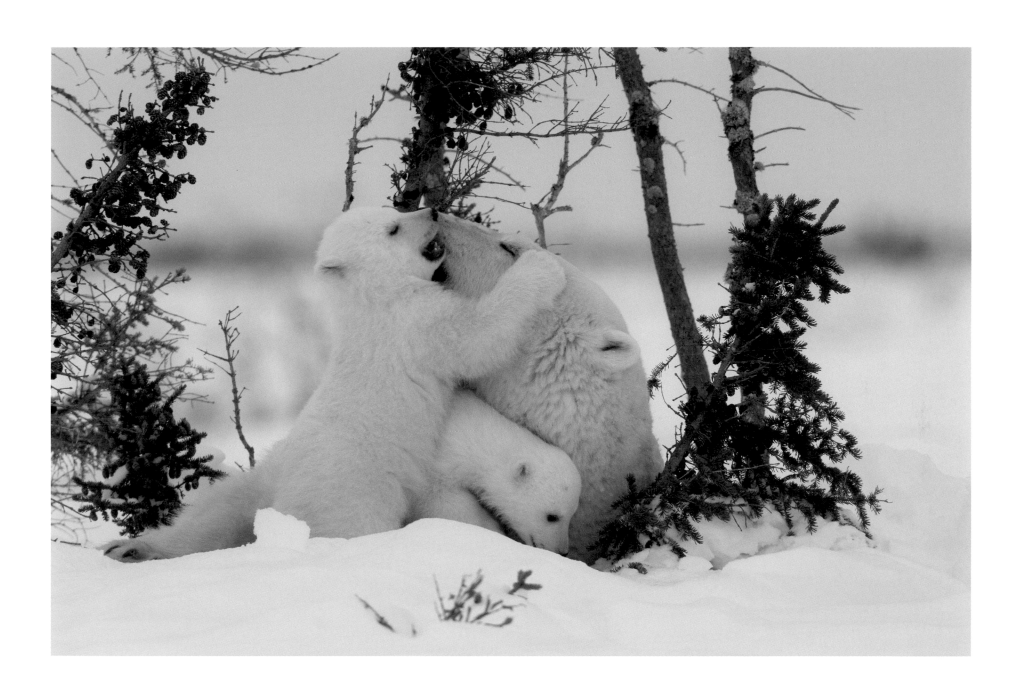

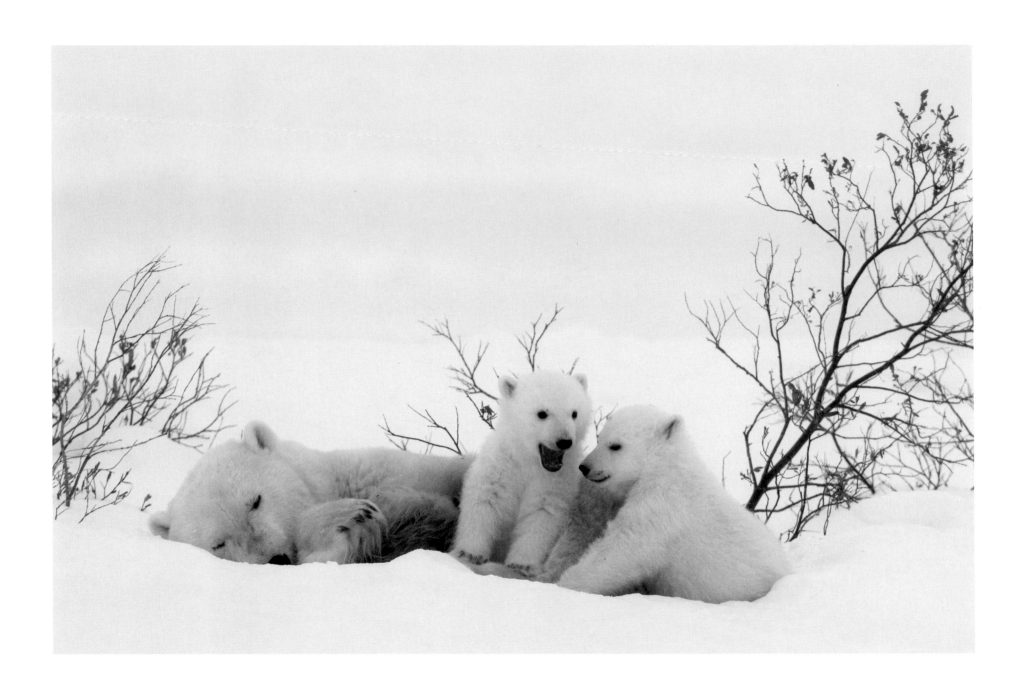

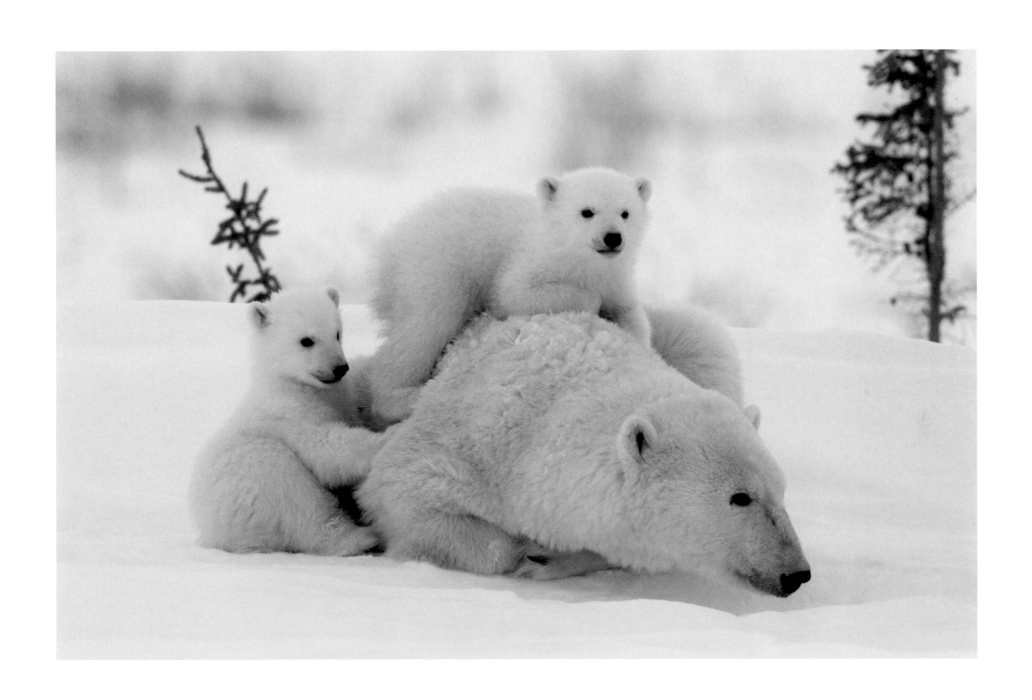

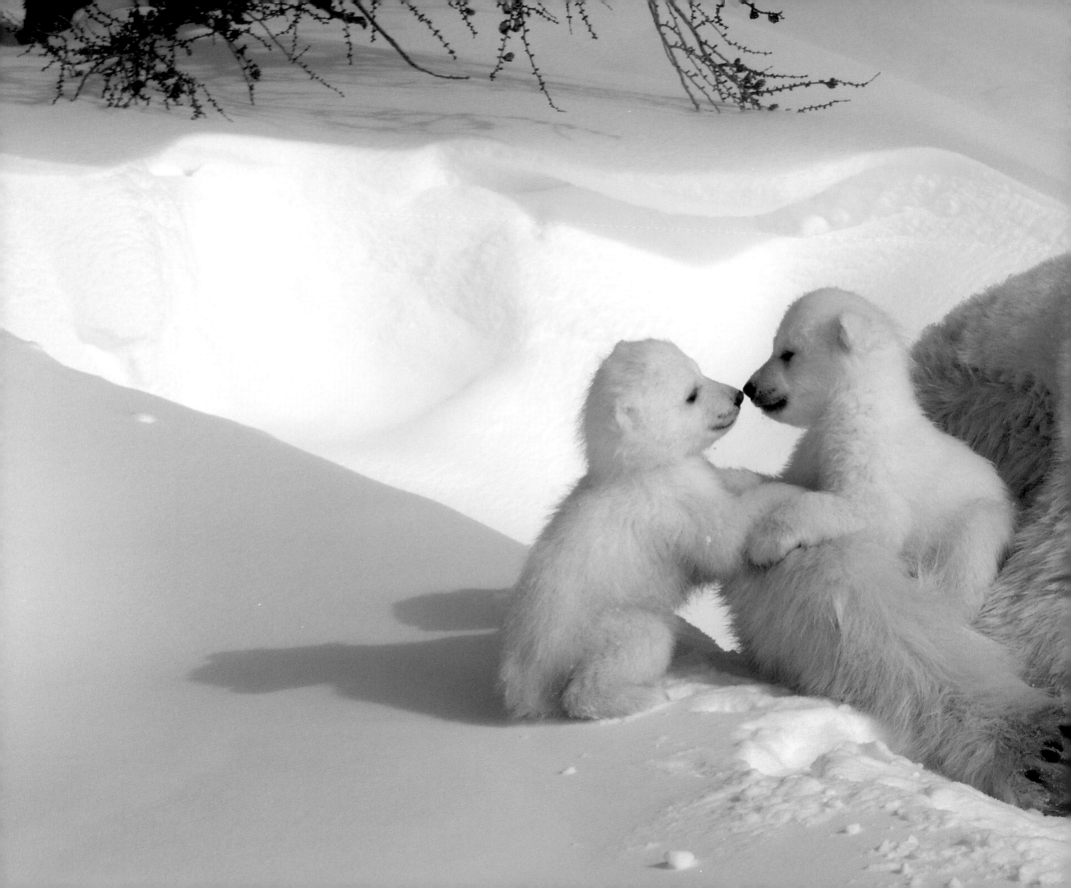

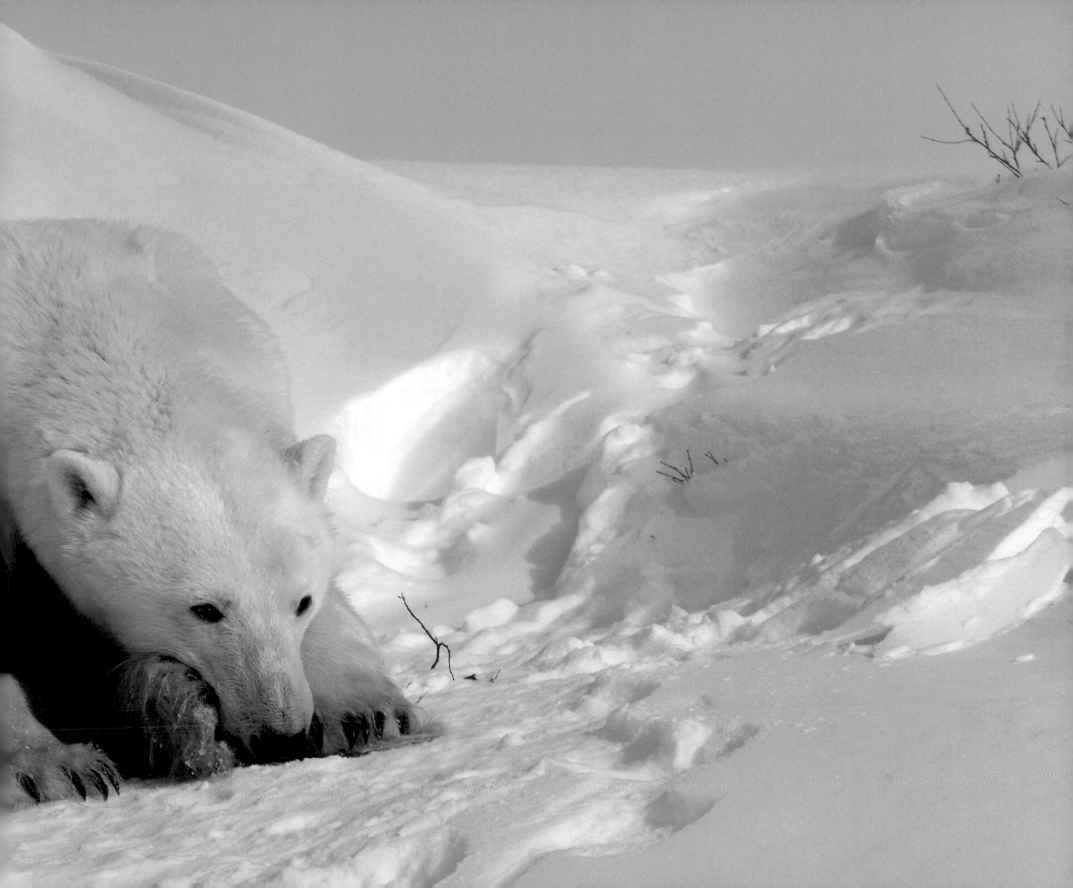

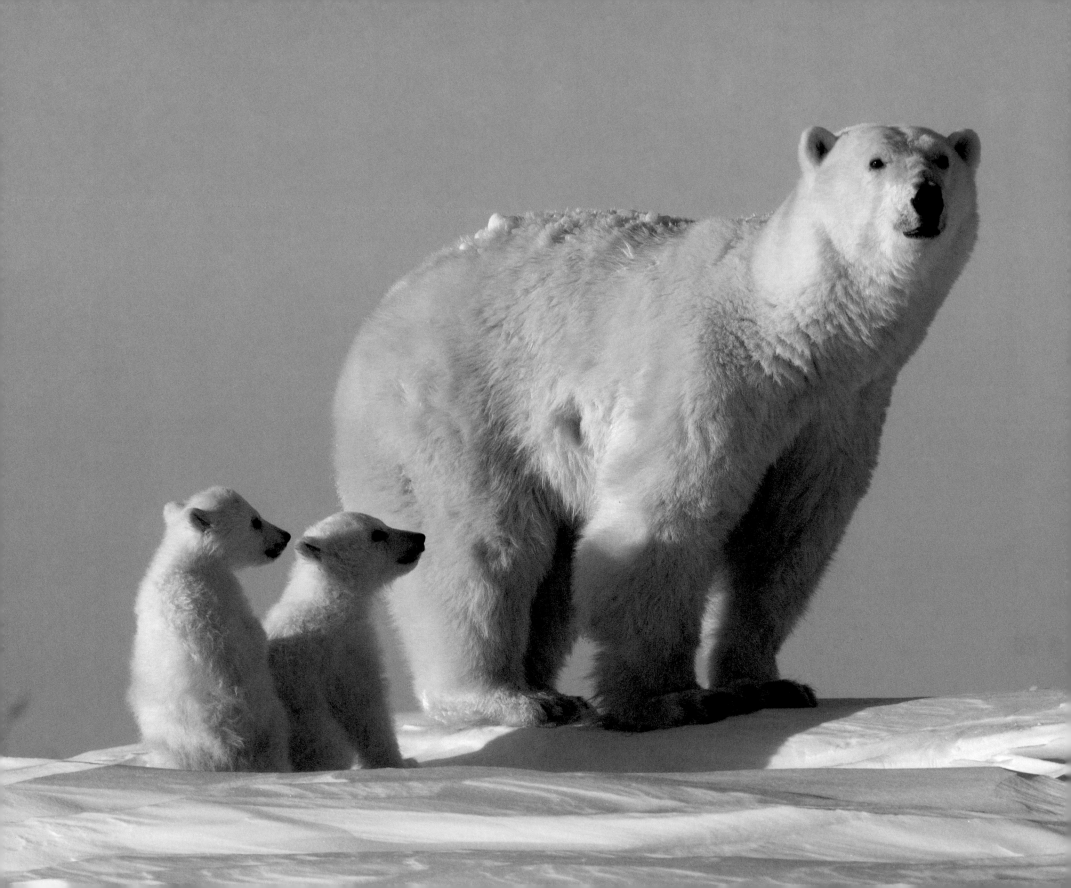

The Life of Polar Bears

The more I learn about the large white bears, the greater my admiration for these animals becomes. Polar bears are superbly adapted to their habitat, which is covered in ice and snow and plunged into extremely low temperatures for at least two thirds of every year, providing nourishment for only some months.

The polar bears were given their Latin name Ursus maritimus – or "sea bear" – for their excellent swimming ability. Despite their massive size and enormous weight, polar bears are outstanding divers and can easily swim across a distance of 100 kilometers. They are equally adept on land, where they move at a pace of five to six kilometers per hour and even manage a brief sprint when they are hunting.

With a length of up to 2.6 meters and a shoulder height of roughly 1.6 meters, the male polar bear is the world's largest land predator. Fully grown, and at the end of a good hunting season, a male can weigh up to 700 kilogram. Females are only about half the size and weigh between 200 and 300 kilogram; during pregnancy, however, when they move into their birthing den after having accumulated an impressive layer of fat, females can also reach a weight of up to 500 kilogram. Polar bear cubs, on the other hand, are tiny at birth, weighing in at no more than 600 to 700 gram. They reach maturity only after five to six years and can live as long as fifteen to twenty-five years. Their natural habitat is limited to Alaska, Greenland, northern Canada, Siberia and Spitsbergen.

Polar bears live with the ice. They roam through ice and snow all along the coasts of the continents and archipelagos in the Arctic and have only one natural enemy: humans. They are never cold, despite the freezing temperatures in the Arctic, because the coat of polar bears is unique. Every hair is translucent, allowing the rays of the sun to shine right through to the bear's body. The skin underneath the fur is black, thus absorbing the warmth of the sun in an optimal fashion. The longer hairs near the skin trap the heat at the surface of the body by limiting the movement of air between the hairs. The result: excellent and lightweight insulation.

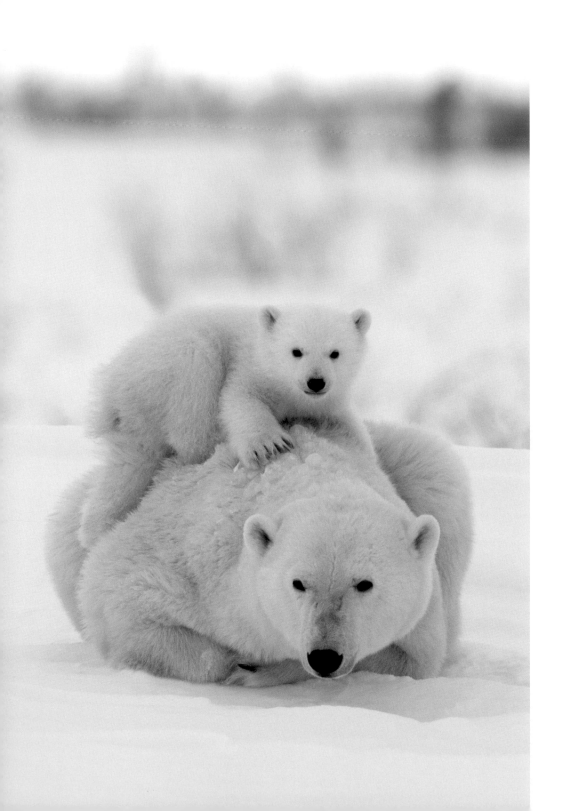

Still, no animal, not even a polar bear, is entirely protected against the cold by their fur. Out of necessity, the eyes, mouth, nose and the pads on their feet remain uncovered. Excess heat – for example, after a short sprint – can dissipate via the parts of the body not covered in fur. On land – that is, on ice and snow – the polar bear's hairless foot pads function as suction cups thanks to small papillae and cavities, which provide the bear with a sure footing even on the most slippery of surfaces.

In the water, however, polar bears benefit neither from their fur nor from their suction cups; there, they must rely entirely on their excellent swimming skills and on a layer of blubber that is up to ten centimeters thick and offers excellent insulation. It is this layer of blubber that enables polar bears to swim in freezing waters. And their huge paws serve as excellent paddles.

Contrary to their dark-furred relatives, polar bears are primarily carnivores. Winter is the hunting season for these white giants,

when the land is covered in snow and ice and the bays are frozen solid. Their preferred prey is seals, which they can kill with a single blow. They are excellent hunters thanks not only to their white fur, which acts as a perfect camouflage, but also due to their highly developed sense of smell which allows them to detect a seal from as far away as one kilometer. Sometimes, they also hunt bearded seals and rarely walrus, narwhals or beluga whales. (However, only every tenth to fifteenth hunt ends in success, that is, in a blubbery feast of meat.) When the ice has melted in Hudson Bay in late summer and fall, the bears turn to seaweed, berries and tundra grasses, or even carrion for food. In other words, the ice-free season is a time of minimal diet or starvation for polar bears. During this time, they reduce movement and roaming to a minimum, saving energy and spending most of their time sleeping and living off the layer of blubber they have accumulated during the hunting season. Polar bear mothers, in particular, are highly adept at surviving starvation periods.

Polar bears arc solitary creatures, with the exception of the females who remain with their young to raise them. Males relinquish the pattern of living alone only during the mating season from the end of March to the end of May. The male will stay with the female until she is in heat and they have successfully mated. During this time, the dominant male strives to keep rivals away from his fertile mate in order to secure his own reproduction. Heated confrontations are not uncommon, although they are rarely fatal.

What is unique, however, is the process that follows in the female once she has coupled with her mate: the inseminated egg docs not lodge in the uterus, which means that it doesn't develop at first. For this is the time when the female must make the most of the brief hunting season that remains in order to build up a thick layer of fat. Females undergo an enormous weight gain during this period and may reach a weight of up to 500 kilogram.

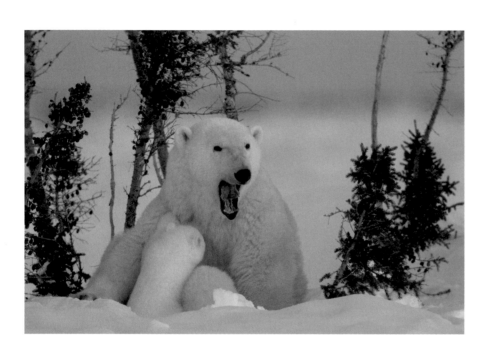 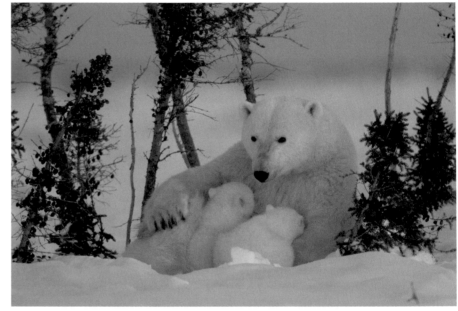

46

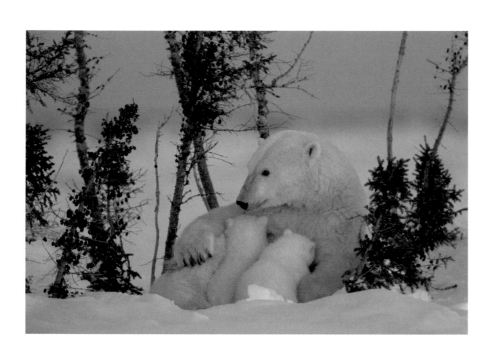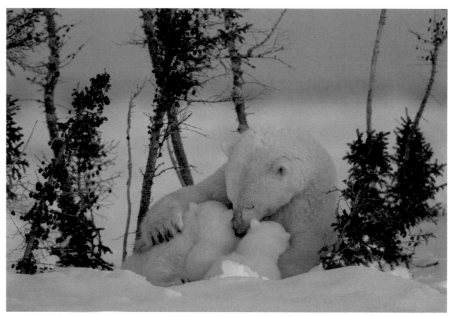

47

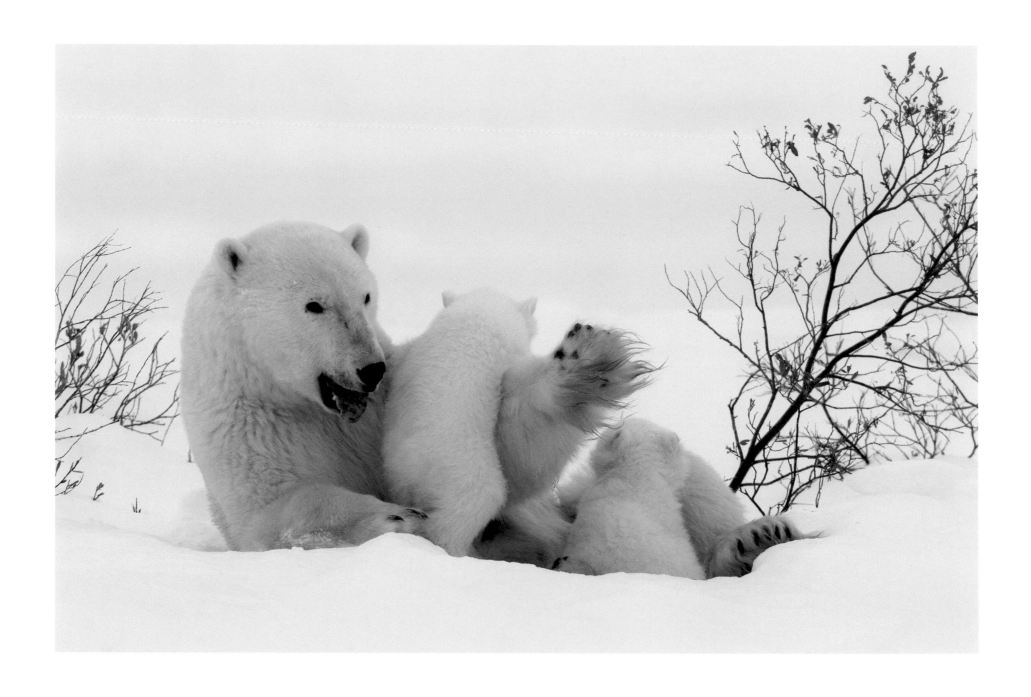

48

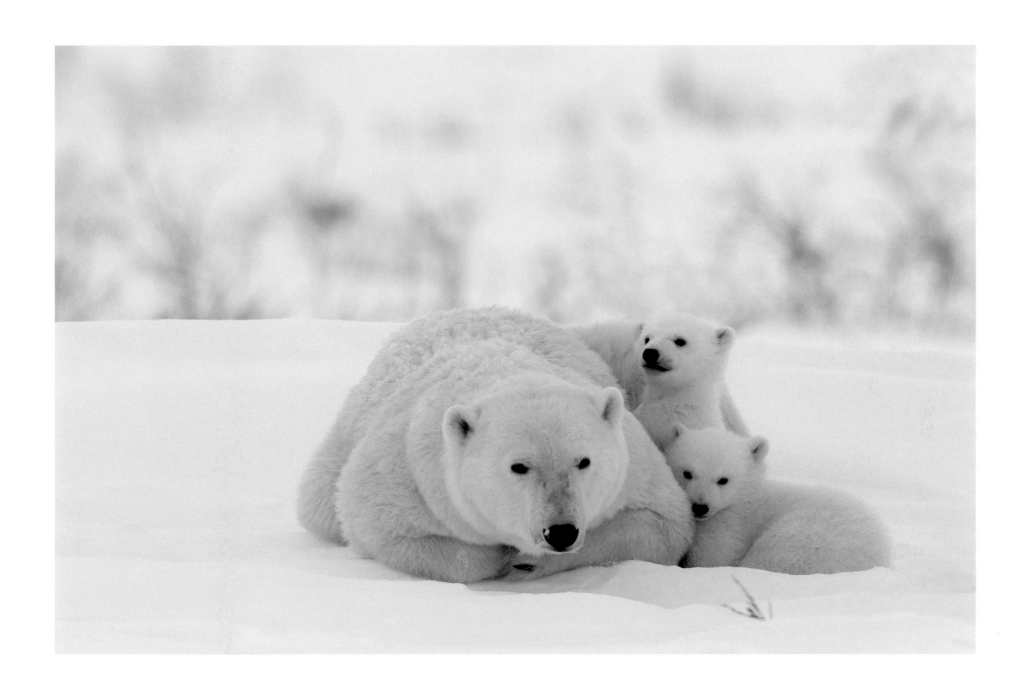

49

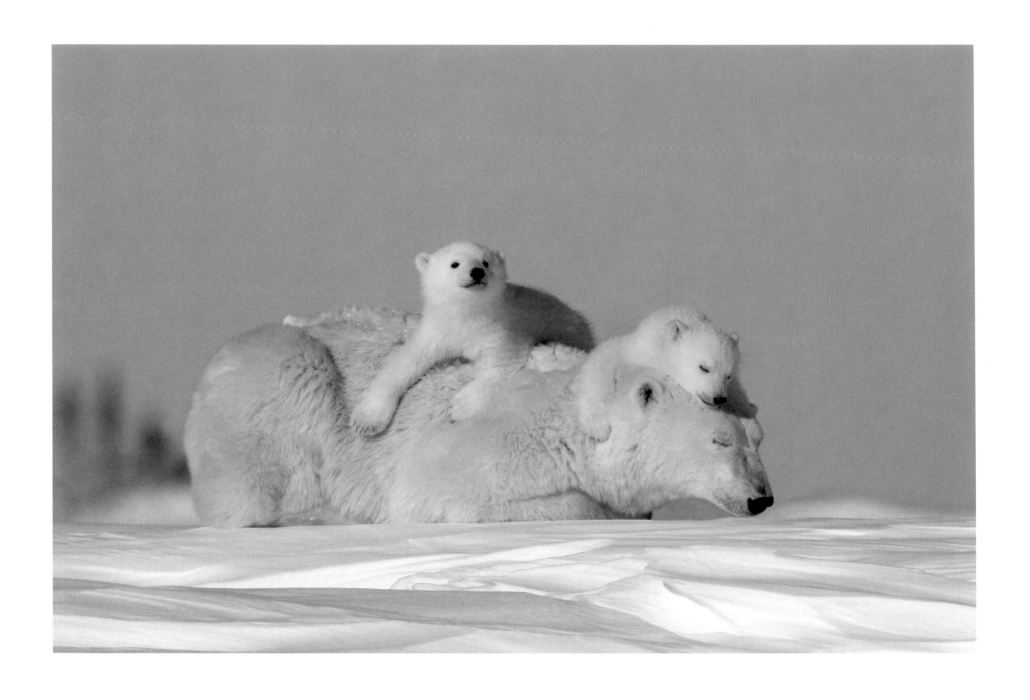

50

The season of hunger, which can last up to eight months for a polar bear mother in Hudson Bay, arrives as early as July. Toward the end of September or in early October, the fertilized egg travels to the uterus of the female and the development of the embryo commences; the gestation period is only some 90 days. By mid-October, the mothers-to-be retreat into the interior, where they search for a den or burrow a new one. The cubs are born between late November and early January. Nearly 70 per cent of all births are twin births. On rare occasions, a single cub is born and very rarely, a female will give birth to triplets. The cubs – no larger than rats at birth – soon grow stronger thanks to the care of the mother bear and her highly nutritious milk. In February, they are usually ready to leave the den with their mother and migrate toward the ice on Hudson Bay.

Despite the care with which polar bear females raise their young, only six of ten cubs survive the first year. Some die of malnutrition, although many are also killed by older bears or fall prey to wolves. The cubs remain with their mother for two and a half years; during this time, she protects and feeds them and teaches them how to hunt. Once this is accomplished, she chases her adolescent young away and they must go their own way. Given this long "family time," the females come into heat only roughly every three years. This, in turn, increases the competition among the males, which may be one of the reasons for their massive size.

Today, the polar bear population is estimated at 20,000 to 30,000 animals worldwide, of which nearly 15,000 live in Canada. Polar bears were at the brink of extinction over a century ago, when polar bear meat and fur were very popular. Although the hunting of polar bears is now subject to stringent limitations and is the exclusive right of the Inuit people, once again the economic factor has unfortunately begun to play a greater role in recent years. In 2005, the territorial government of Nunavut issued more than 500 licenses for hunting polar bears, in order to provide Inuit with the opportunity to sell their "polar bear shoot" to trophy hunters for as much as 25,000 to 40,000 US dollars.

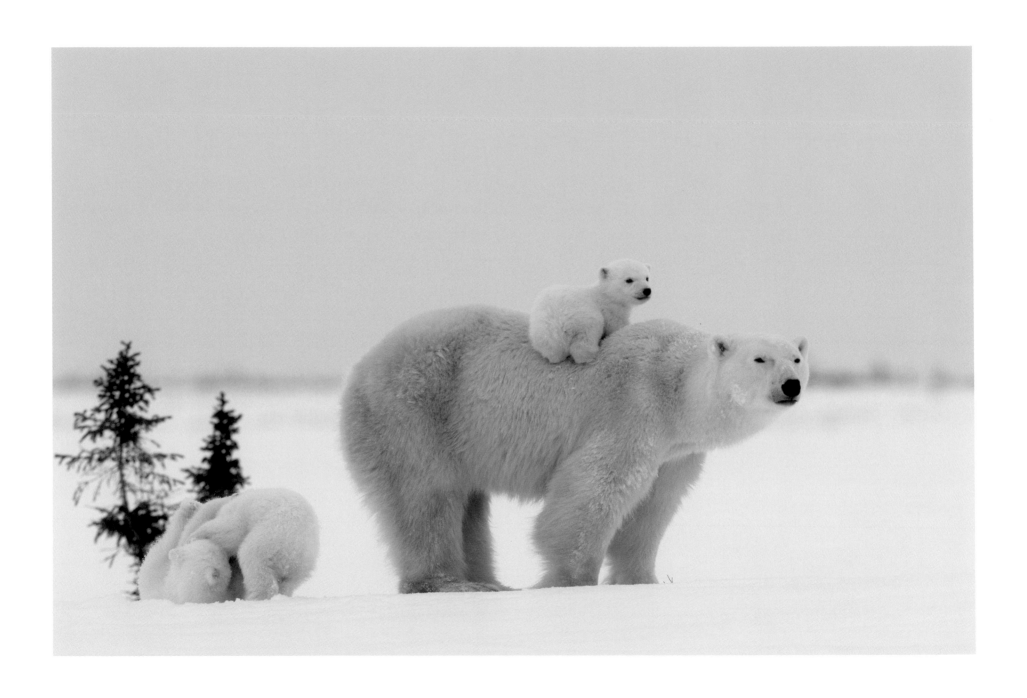

52

Global warming poses an entirely different threat to polar bears since the pack ice freezes later and later every year and also breaks up sooner. Hudson Bay is the southernmost habitat of these bears and this is therefore the region where the effects of climate change are most evident. Over the past century, the average temperature has risen by some 5 °C. In the western reaches of Hudson Bay, the ice cover on the bay remains for two and a half weeks less than just a few decades ago. This gives the polar bears less and less time to hunt for ringed seals, their preferred prey, on the pack ice; the hunger season is growing longer. This is especially difficult for the polar bear mothers, who must increase their food intake to build up a thick layer of fat and who are moreover prevented from taking advantage of the remaining hunting season because of their young.

But younger bears are put at risk by this development too, because they are finding it increasingly difficult to leap across the growing distances between ice floes. With every week that the ice breaks up earlier, thus cutting a polar bear off from his food source, he loses several kilograms of fat. If this trend continues, the consequences for the polar bears in Hudson Bay would be dramatic indeed. For the survival of polar bears it is therefore vital that the industrial nations of the world finally implement efficient measures to halt global warming.

Northern lights in the Arctic expanse – *Aurora borealis*.

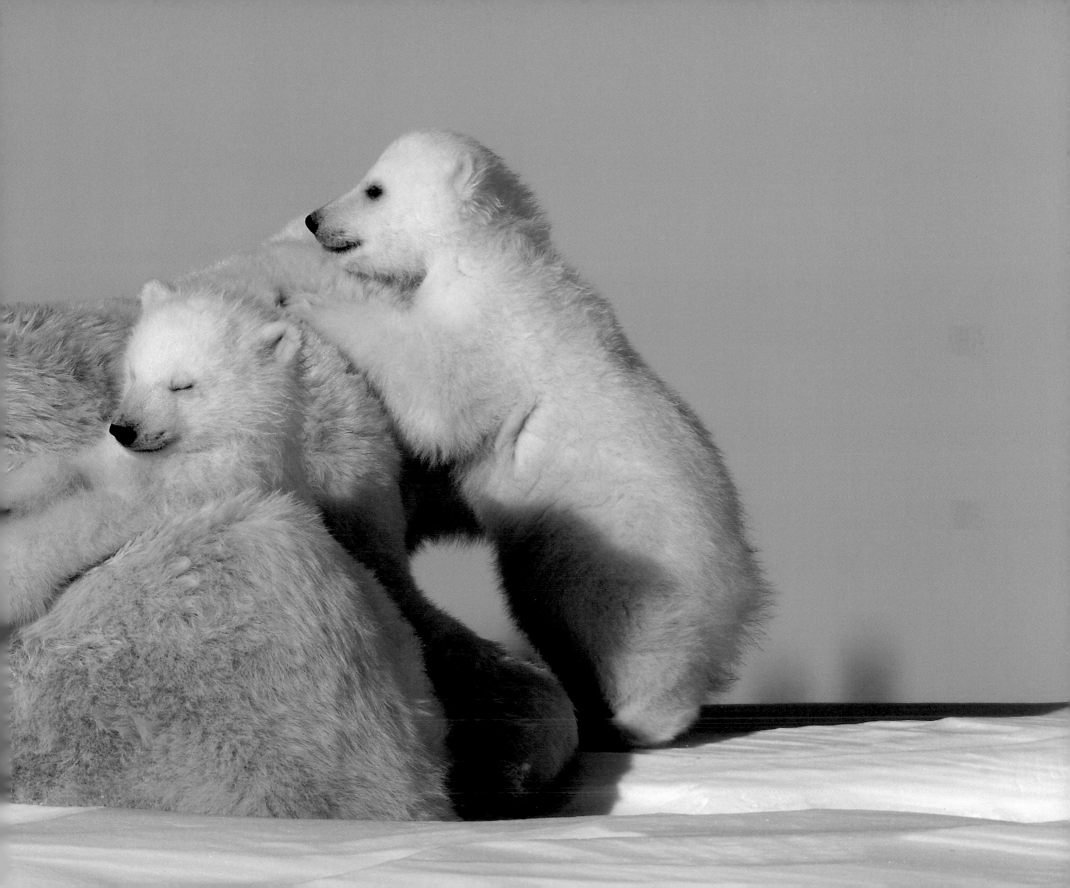

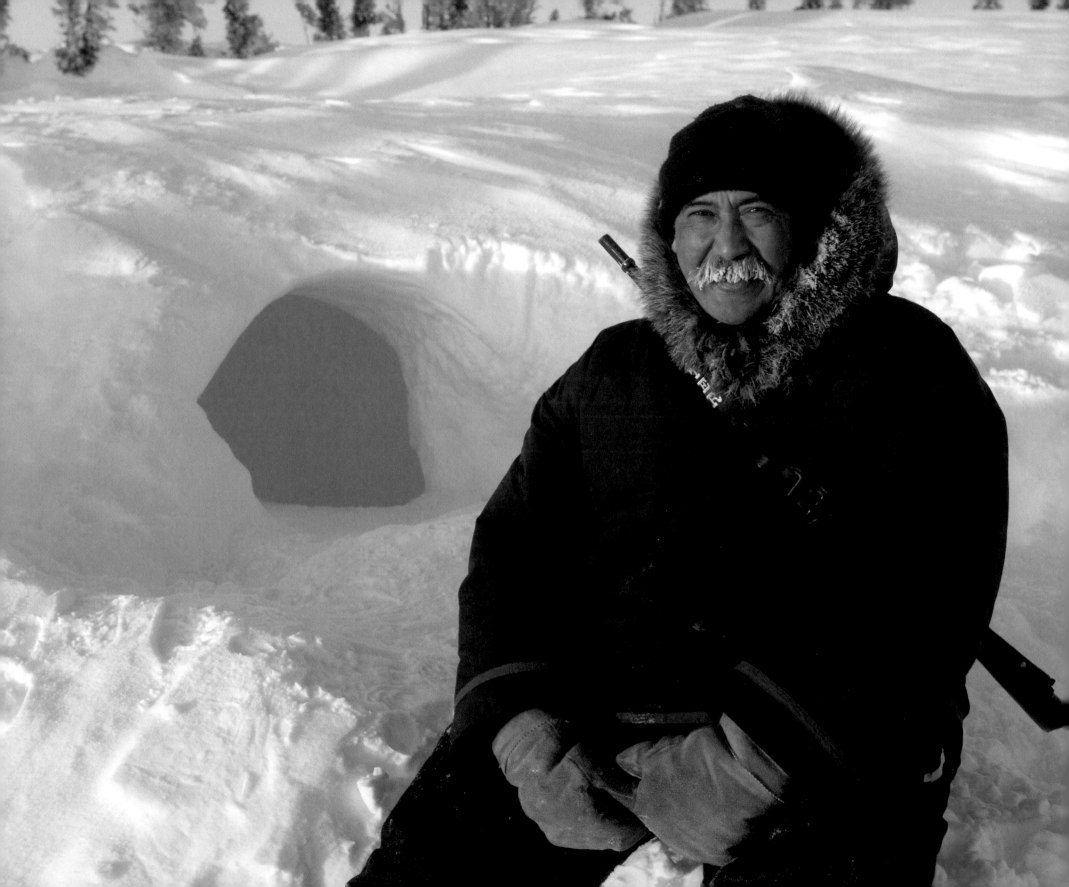

The Trackers

Without Morris, I would not have been able to take a single shot of a polar bear, nor would I have been able to catch a glimpse of white fur. Morris Spence, founder and co-owner of Wat'chee Lodge, passionate tracker and the polar bears' best friend, is a Cree Indian. The Cree, like the Inuit and the Dene, were the first to settle in the vicinity on Hudson Bay and are today one of the most important peoples among Canada's First Nations. Morris' ancestors lived exclusively from the hunt: they set up traps and hunted for caribou, moose and polar bears on the ice and in the forests to support themselves and their families. The first white settlers moved into the area at the beginning of the 18th century and traded with the Cree, exchanging goods for fur. As time went by, the Indians were increasingly involved with the trade transactions of the Hudson's Bay Company as suppliers of fur; finally, they were divided into communities and more and more restricted in their freedoms. In this manner, the Cree became dependent on the colorful economic development of the Hudson's Bay Company. When the railroad reached Churchill in 1929, the changes were even more drastic – in favor of the white settlers. In 1931, the so-called Port Churchill was completed, marking another turning point in the life of the Indians who felt closely connected to nature and the wilderness. The Cree moved to the other side of the Churchill River. The town of Churchill with some 900 inhabitants – natives and whites in peaceful co-existence – exists to this day.

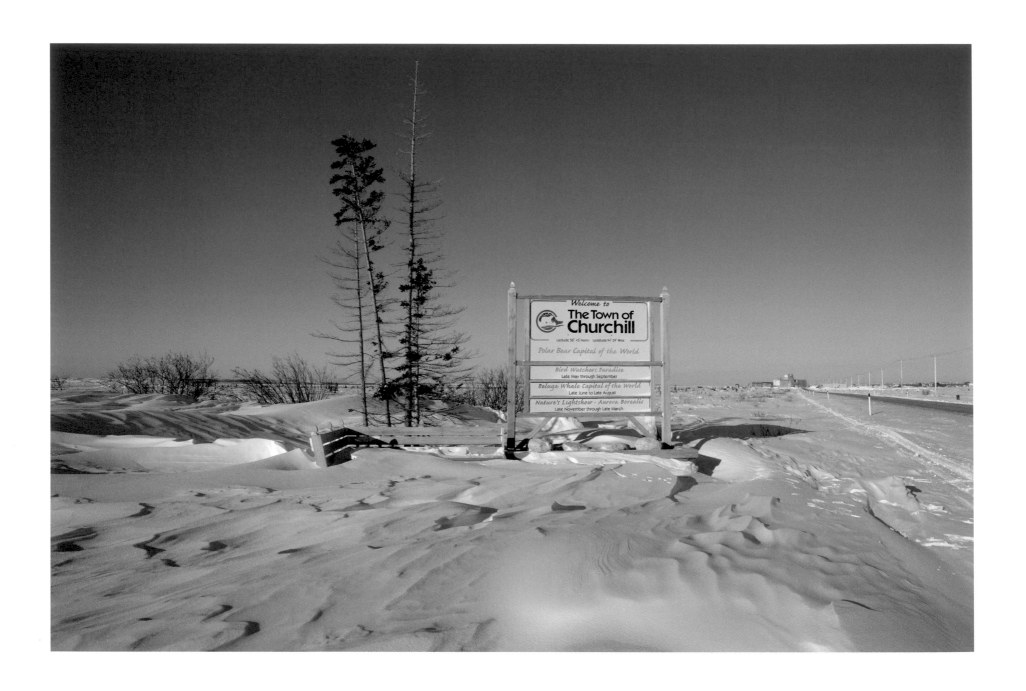

60

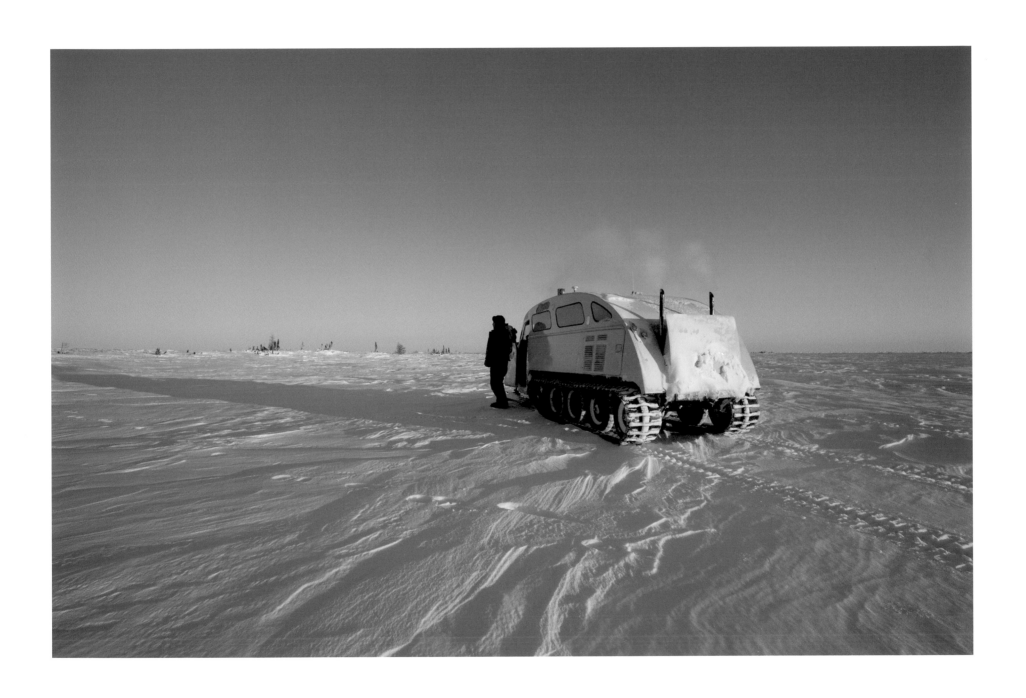

61

Today, some Cree families still own trapper land in the vicinity of Wapusk National Park. They continue to hunt – not for commerce, but rather to keep their traditions alive.

Morris, Michael and James Spence also inherited trapper land from their father. Morris and James still use the trapline for hunting. The land lies to the east of the railway line and reaches all the way into Wapusk National Park. The brothers have known this region since childhood – it is their home. The story began when Morris returned from the trapline one day and told his brother Michael that he had seen many polar bear females with their cubs in the area. Polar bears had never been hunted there before. Is this perhaps why the polar bear mothers felt so safe in the area?

Searching for bears: We drive across the denning area in our snowmobiles.

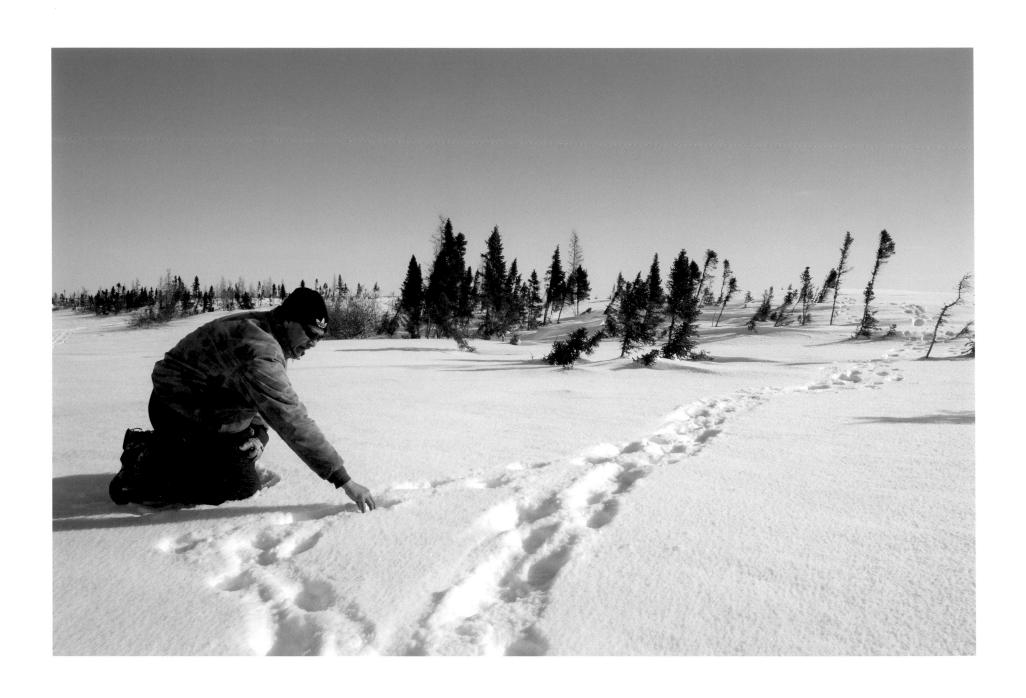

64

Morris and Michael set out together to track and observe polar bear families. They were so impressed by their experiences that they wondered what it might be like to offer others the opportunity of seeing the young polar bears and their mothers and of experiencing nature's beauty on Hudson Bay. Of course, nothing was to disturb or threaten the polar bears. To this end, only a few guests should be invited at a time and given a guided tour to the polar bears. So the idea for the Wat'chee Lodge was born. Although their father insisted that they were crazy, he did agree and gave them permission to utilize the land for their plan. Wat'chee Lodge opened its doors to the first guests in 1994 and the brothers were able to offer guided tours to see the little polar bears.

The two brothers had long held a deep affection for polar bear mothers and their young, a sentiment that had been fostered to no small measure by their father. He had told them a story: in 1933, long before Morris and Michael were born, he had returned from a polar bear hunt with two orphaned cubs, which he sold to the Hudson's Bay Company. The company in turn sold the little ones to a zoo. This story had stirred the brothers to great compassion since they knew that even the best zoo would never be able to provide these animals with anything close to the living conditions they needed.

Today, the brothers are therefore all the more determined to ensure that polar bears can continue to exist in the wild and to contribute to the preservation of their natural habitat. Only those guests of Wat'chee Lodge who wish to photograph, study or report on the polar bears can make their own contribution to this goal, especially if they pass on their enthusiasm to a broad public through film, media reports or books, thus helping to promote the need for preserving this unique environment.

Morris is a tracker, heart and soul, while Michael takes care of the organization and acts as a driver. On most tours, Morris is accompanied by his friend Amuck and together they are an unbeatable team. They alone can live up to the tremendous challenge of tracking down these young polar bears in the vast region. Morris loves to journey into the wilderness in search of the young bears. Every year he eagerly awaits the first snowfall and the season when the land is plunged into subzero temperatures.

67

68

As Morris puts it in his own words: „This is a very special time of the year for me when the mother polar bears start emerging from the dens with their newborn cubs. This is something that I always look forward to. I am also glad that I am able to share this opportunity with visitors that are interested in viewing these new polar bear families in their natural denning area."

In Wapusk National Park, the face of nature changes rapidly depending on weather and wind and it is very difficult to locate the bear dens. But Morris and Michael know Wapusk National Park like the back of their hands. They know where to search and how to read the tracks. Still, the effort is considerable every single time, but this is quickly forgotten as soon as they have found the little ones. Neither subzero temperatures nor snowdrifts or technical mishaps can stop them from embarking on the search in their Ski-Doos. Because for them, the joy and sense of happiness when they discover a polar bear family is irreplaceable.

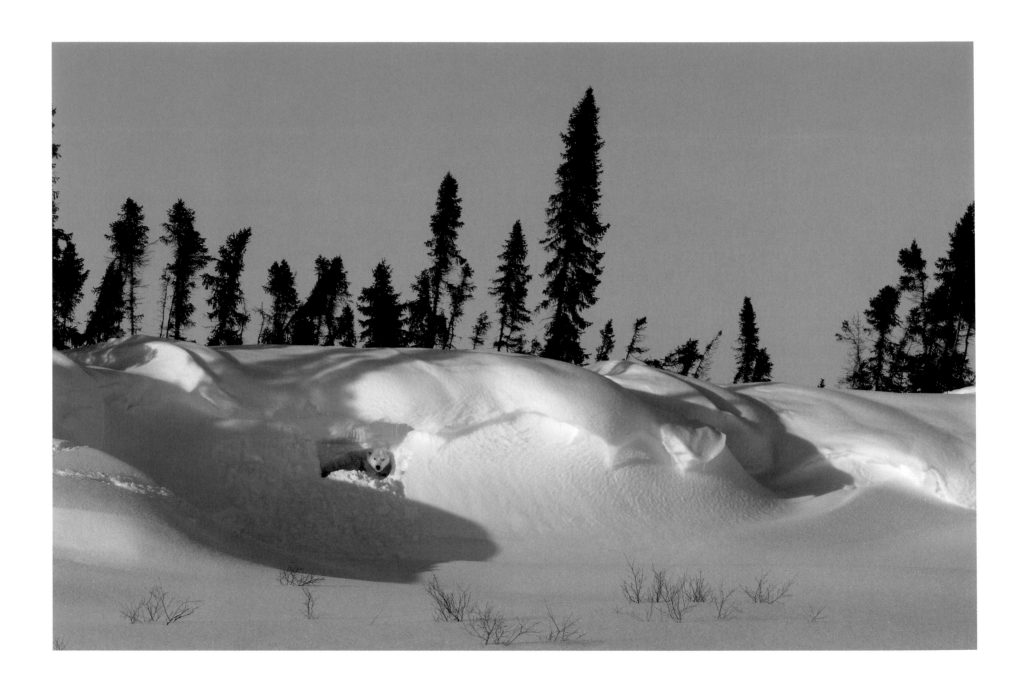

70

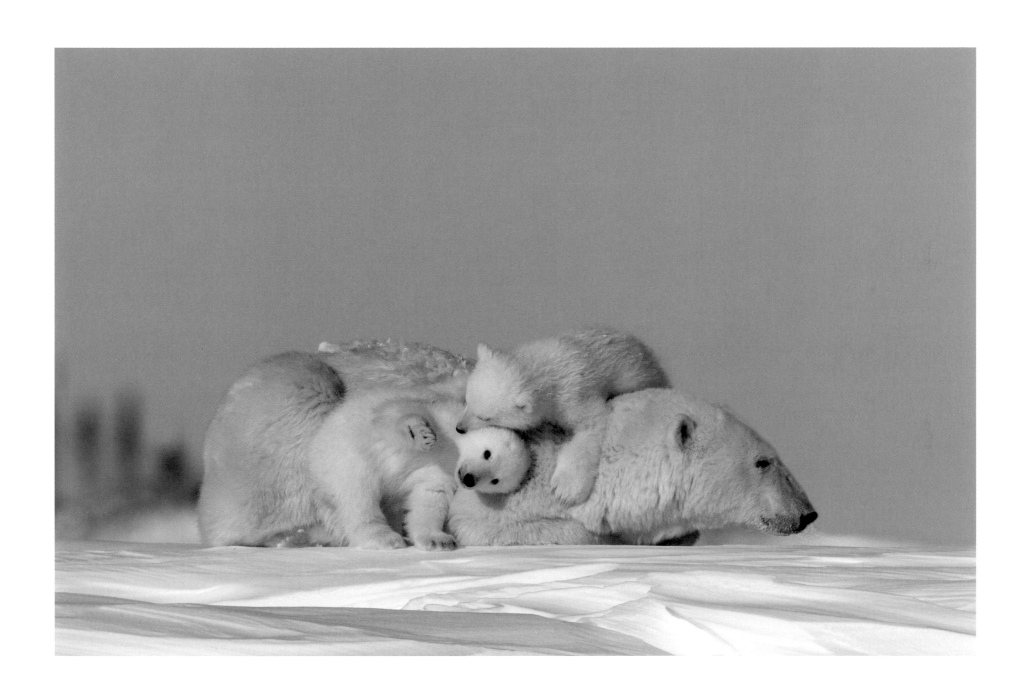

71

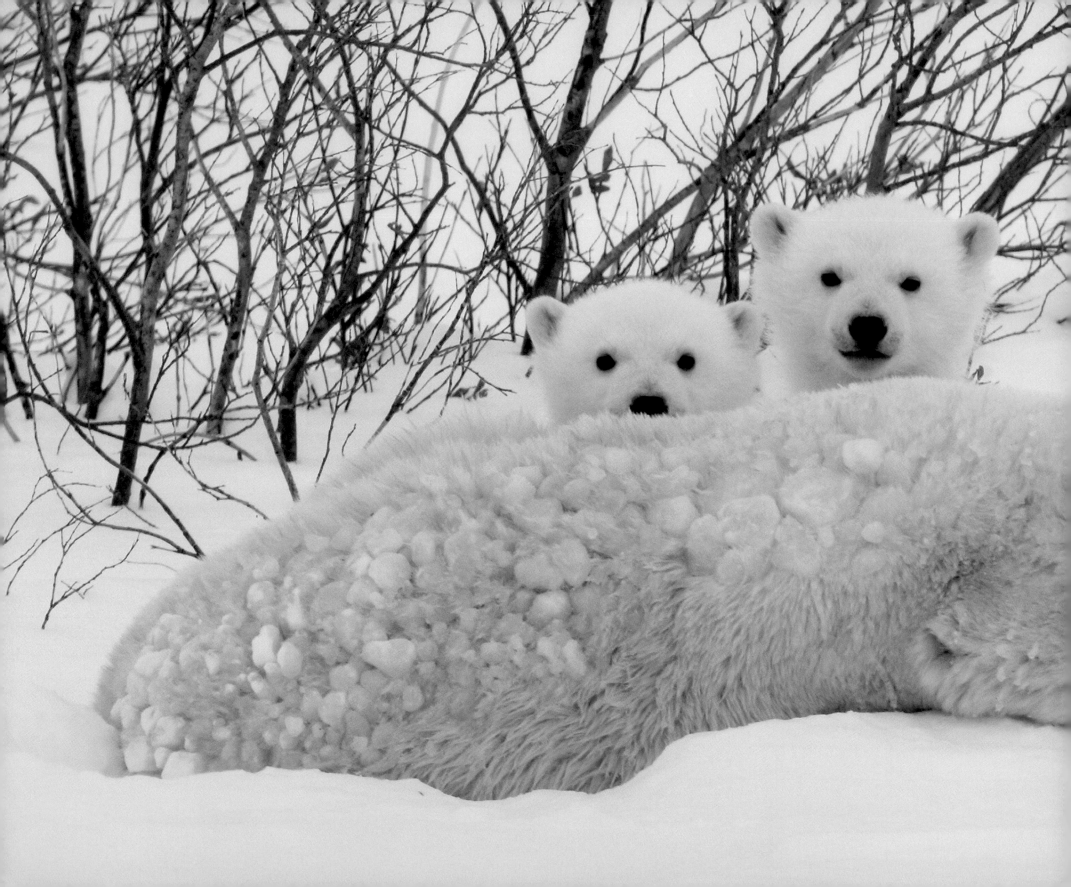

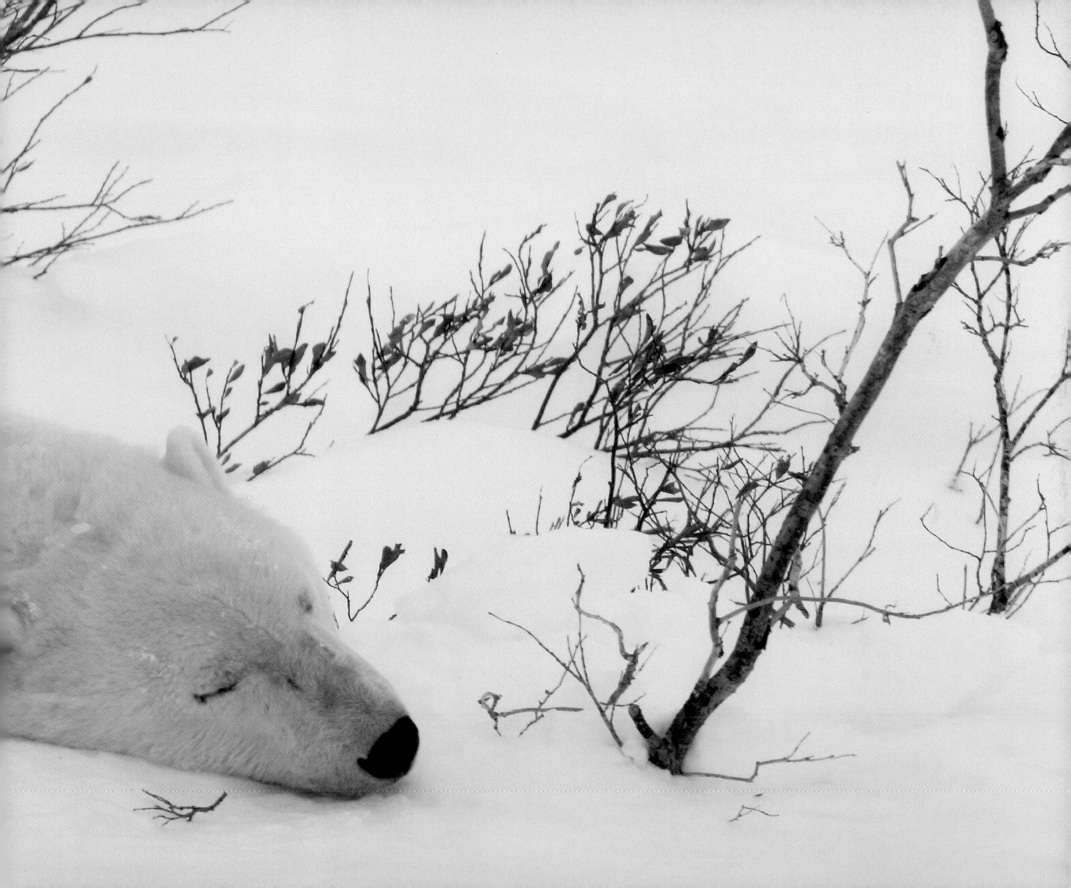

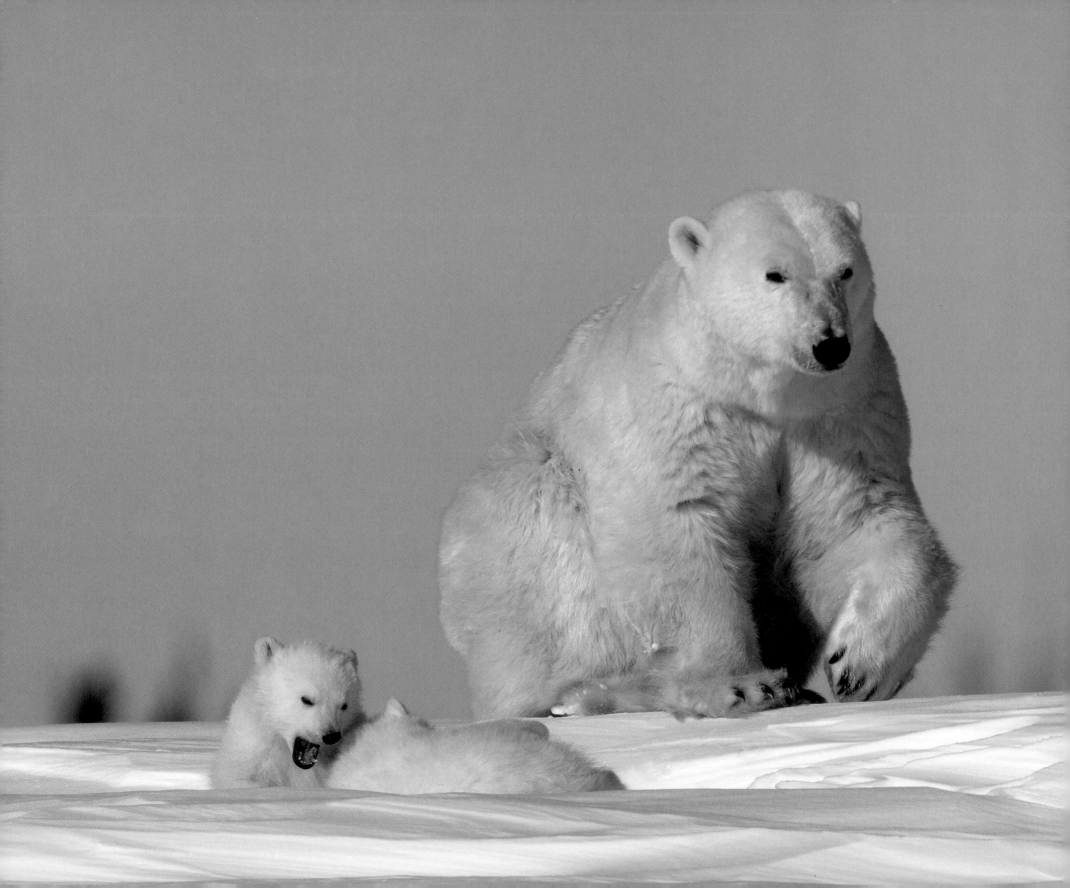

Departure

I traveled from Winnipeg to Churchill by plane. After a two-and-a-half hour flight, I finally landed in the 'polar bear capital' on Hudson Bay. In mid-February, Churchill is a sleepy town; few tourists come this way during this season.

I had come to see the "nanuq" as the polar bear is called in the native Inuit language. But there was not a trace of polar bears far and wide! No wonder: Hudson Bay had been frozen over since the end of October and this, therefore, was prime hunting season for the polar bears. The bears migrate far out onto the pack ice to hunt seals.

I wasn't terribly disappointed though, because I hadn't come to see the white giants. I wanted to search for polar bear cubs and the season was perfect for my purpose.

Two days later I drove to Wat'chee Lodge on the edge of Wapusk National Park, some 70 kilometers from Churchill, where I would go in search of polar bear dens. The closer I came to my destination, the greater my tension and anticipation became. Would I be lucky enough to see the little bears face to face and within range of my lens?

In the summer months, the park is a vast wetland divided into lakes, rivers, forests and open range. The swampy plain in the lowlands forms a huge peat bog with peat layers that are often several meters thick. This area is still undeveloped; there is no infrastructure here. It is home to polar bears, black bears, wolves, wolverines, red- and Arctic foxes, moose, caribou, owls and hawks. Nearly 200 bird species breed or spend their resting period in this region.

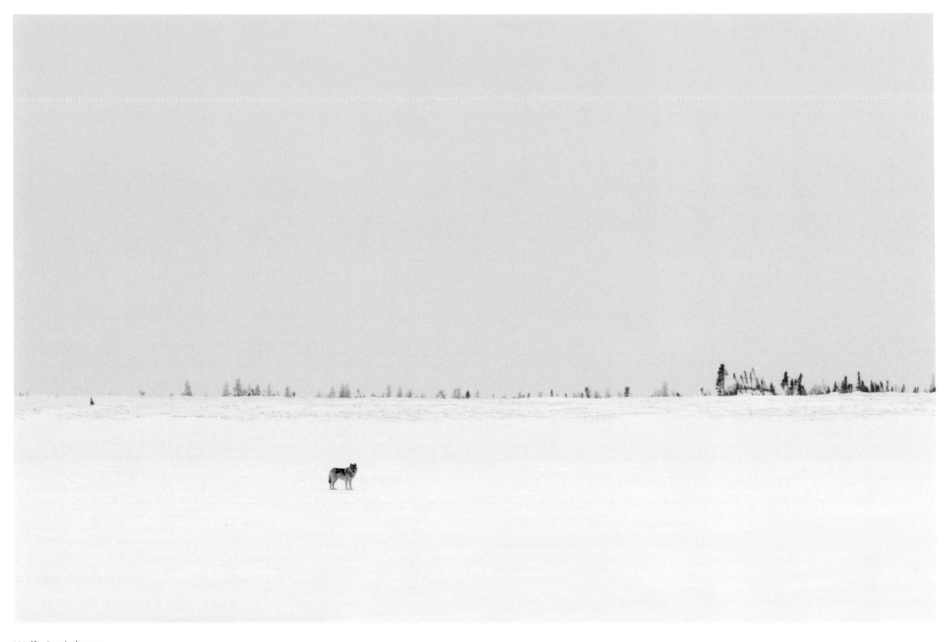

Wolf *Canis lupus*

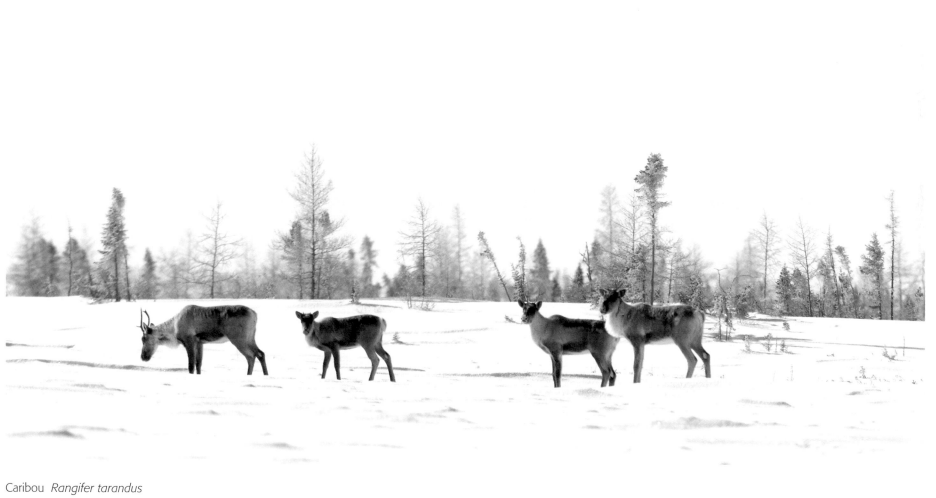

Caribou *Rangifer tarandus*

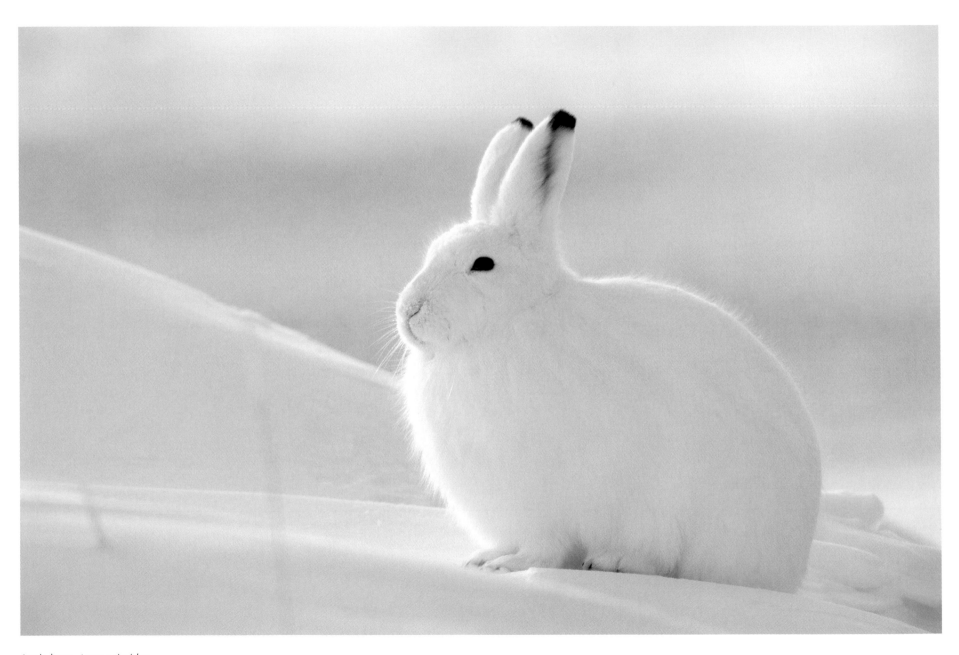

Arctic hare *Lepus timidus*

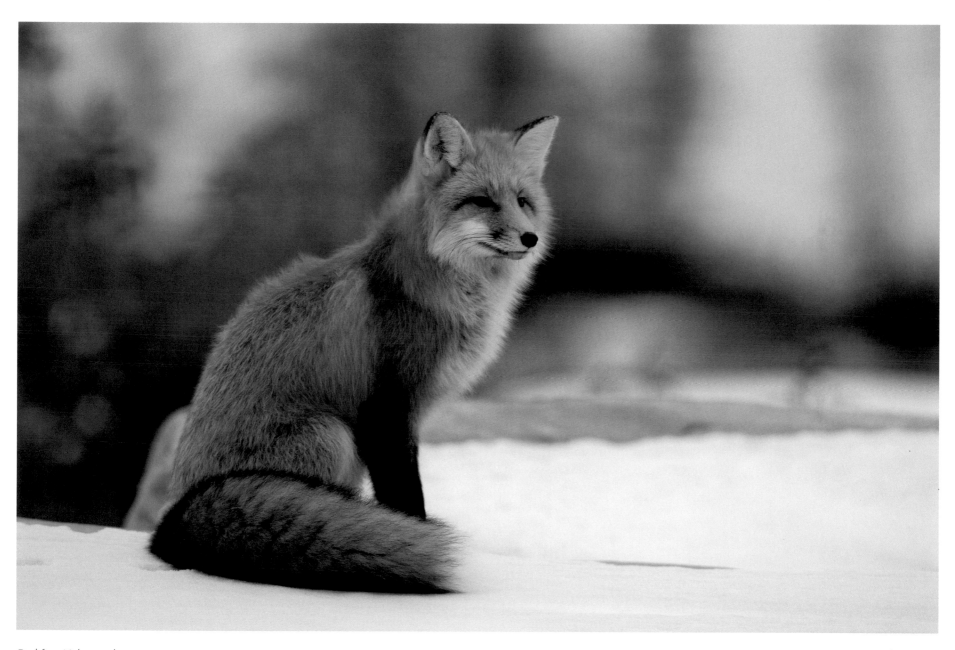

Red fox *Vulpes vulpes*

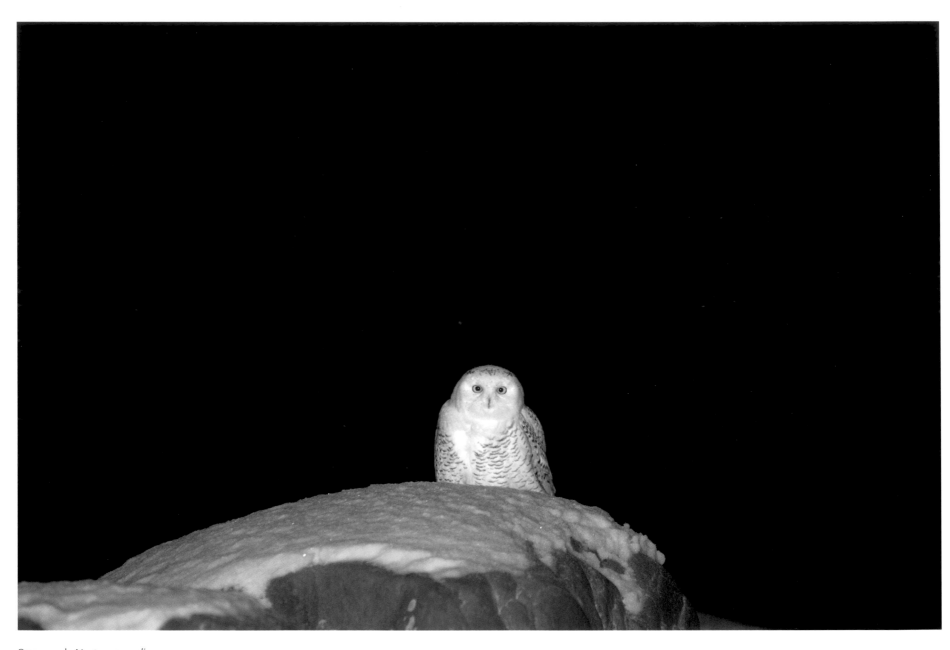

Snow owl *Nyctea scandiaca*

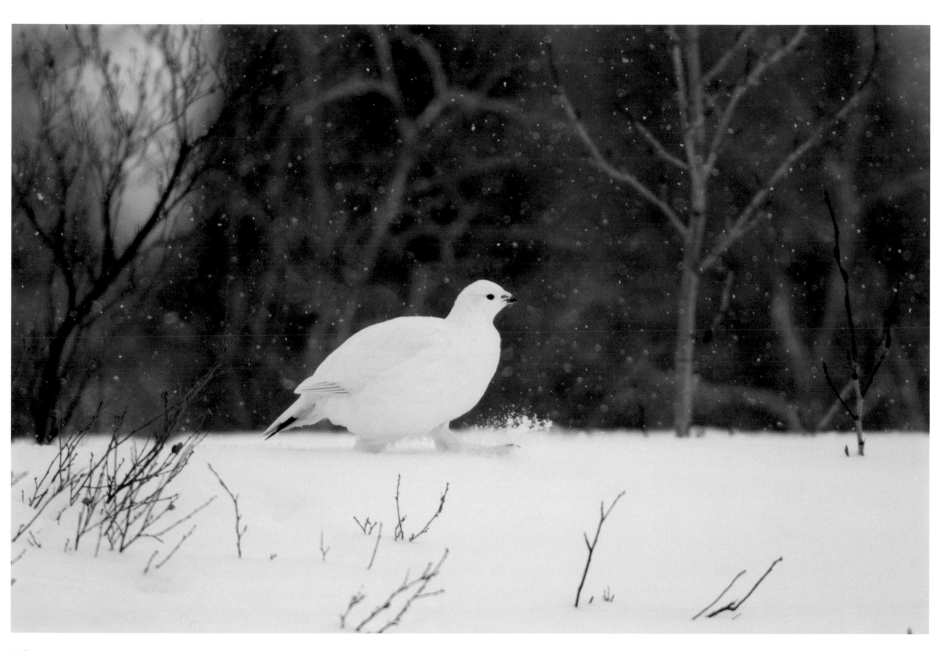

Willow ptarmigan *Lagopus lagopus*

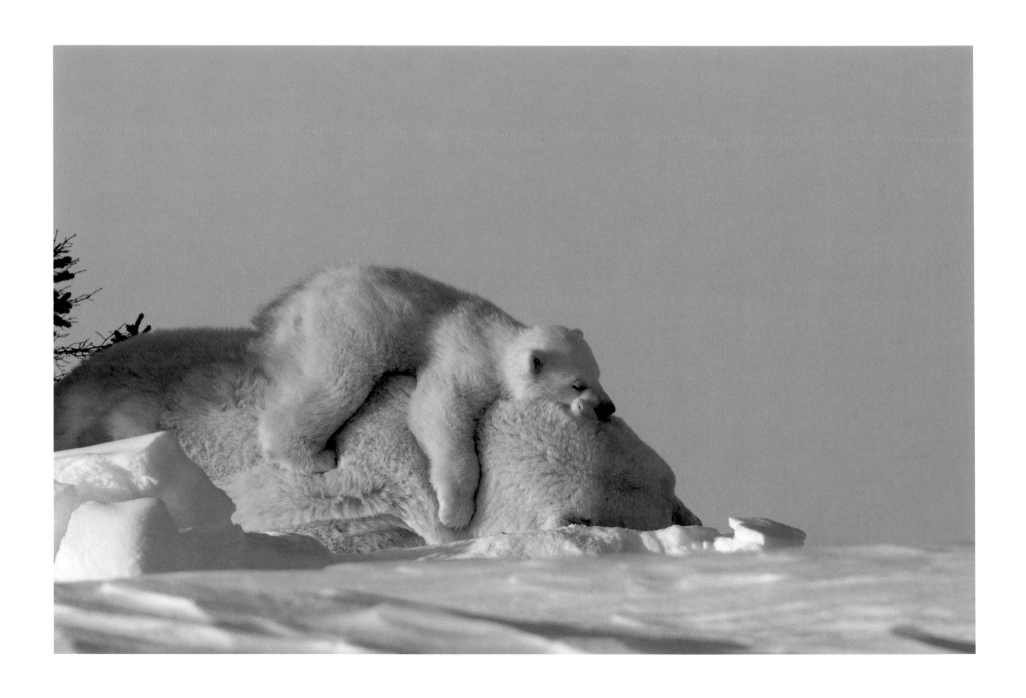

82

In winter, snow and ice dominate the landscape; orientation becomes nearly impossible to foreigners like myself. I would even get lost just a few hundred meters from the lodge. I would never be able to find the bear tracks in this sheer endless white landscape. I had to place all my faith in Morris, Michael and their crew. The morning after I had settled into the lodge, we set off. By "we" I mean Morris and his friend Amuck – who explored the areas where they assumed the inhabited dens would be on their fast, agile Ski-Doos – a few other photographers, myself, and Michael. The latter group climbed into the more cumbersome "Bombardier" tracked vehicles and vans that had been converted into snowmobiles, and followed the Ski-Doos at a slower pace. On this excursion we were accompanied by additional guides on Ski-Doos, who fanned out to search close by.

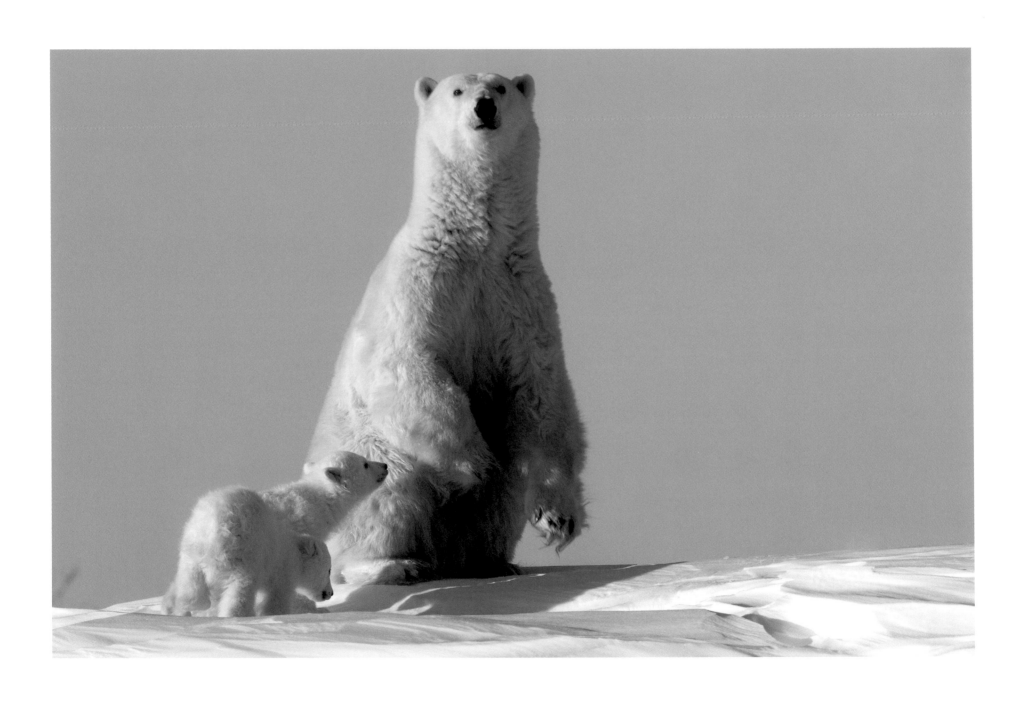

84

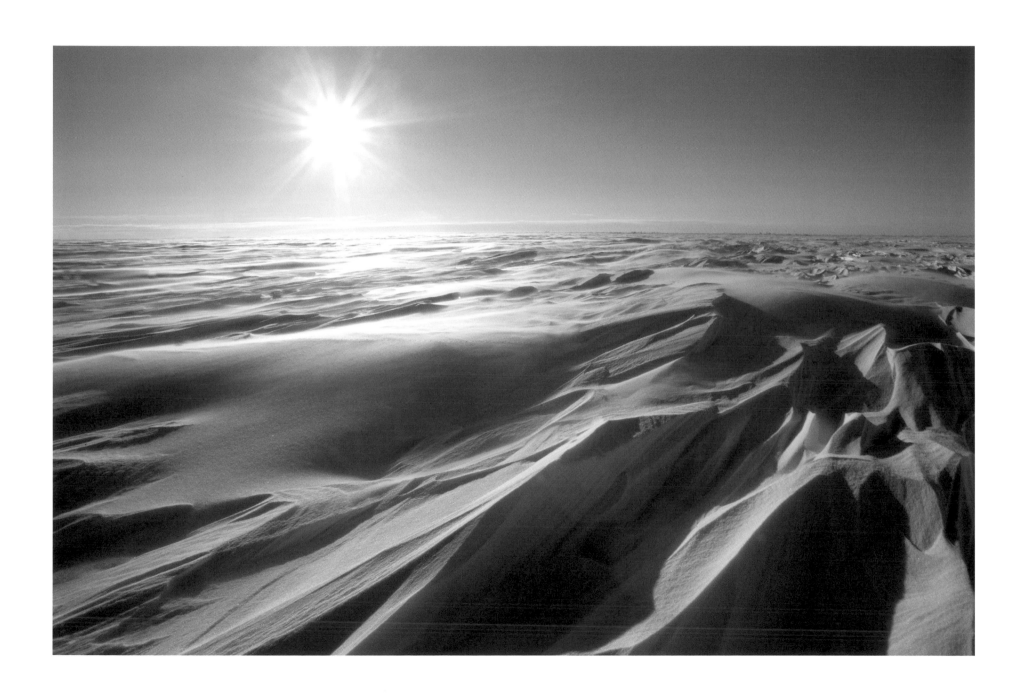

85

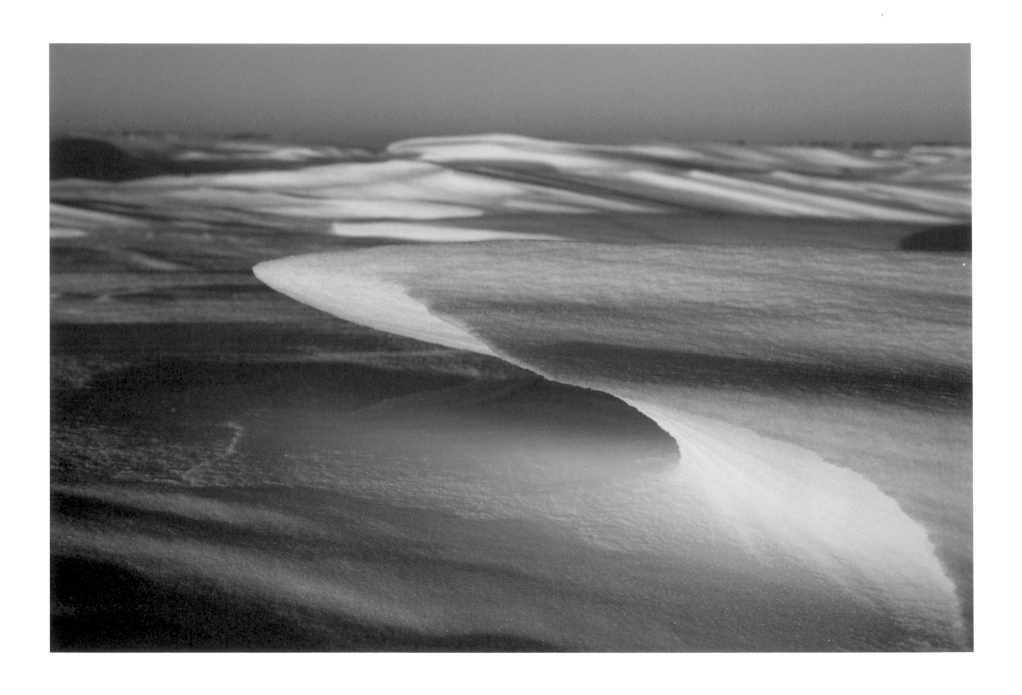

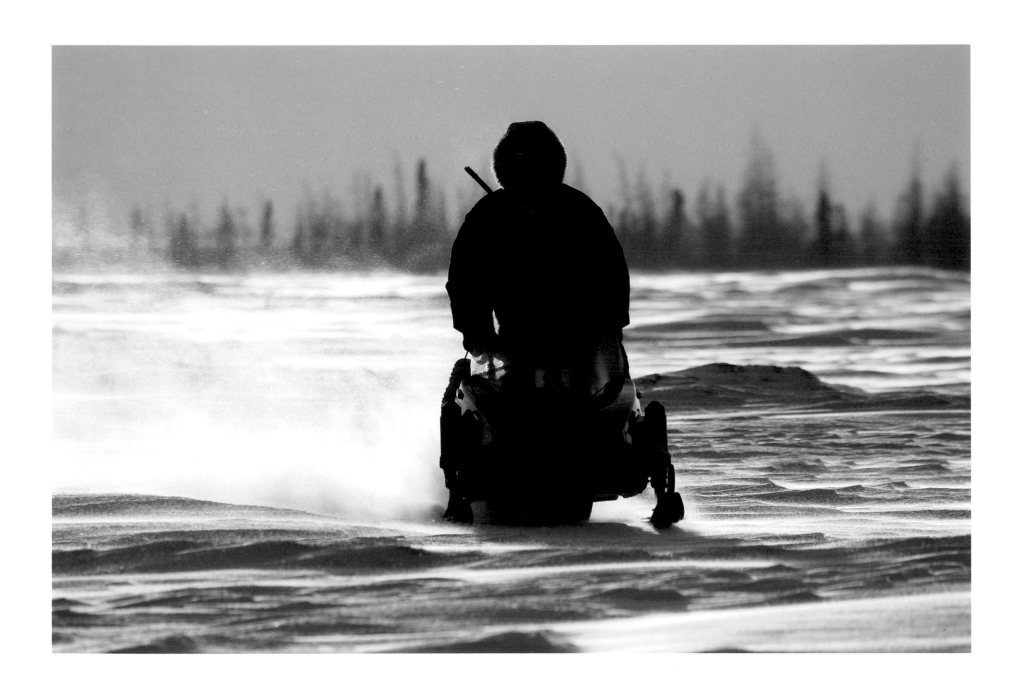

89

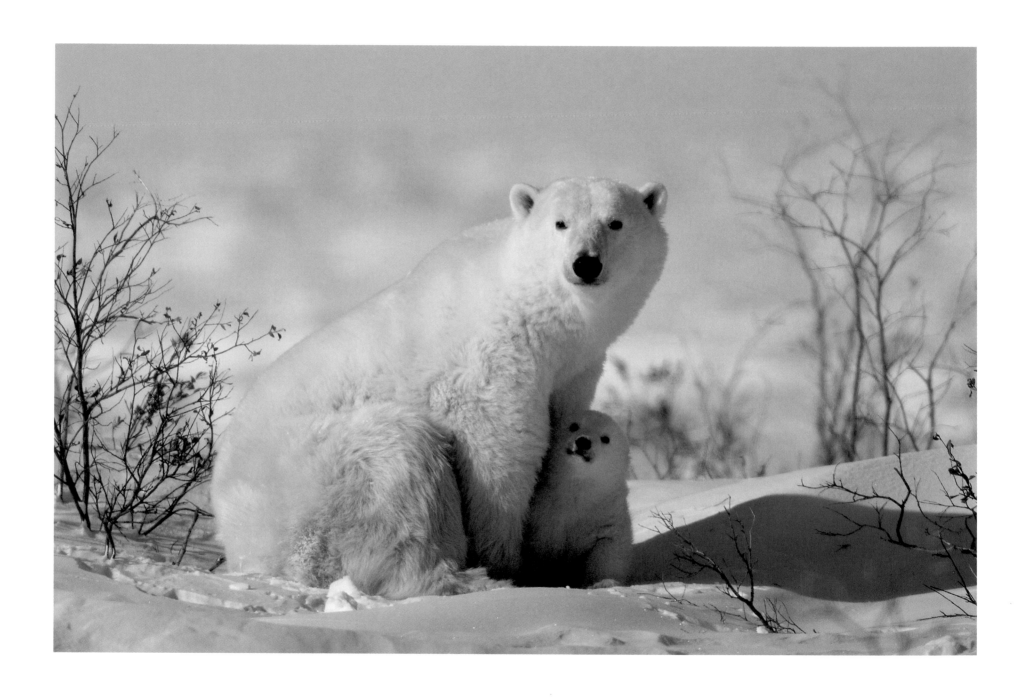

90

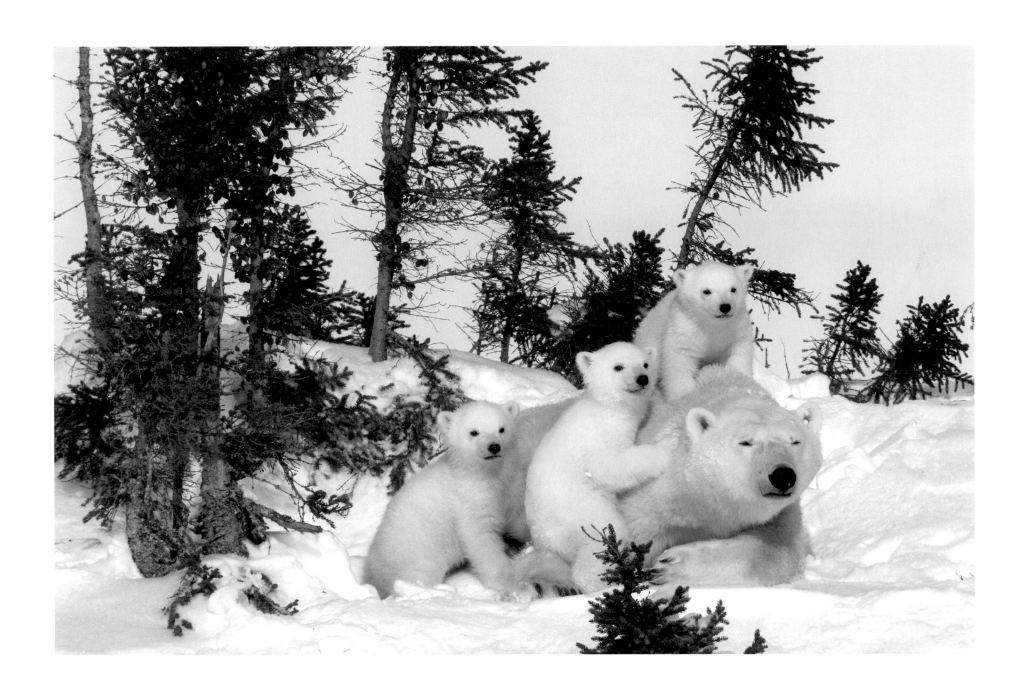

91

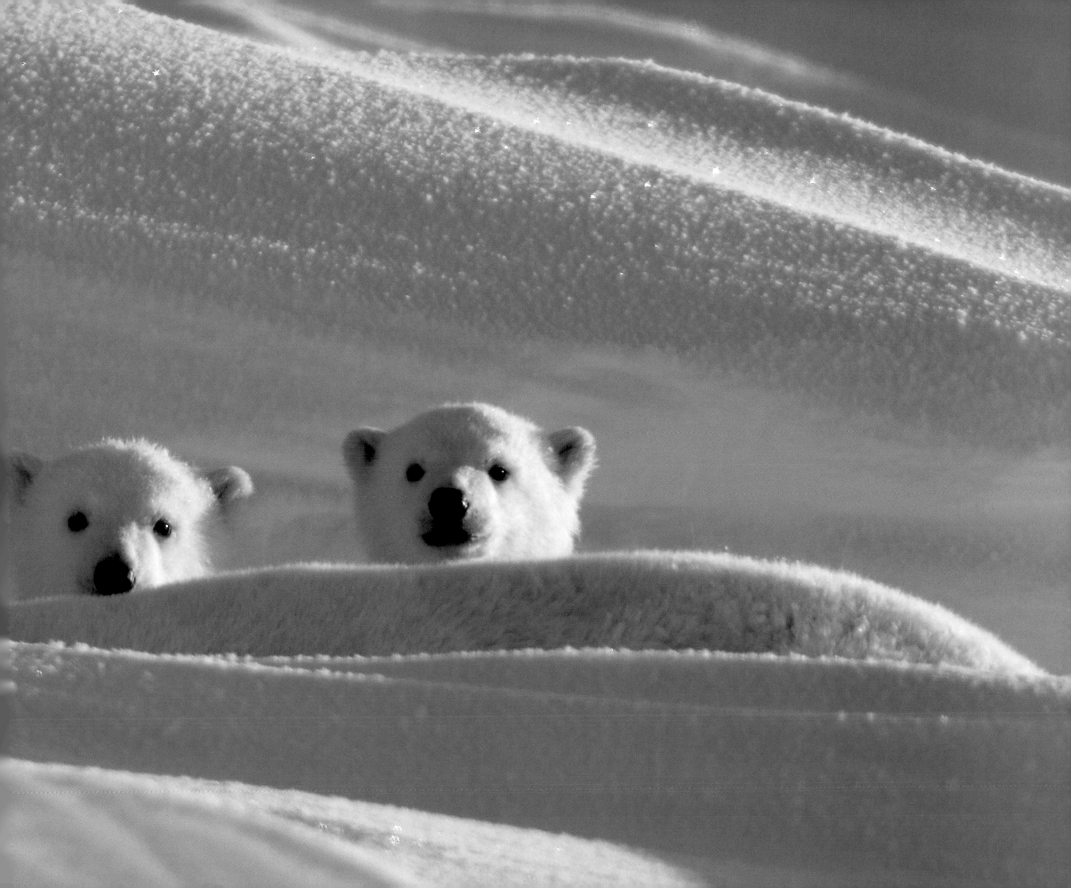

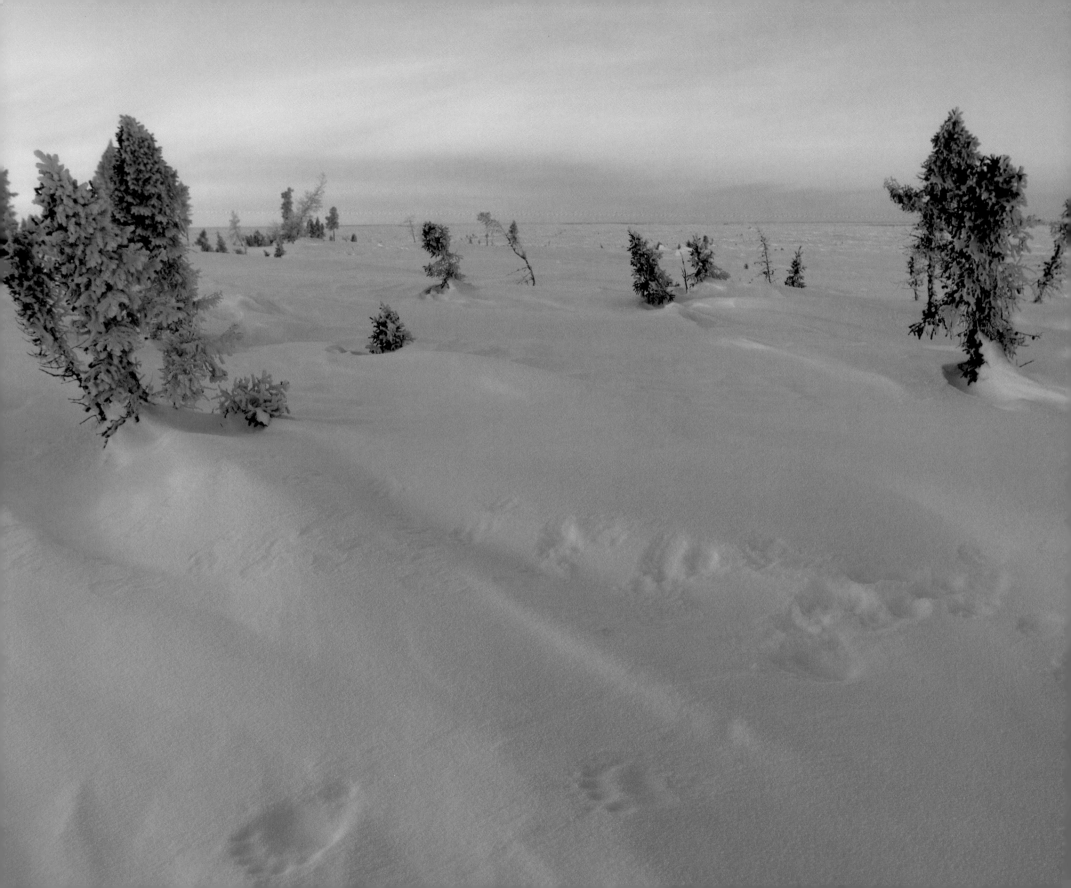

The Search

We've already traveled for two days – in vain. Today, however, barely half an hour from the lodge, Morris calls in on the radio. He has discovered the first tracks, very close to where we are. The first tracks – my heart begins to pound. This means that the bear families have already begun to leave their dens. Morris and the other guides examine the tracks and determine that they are already two days old. Two days can be a long time. For depending on their condition and on the weather, polar bears can travel between five and twenty-five kilometers per day. In this area, that translates into an enormous distance because our progress in the big snowmobiles is quite slow.

Without the guides, who are equipped with GPS and satellite phones, I would be lost. A strong sense of intuition and a lot of experience have made the Cree experts in this field. They have learned to live with and from nature. They understand the signs of the wilderness and respect the animals and their needs. They would never allow the polar bears to be disturbed and there are never any dangerous encounters. The guides ensure that a safe distance of roughly 100 meters is maintained at all times.

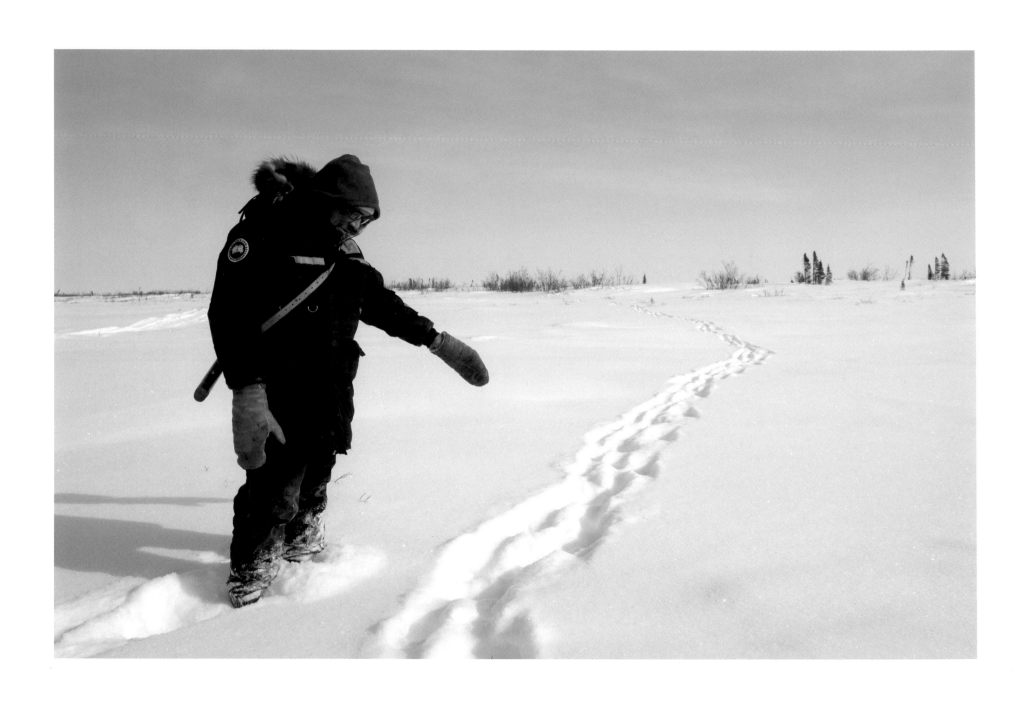

96

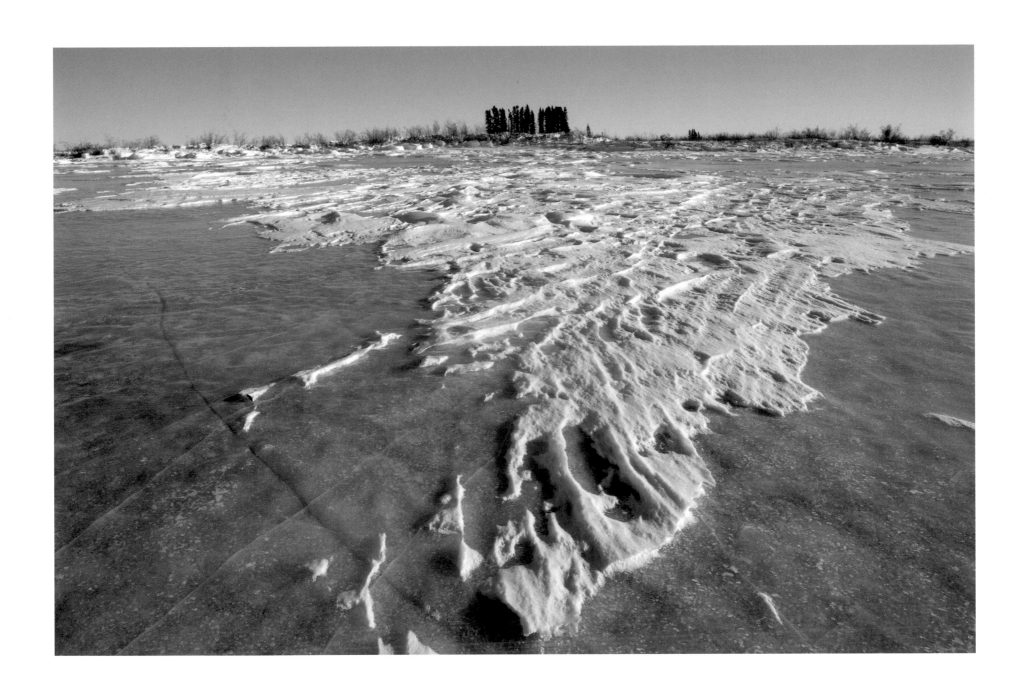

97

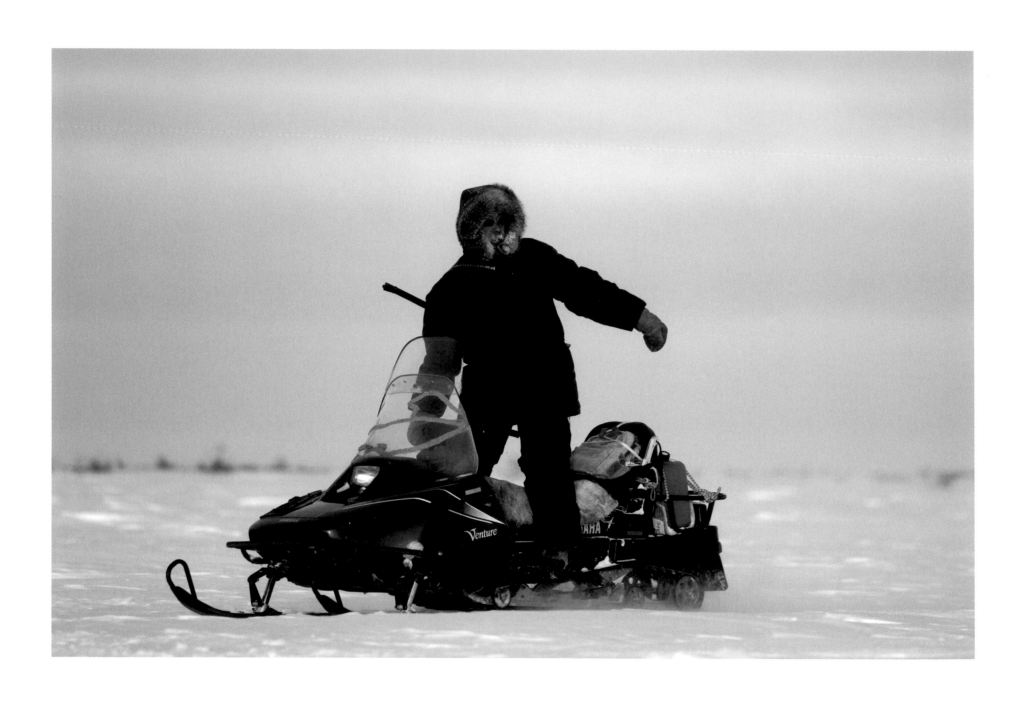

98

The search for tracks continues. We drive through the areas where dens were often located in years past. We encounter caribou and snow-grouse. Sometimes we even spot a shy wolf in the distance. Alas, no bears. Time passes and gradually I'm getting worried. Morris and Amuck still my concerns. And they prove to be right: all of a sudden, we come across new polar bear tracks. This time they are fresh, only a few hours old. Our excitement mounts: where are the bears? Morris and Amuck, the two guides who can explore a larger area more quickly on their Ski-Doos, set off on a new search. Once again we are left to wait. Finally, we hear the longed-for words issue from the walkie-talkie: "We found a bear!"

"How many young are there?" we ask. "Twins – as usual." Morris gives the position and Michael, our driver, enters the coordinates into the GPS and off we go. Although the distance is no more than a few kilometers, the drive takes another hour. Luckily, the temperature is a moderate –18 °C and there are no strong winds. Despite our Arctic gear, we prepare our hand warmers just in case. Several hours can pass quickly when you are observing and photographing wildlife. When you are standing still, –20 °C can quickly feel like –40 °C, especially if the wind picks up.

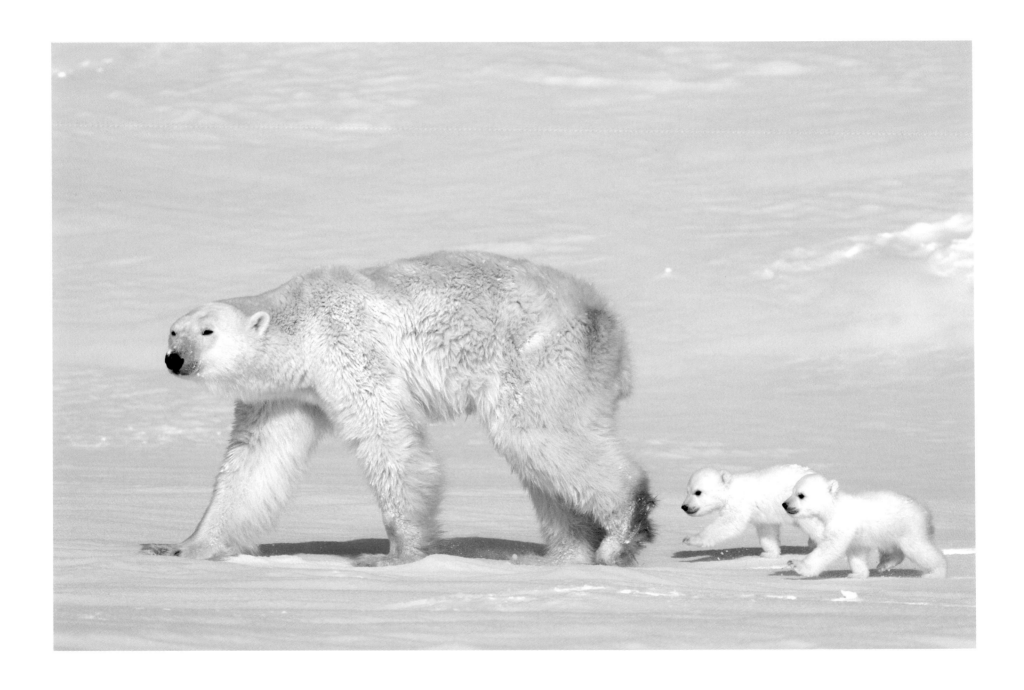

100

By this time, my anticipation is almost unbearable. We see the guides on their Ski-Doos, but where are the polar bears? Our driver points straight ahead: something is moving just in front of a snowdrift. A polar bear mother and her two cubs! Have they spotted us too? I quickly reach for my equipment, get my camera ready and step out of the snowmobile. Carefully, we move closer until we have reached a safe distance. In no time at all, I have the polar bear cubs in my viewfinder. Half unsure, half surprised, they peak out from behind their mother, who at first raises her head in alert but soon settles down.

The cold and days of searching in the snow for the bears are forgotten. There are one-and-a-half hours of light remaining, plenty of time to gain a first impression of the family life of polar bears.

108

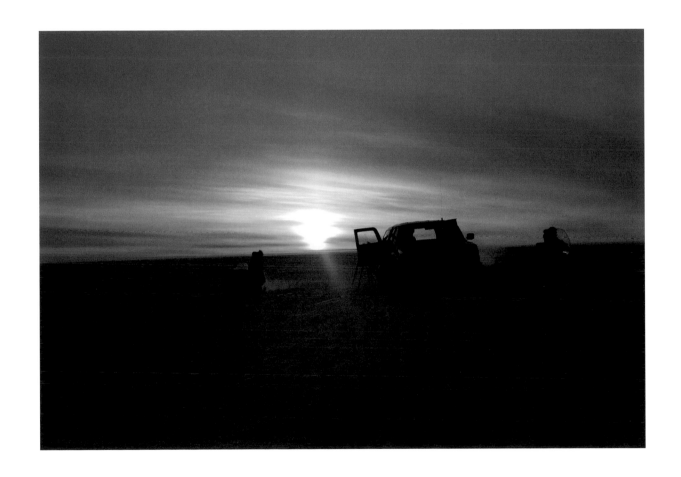

Sunset: time to return to the lodge.

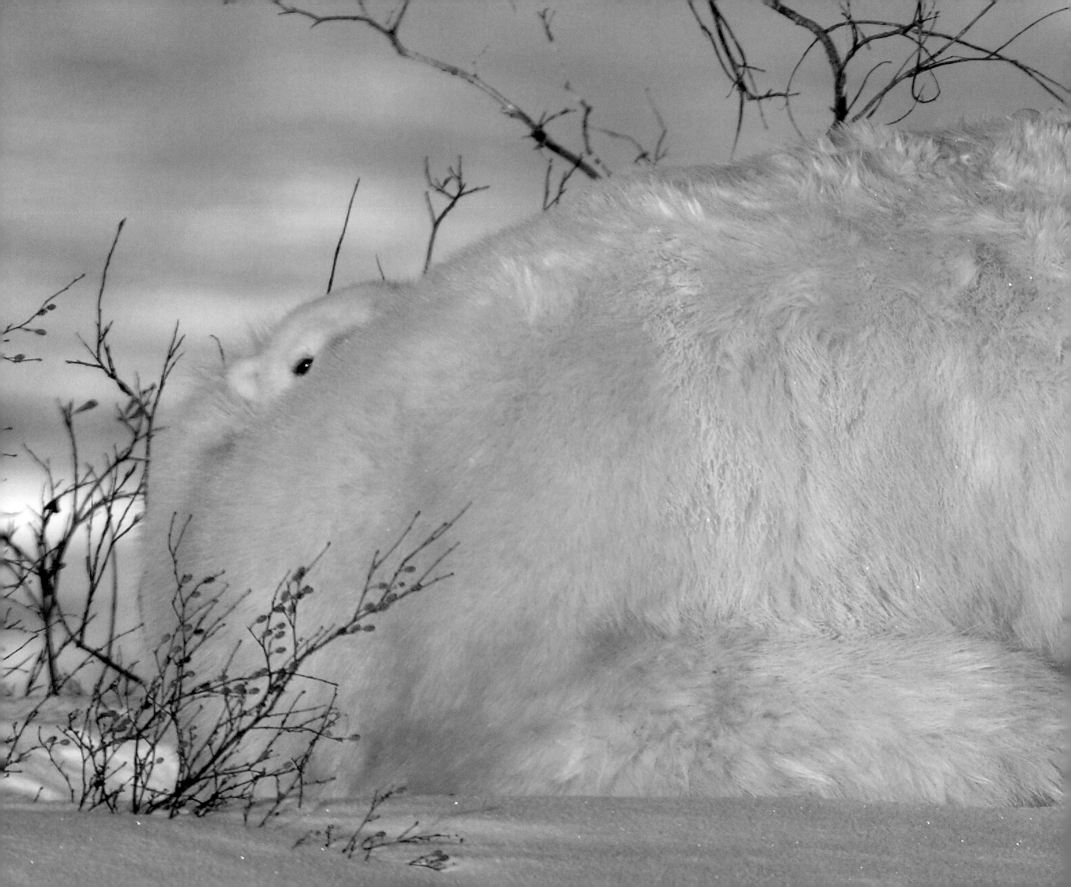

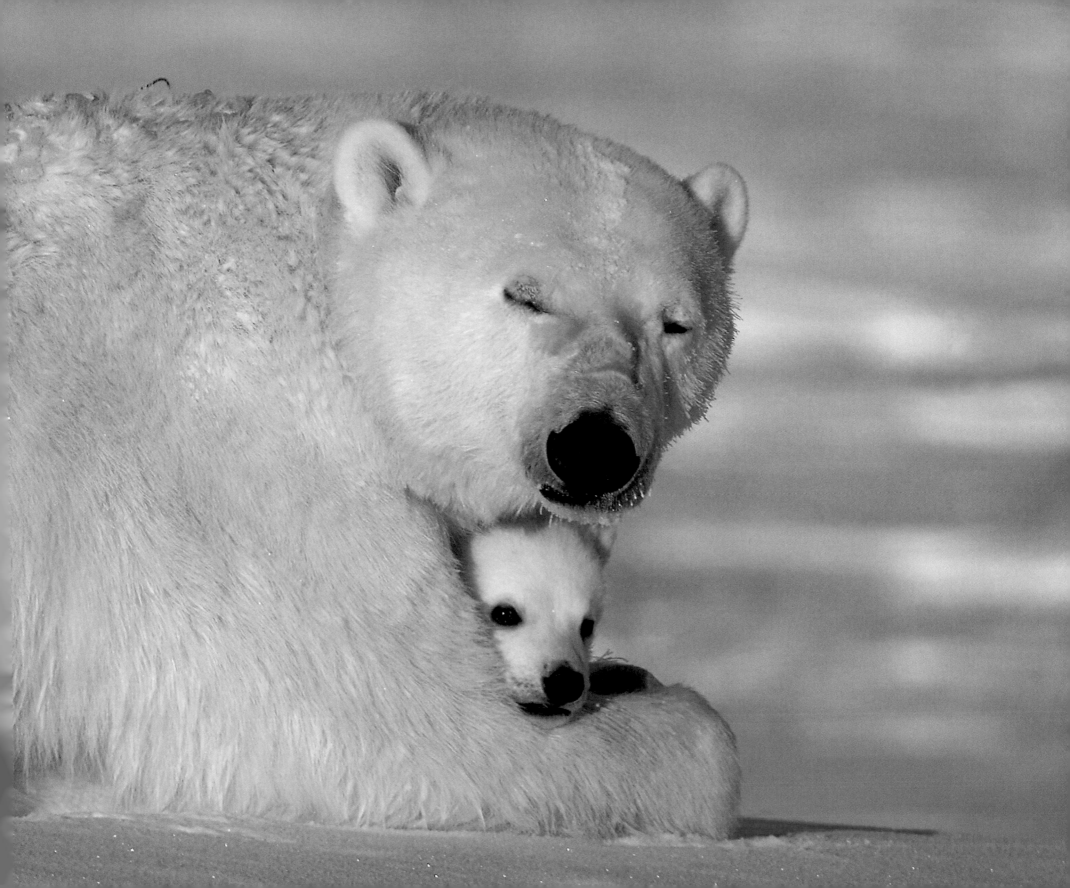

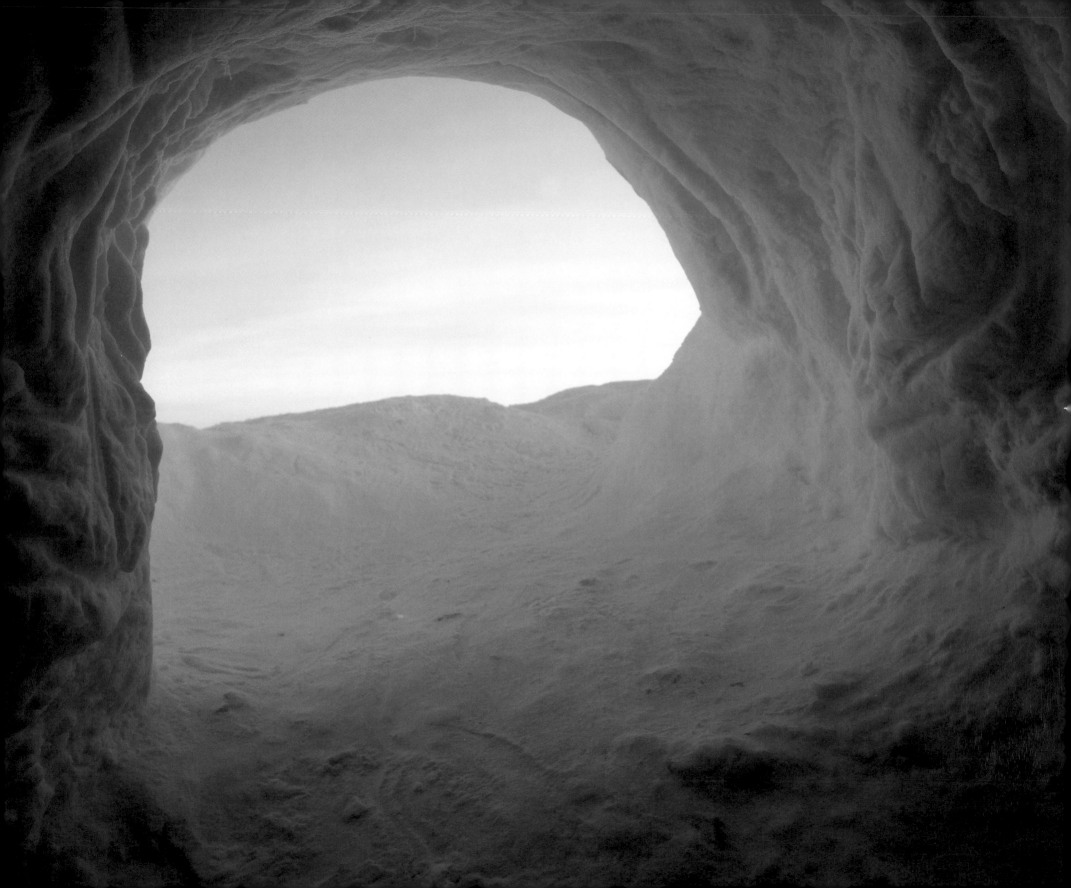

The Den

From mid-October onward, the pregnant females set out in search of a den. To this end, they travel 50 to 70 kilometers into the interior. They often select dens on south-facing slopes, where north winds have created deep snowdrifts and where the rays of the sun are at their most potent. They may come across an old den that was used in a previous year or dig a new one. With her massive paws, the female quickly burrows into a deep hole and lets herself be covered in snow, erasing all traces that might point to her location. Depending on the amount of snowfall, the den consists of a one- to six-meter-long corridor and a spacious cavity measuring three to four square meters. It is several meters below ground level and is heated by the bear's body temperature to create a comfortable climate inside, despite the Arctic cold on the exterior. The icy winds cannot penetrate into this shelter. Sometimes, the den features an additional opening for fresh air. I came across an abandoned den once and had the opportunity to crawl inside, finding it almost cozy; the scratch marks on the interior walls – small ones from the cubs, fairly powerful ones from the mother bear – were still clearly visible.

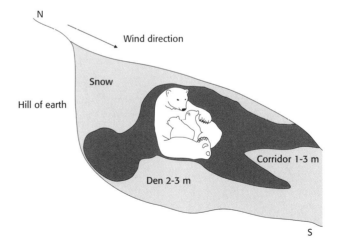

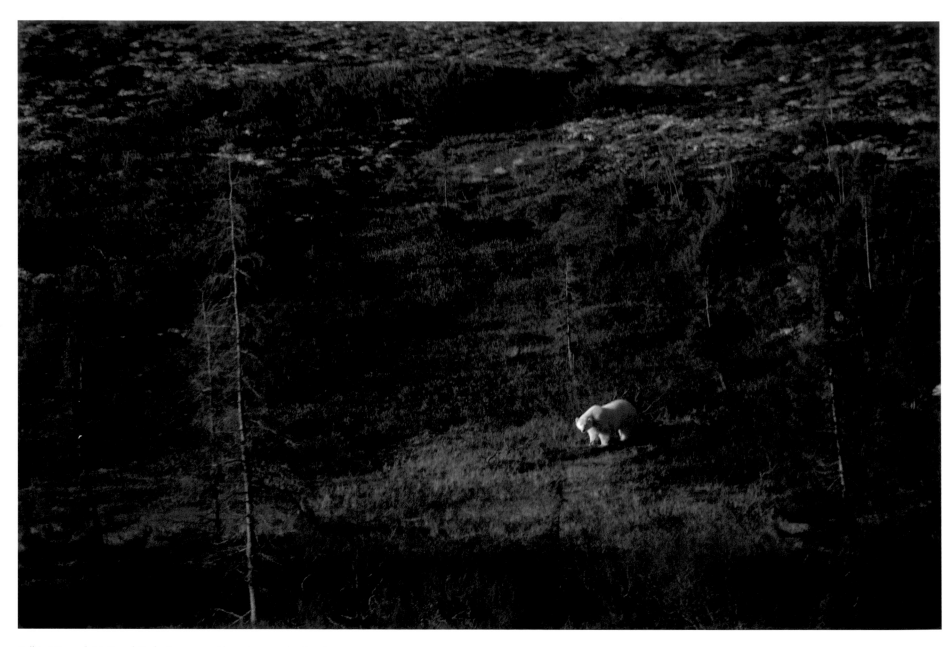

Fall in Wapusk National Park: A pregnant bear in search of a den.

The young are usually born in the second half of December. Upon birth, they are still naked, blind and deaf and tiny by comparison to their mother. Their fine fur only begins to grow after roughly ten days. To stay warm, they nestle between their mother's legs. But their paws are already equipped with sharp and long claws. These enable them to hold on to their mother when they are suckling on her teats. Polar bear mother's milk tastes similar to cod-liver oil and smells of seal, which imprints the future food source on the young ones. Thanks to the high fat content of the mother's milk – roughly 30 per cent – the cubs are strong enough to crawl around after four weeks.

When another four weeks have passed, they will have explored the entire den and are able to play with one another and climb around. At this point, the cubs begin to dig small cavities and corridors of their own and chase each other through the system of tunnels. As the days grow longer and the sun appears higher in the sky, the ferocious blizzards on the outside begin to abate. The bear family is now eager to venture forth from the den: the mother is driven outside by hunger, the young ones because the den is becoming too small to contain them.

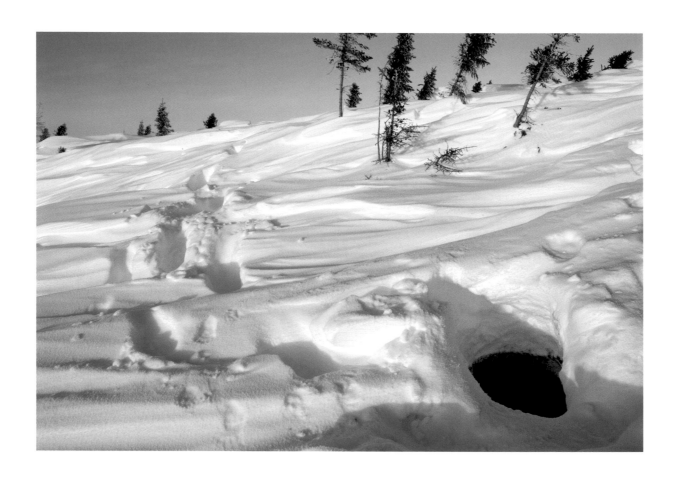

This den was inhabited until very recently.
Right: The cubs see daylight for the first time.

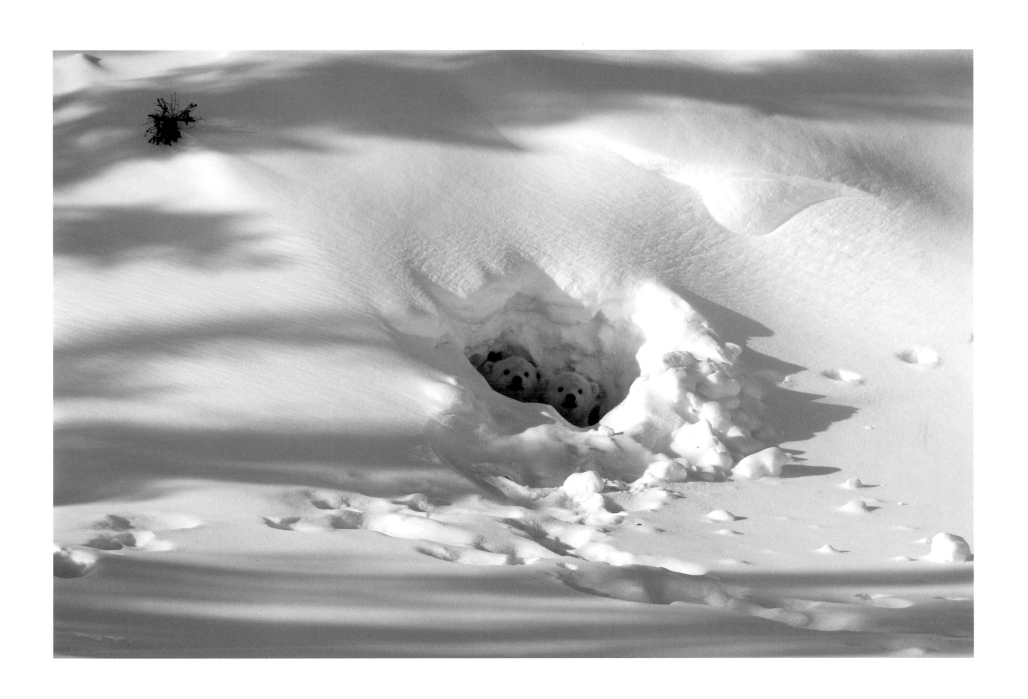

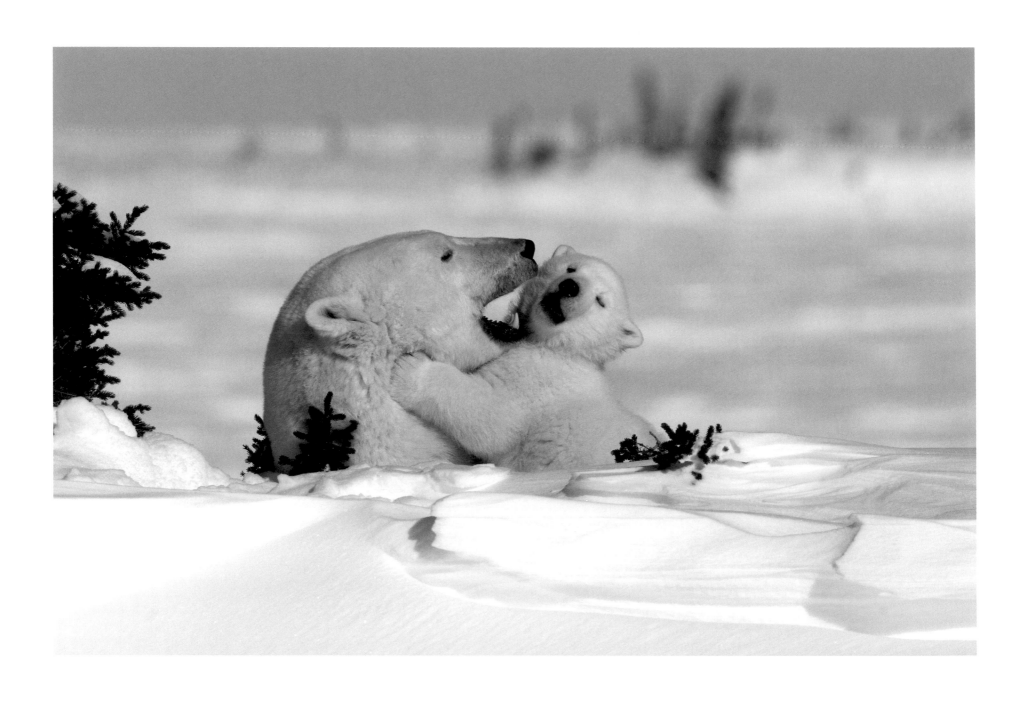

The polar bear mother takes a careful look around from the entrance of the den. She scans the land and explores the scent in all directions: is the air clear? The safety of her cubs is paramount to her. The female ventures a small distance from the den and tries to coax her young ones out by calling to them. Hesitantly, the cubs brave the open air and the icy cold. Soon, their curiosity and the urge to move propel them forward. They play and wrestle and begin to explore their surroundings. The mother never takes her eyes off them. At the same time, the small bears learn their first lessons of survival in the Arctic wilderness. Usually, the family remains near the den for a few days before the mother urges her brood to migrate toward Hudson Bay.

Once the bears have left their den for good, they frequently use temporary dens along the way for protection from snowstorms. Such blizzards can last several days and delay their long journey to the ice. But the family will never return to the den where the cubs were born.

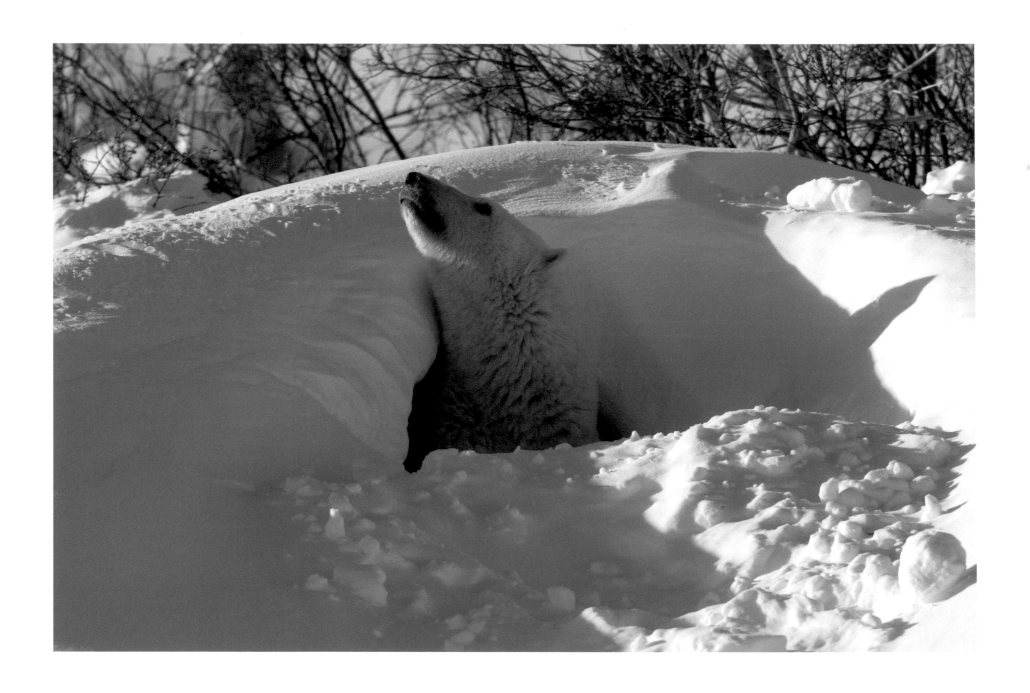

120

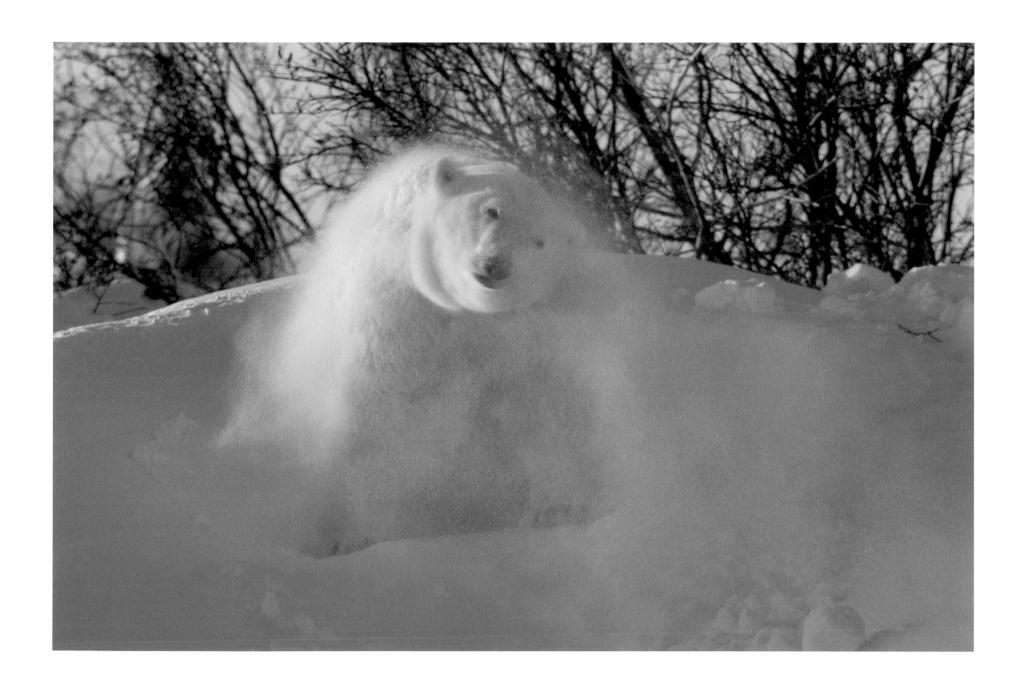

121

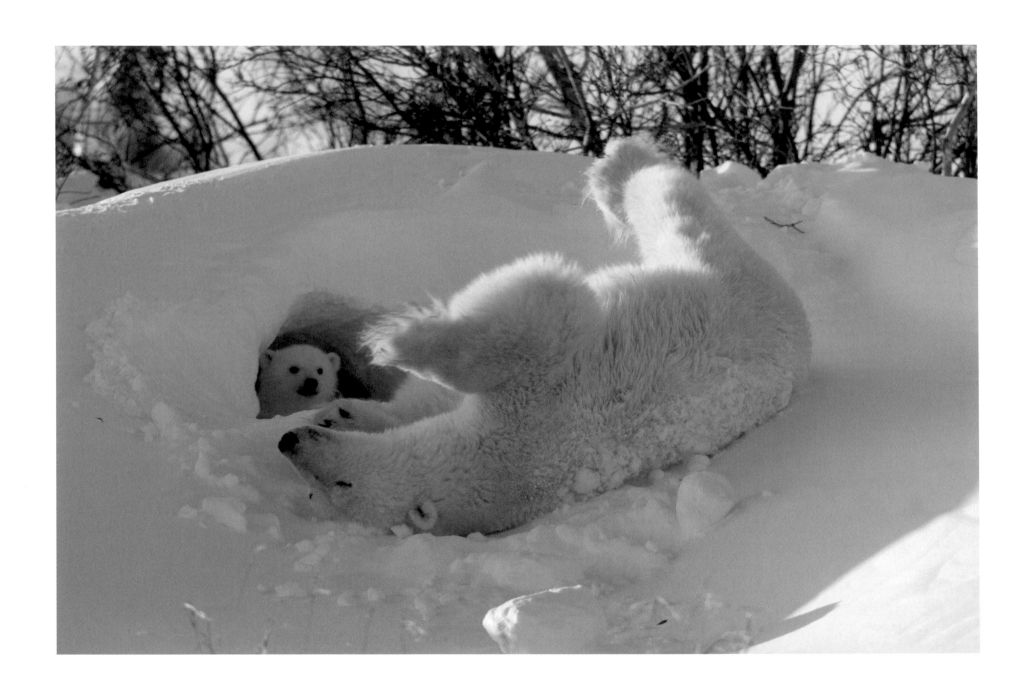

122

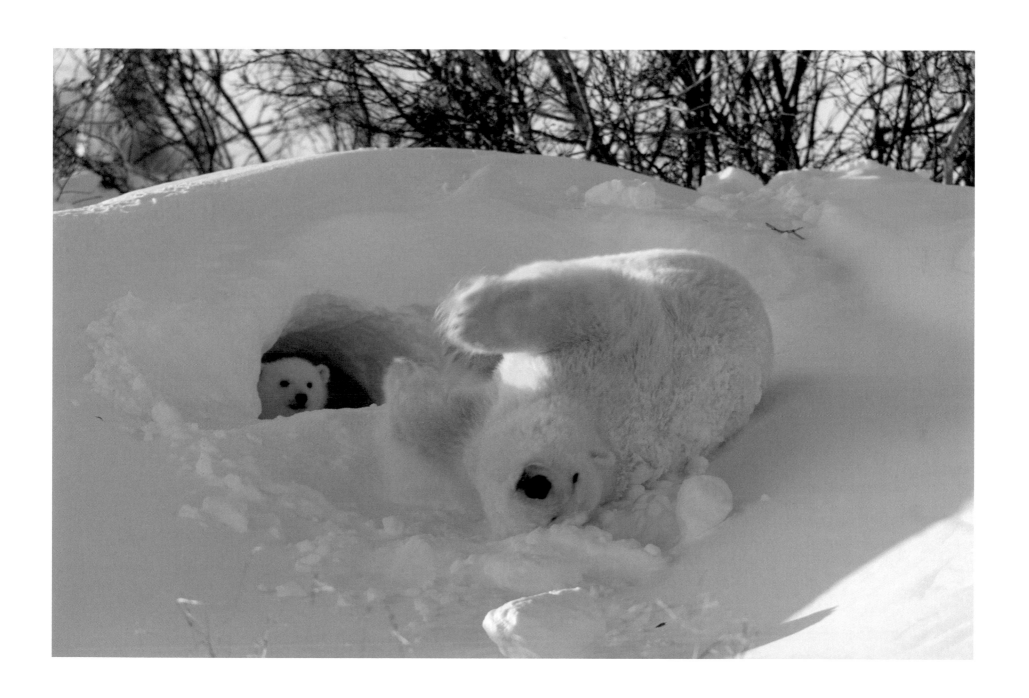

123

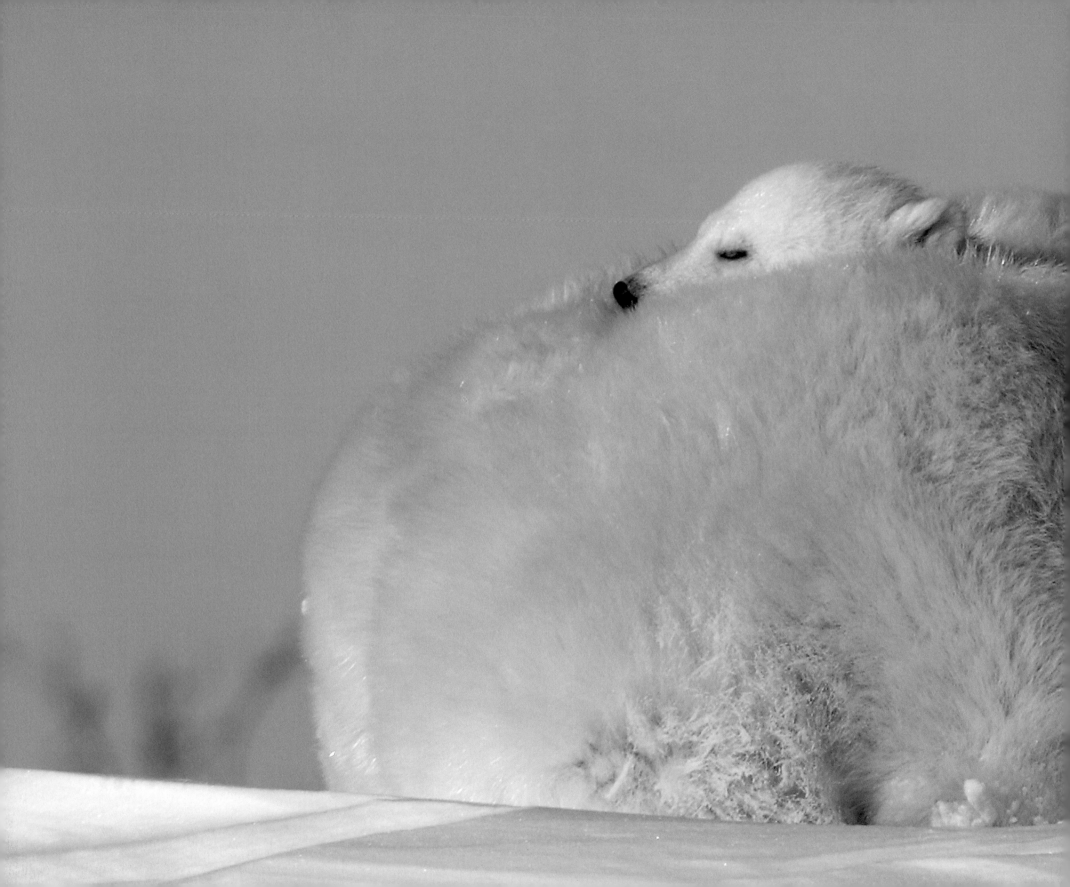

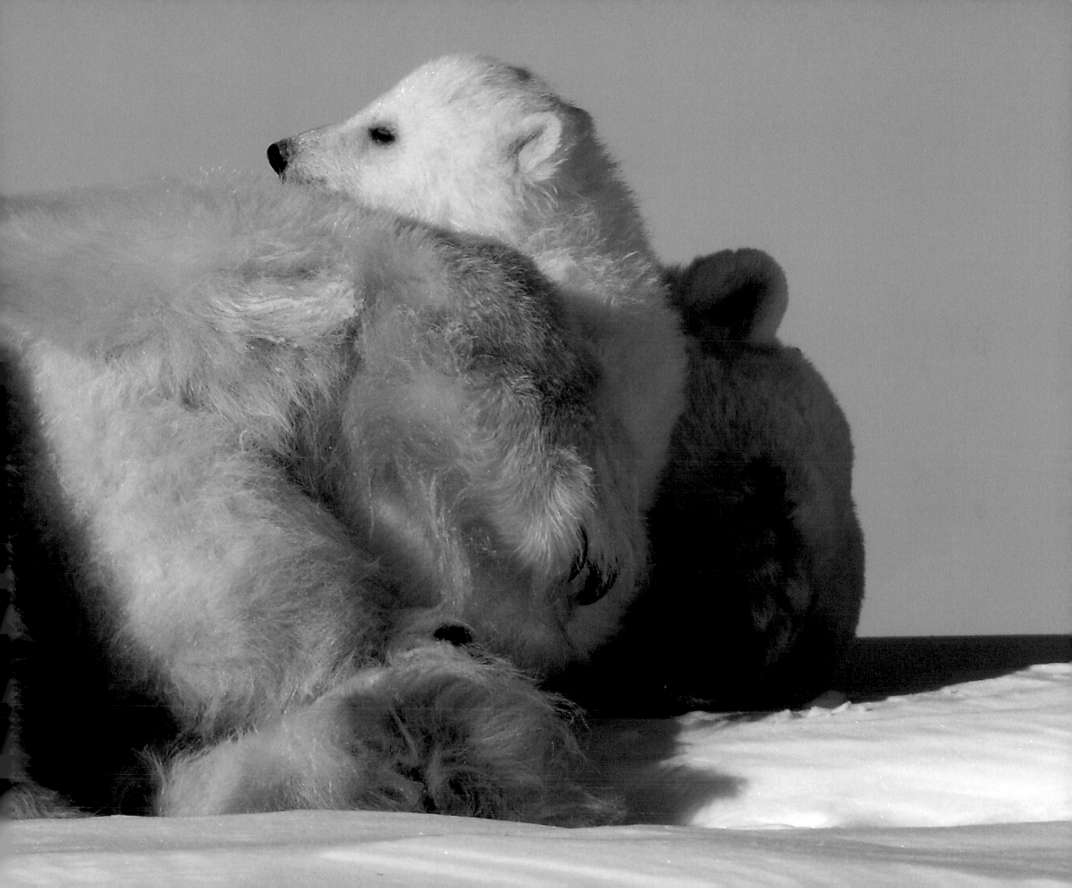

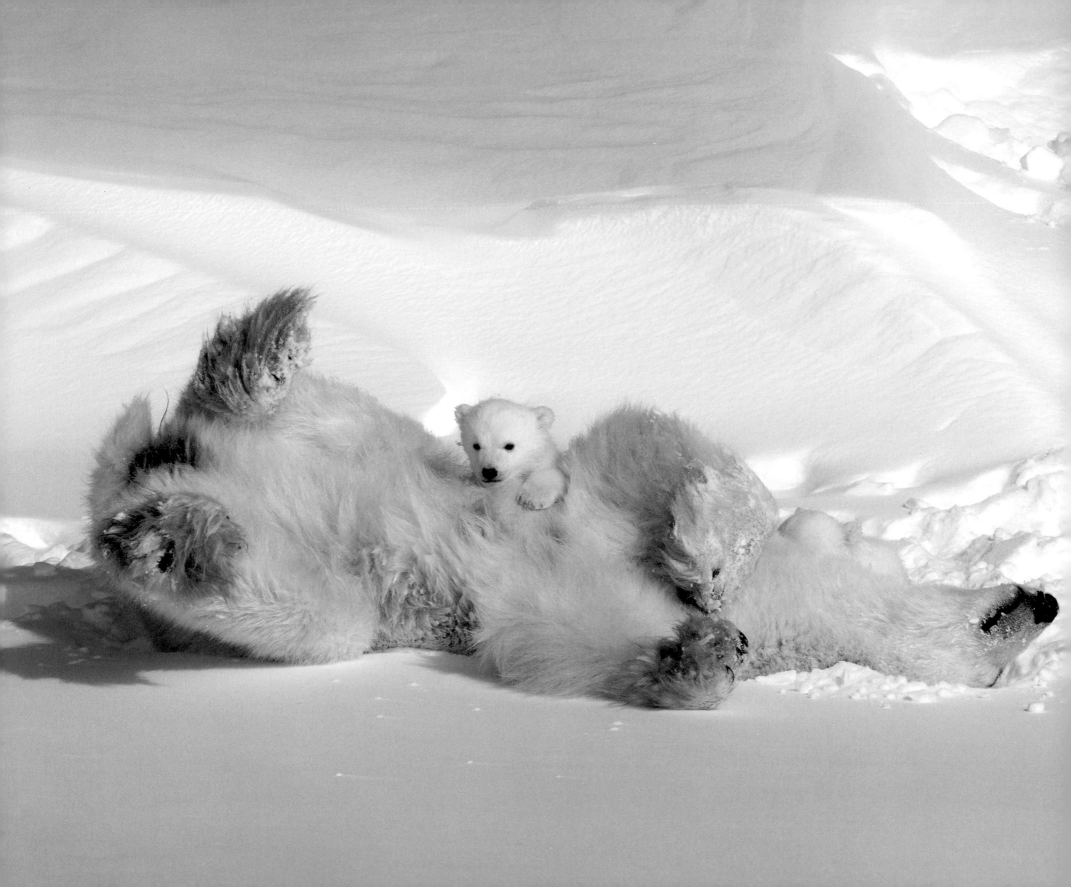

The Family

Polar bears – the emperors of the Arctic – display a very strong sense of family life, albeit without the father. The males are loners and only spend time with the females during the mating season. They can even pose a danger to young polar bears.

The females are the opposite: they are very tender with their young and extremely watchful. Protecting the young comes first. They are constantly scanning their surroundings. Their sense of sight and hearing is more or less the same as that of humans, but their sense of smell far superior. They can spot potential dangers from afar. Does the bear mother know that these funny bipeds with their colorful furs and flashing cameras pose no threat? Regardless, she keeps her little ones close to her; as soon as they stray even a few meters, she calls them back to her. Should a potential enemy suddenly appear, the bear mother would be more likely to withdraw to safety with her cubs than to attack, since that would mean moving away from her young.

In any case, polar bear mothers are patience personified. The young ones are allowed to romp about to their hearts' content, sliding down snowdrifts, wrestling, biting and climbing all over mom. It is soon apparent which of the cubs is the more active and assertive. After all, polar bear cubs will mature to become the largest land predators on earth.

Even the longest and most fun playtime must be followed by a period of rest. The little ones snuggle into mom's fur and go to sleep because mom also serves as a wonderful bed for taking a nap.

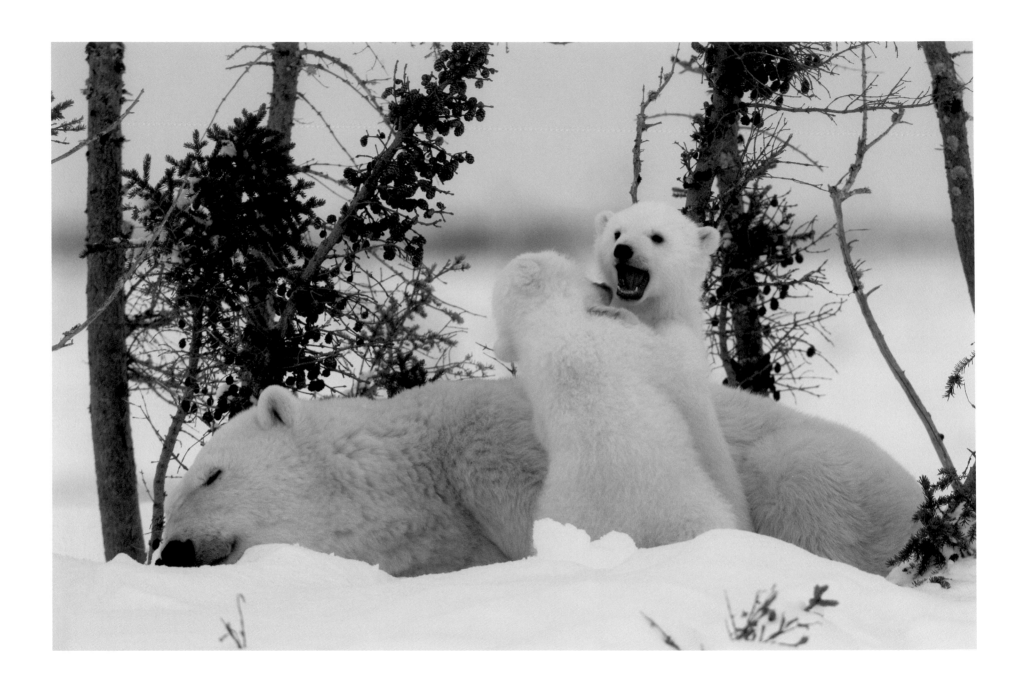

128

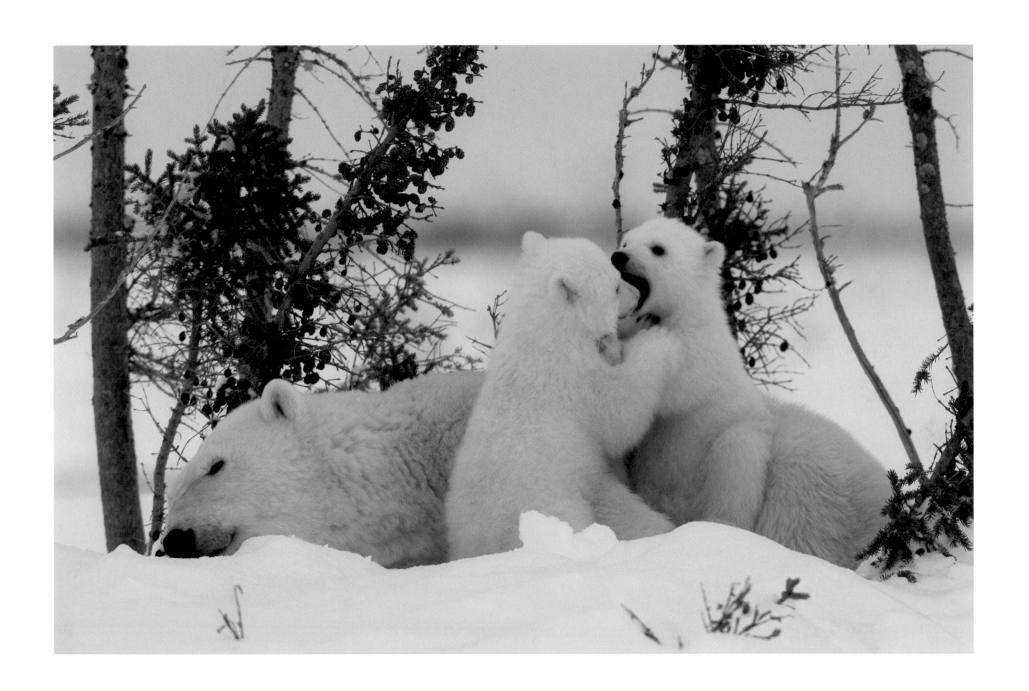

129

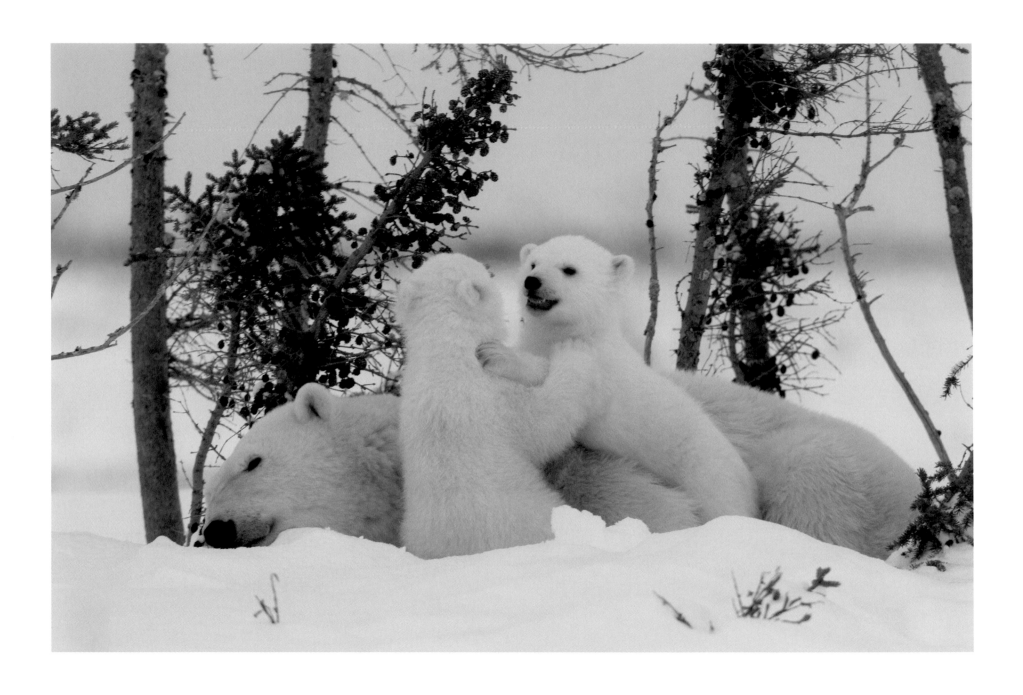

130

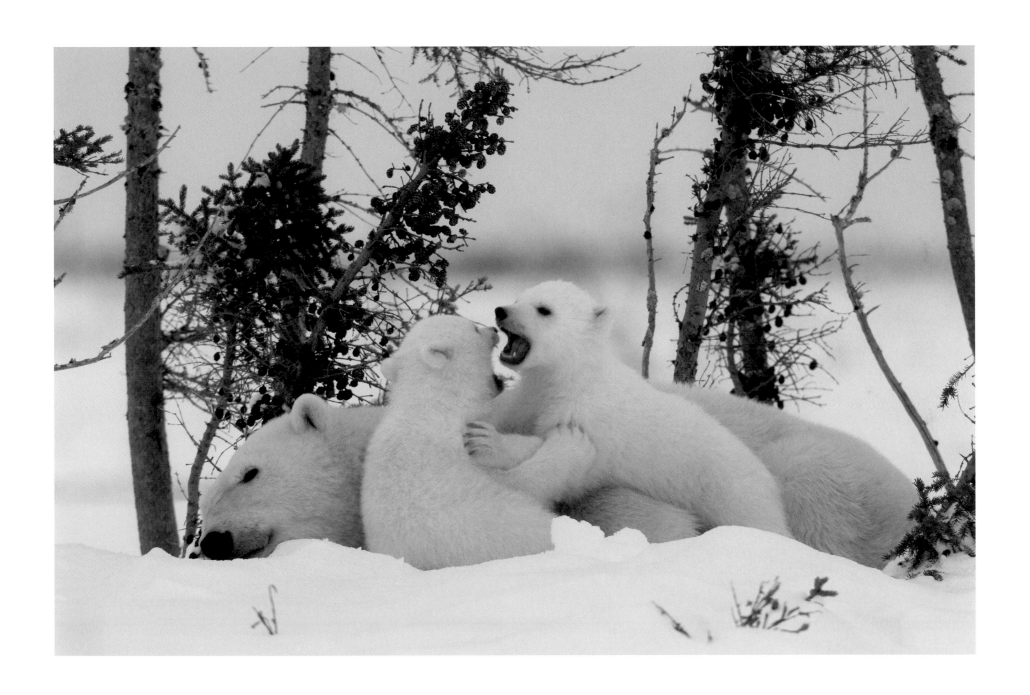

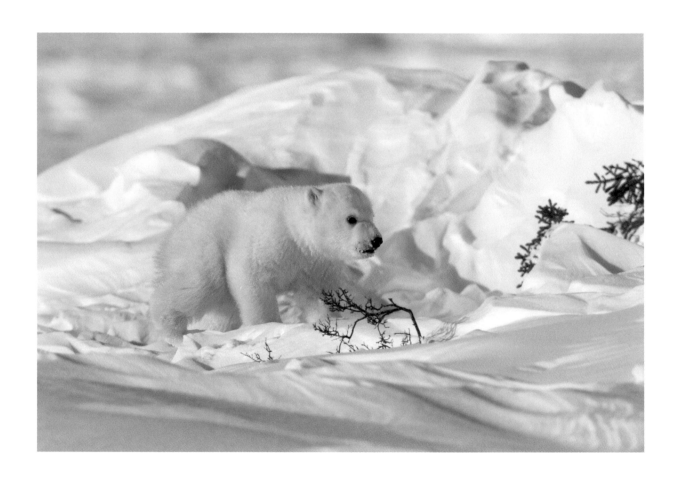

While one of the twins stays with the sleeping mother, the other sets off to explore the terrain;
but the bear mother knows exactly where he is.

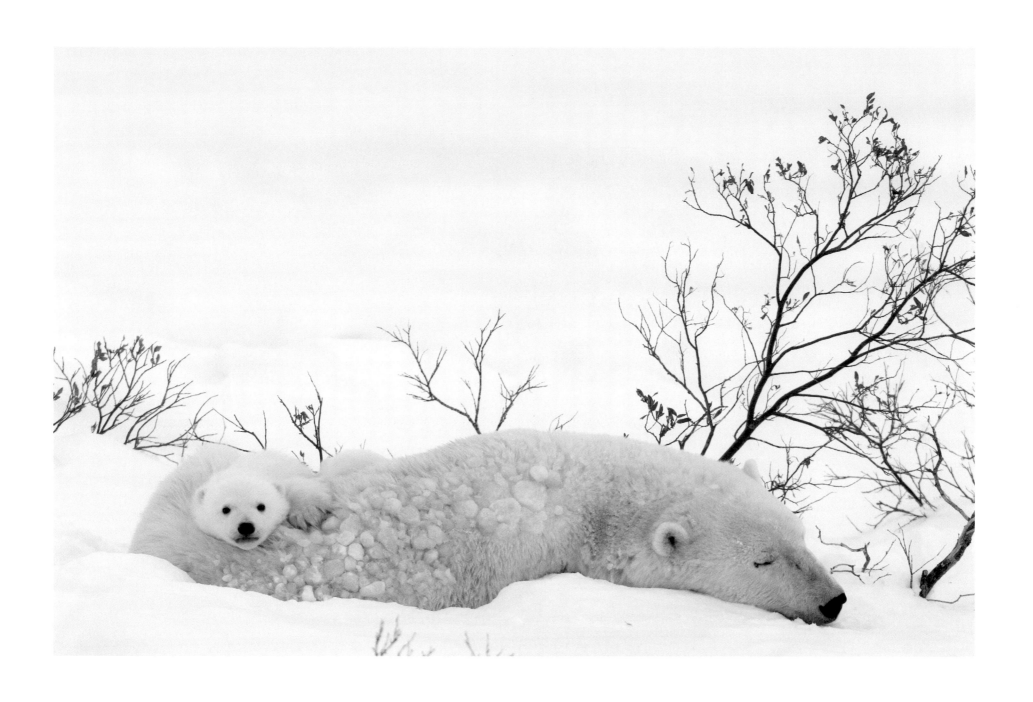

133

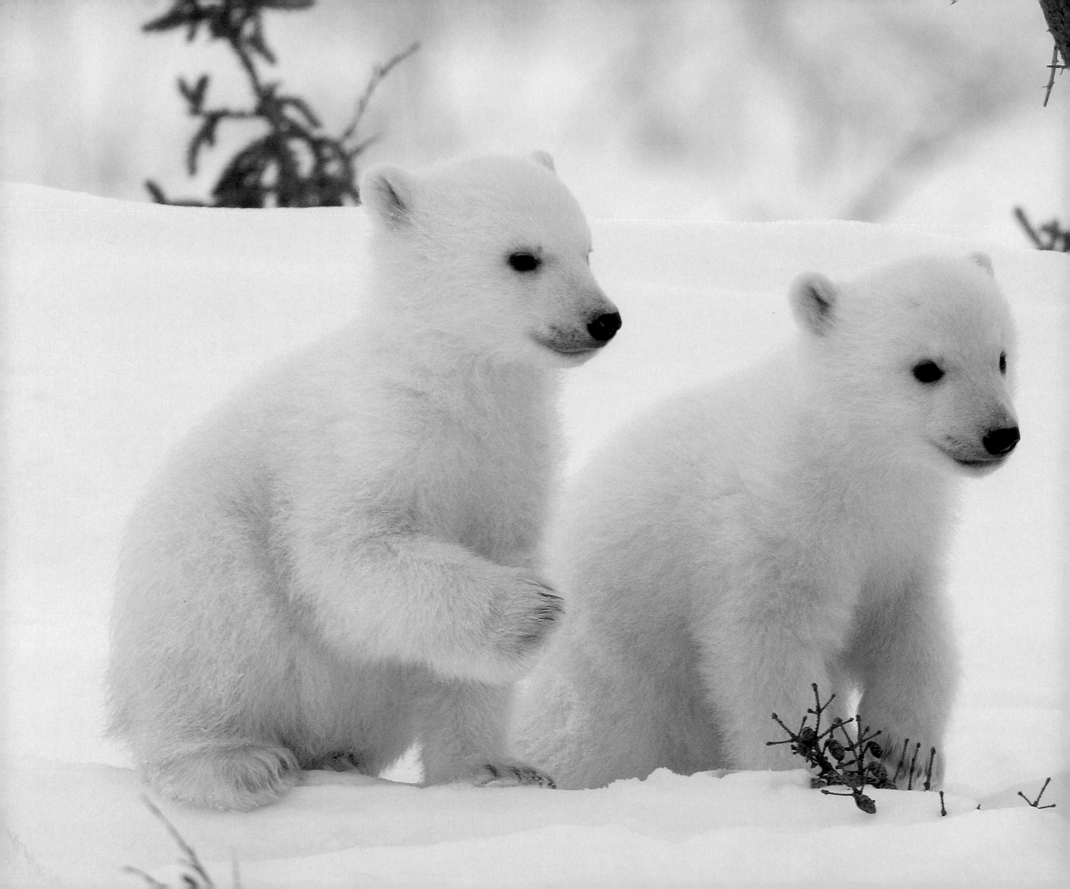

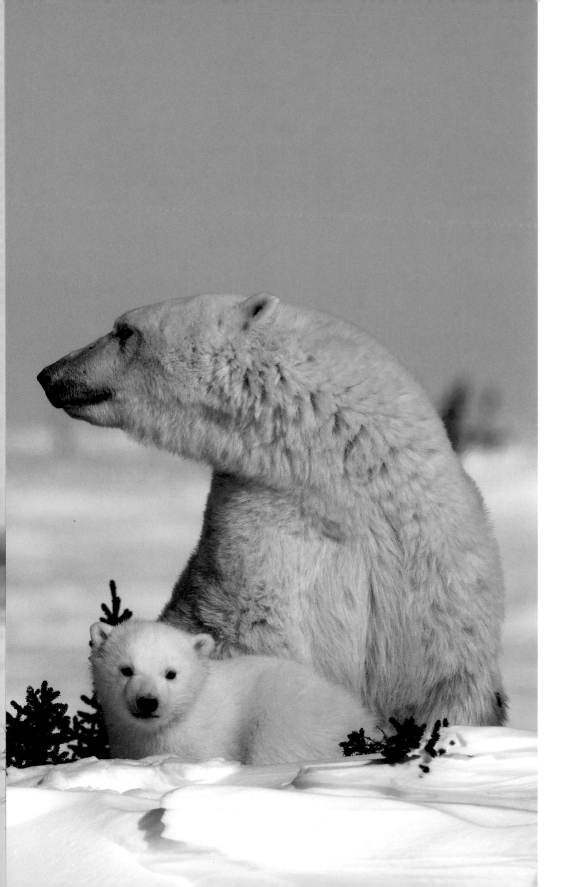

The hunting season for the polar bears begins as soon as the ringed seals have given birth to their young. Young seals stay quietly in their snow holes and wait for their mothers to return from their food excursions. Seal dens are virtually invisible in the vast expanse of snow. Thanks to their superior sense of smell, polar bears can scent the litters and breathing holes of their favorite food from afar. They will stay motionless for hours until they smell or hear the seals. Patience is one of the great virtues of these bears. The hunt for adult seals is a far more difficult undertaking and requires a great amount dexterity and experience, without which the polar bears cannot succeed.

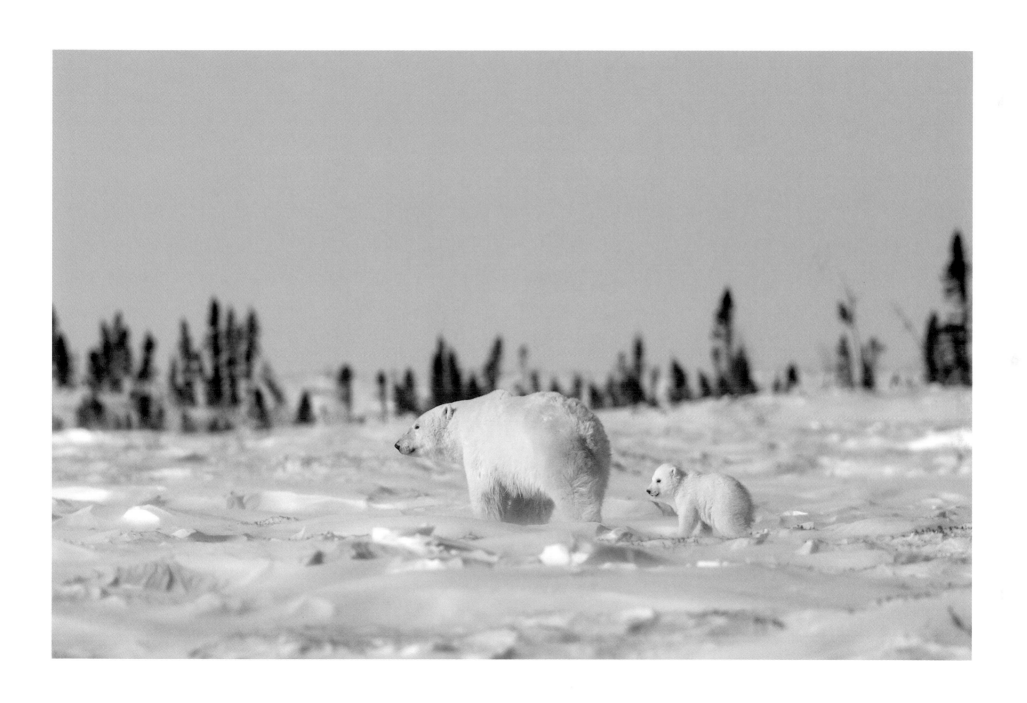

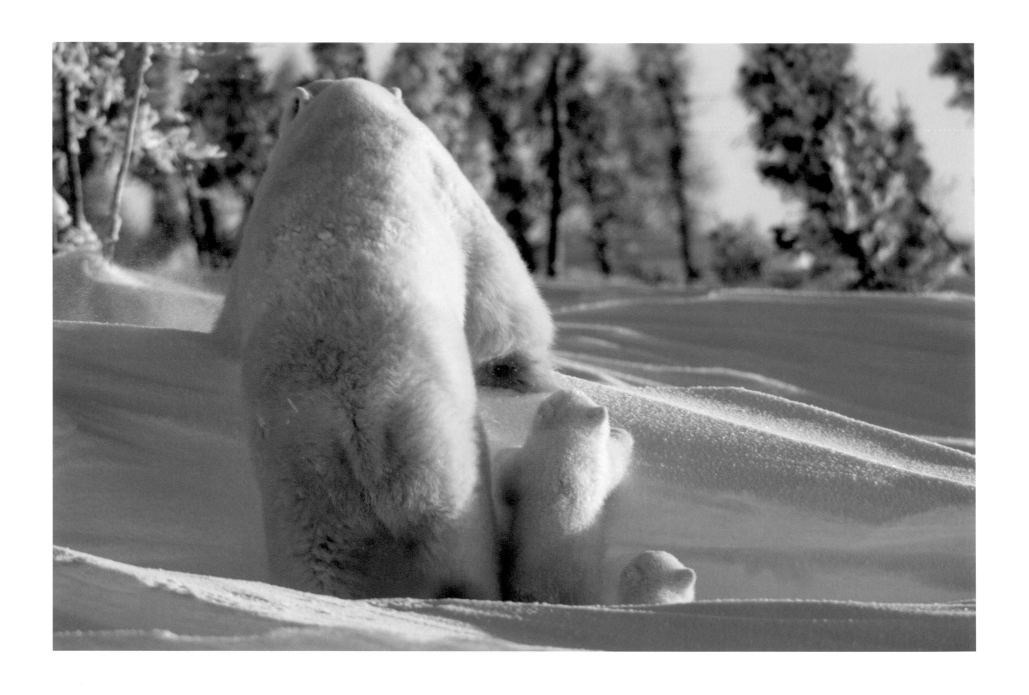

140

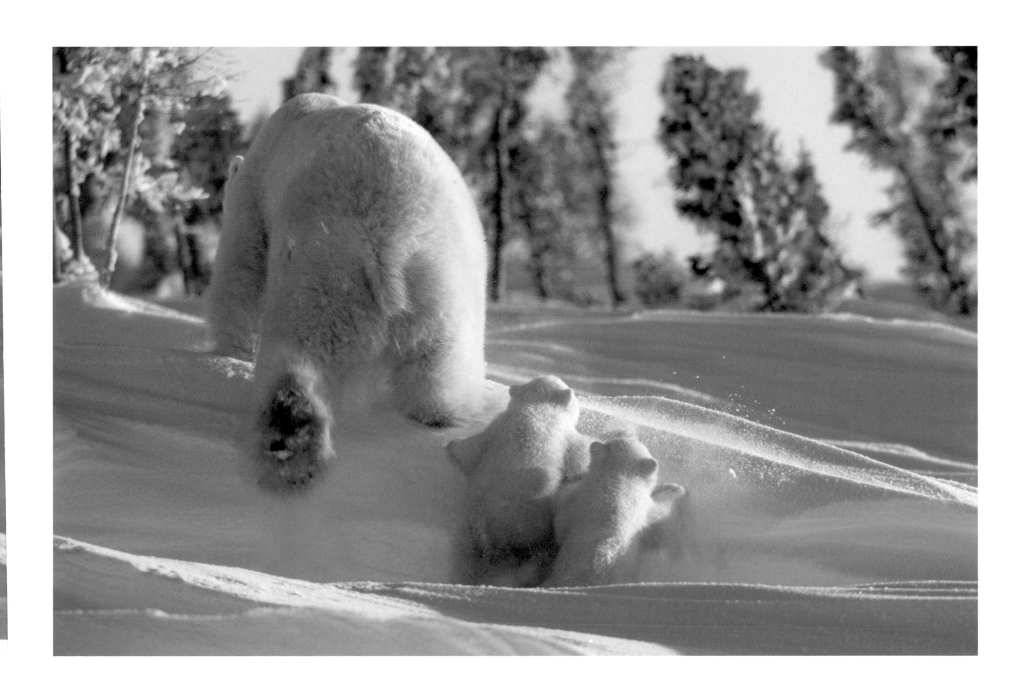

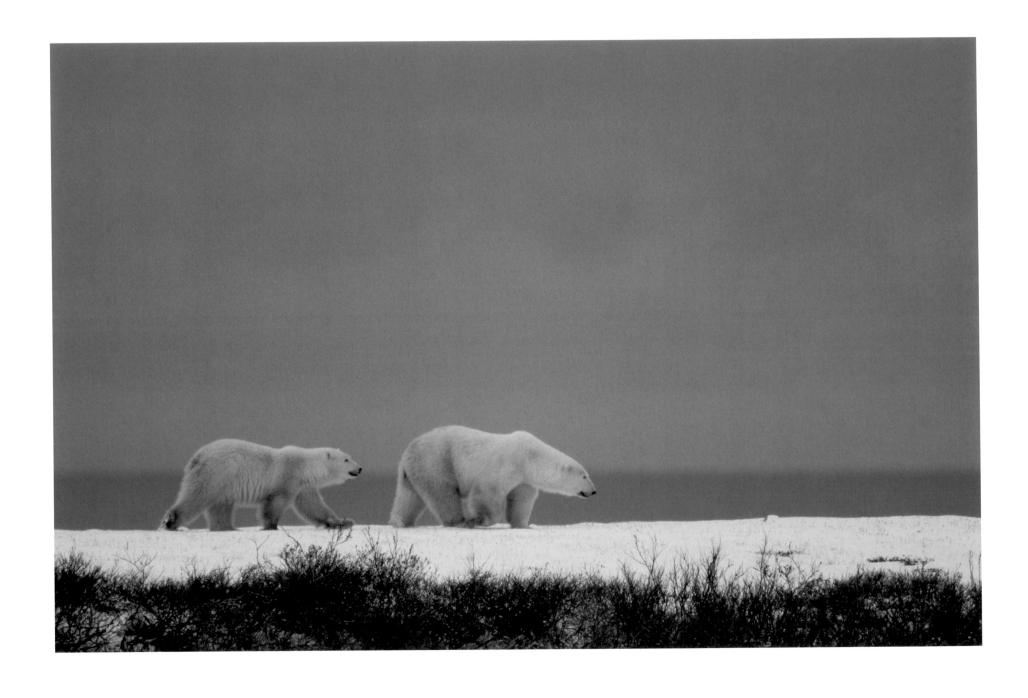

142 146

When winter finally returns, the siblings no longer have any difficulties. However, as summer arrives for the third time in their young lives, the polar bear mother grows increasingly less affectionate with her young. She snaps at them to keep them at a distance, refuses to let them suckle and is no longer automatically willing to share her catch with them. Soon, in April or May, she will mate with another male and return to the denning area in Wapusk National Park the following fall.

The time has come for the small family to part company and for each to go their own way.

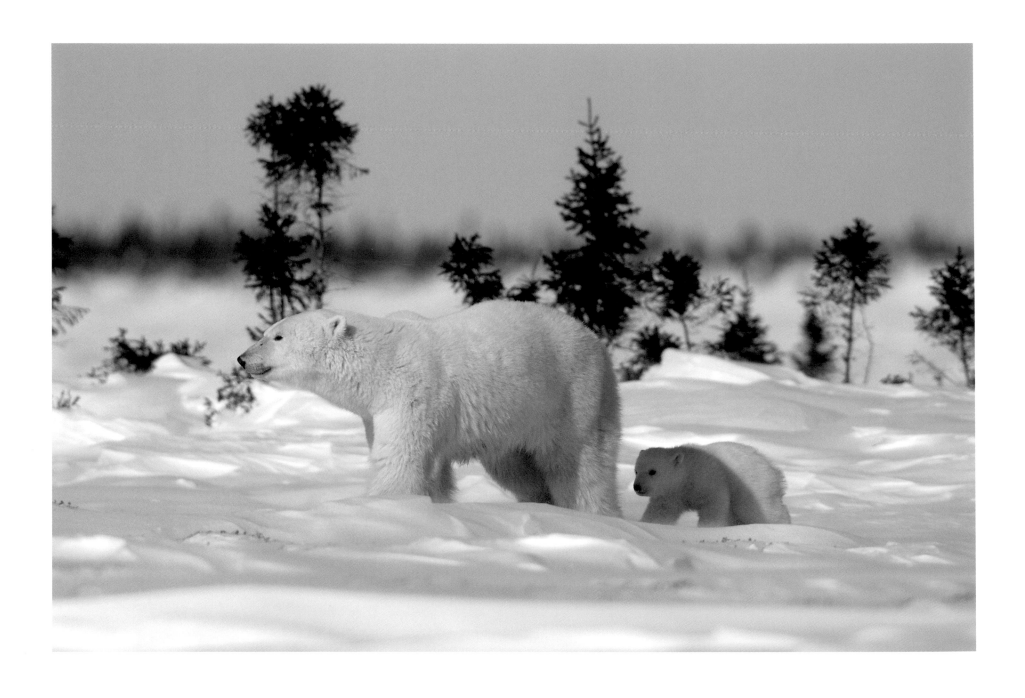

148

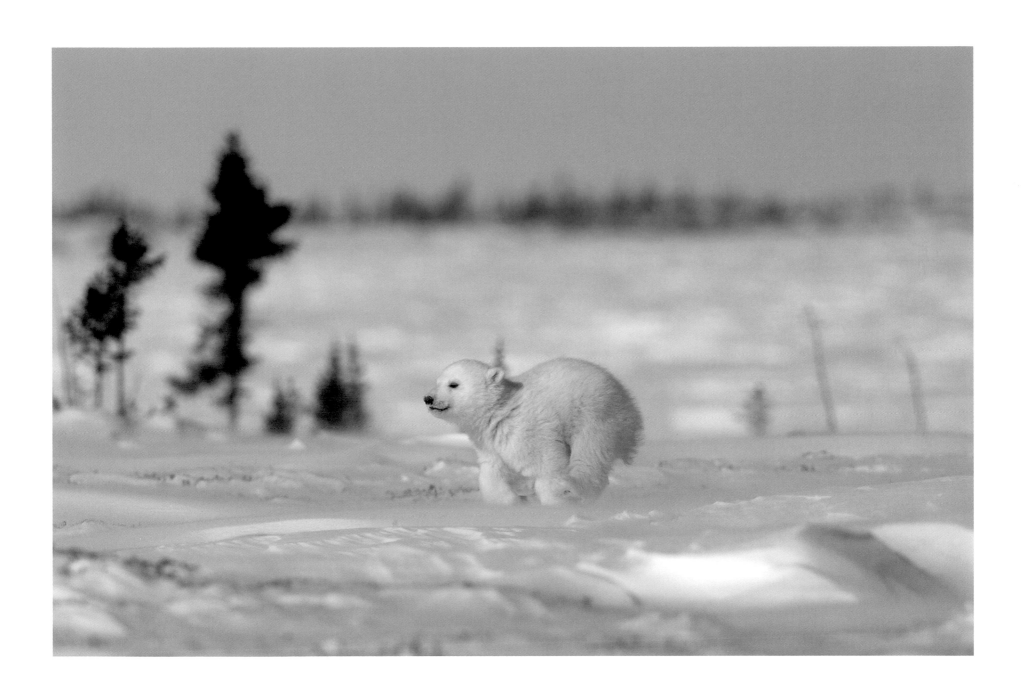

149

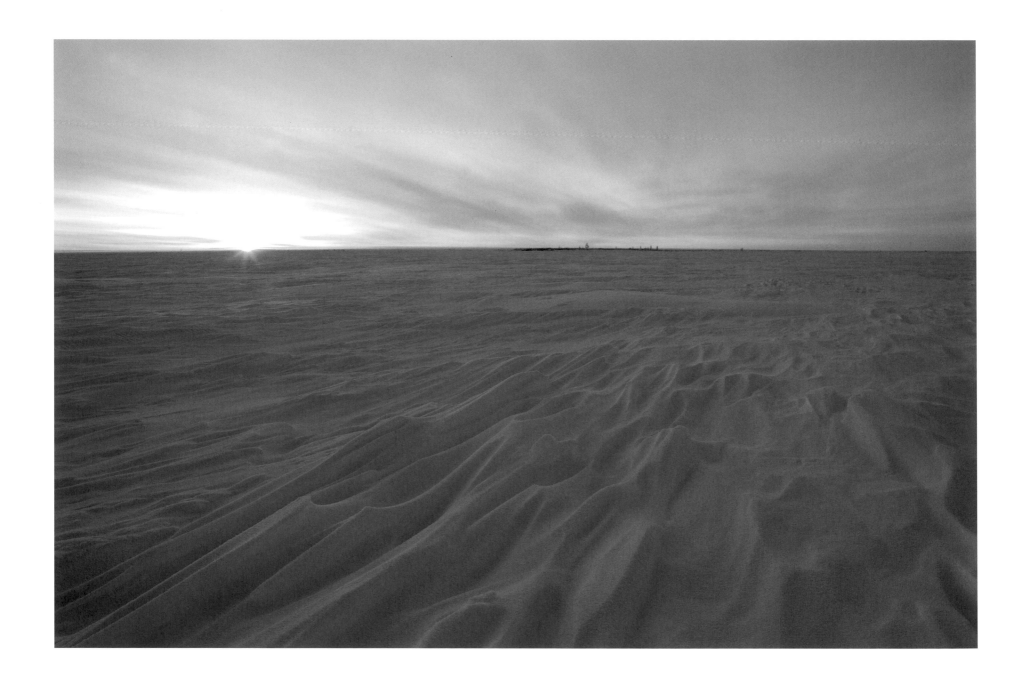

150

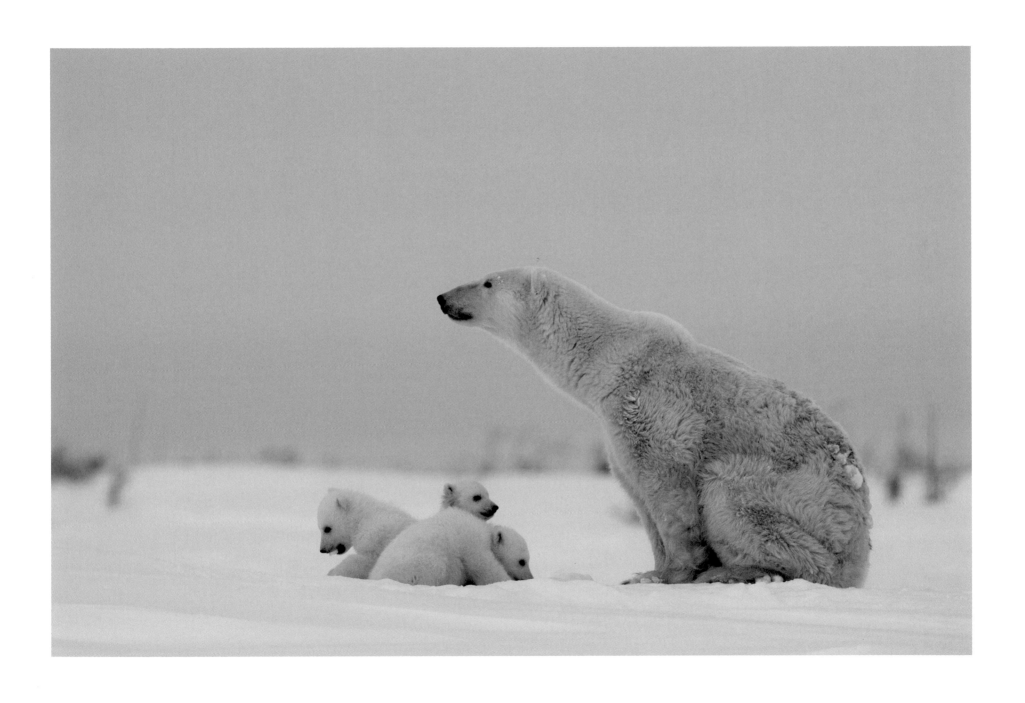

151

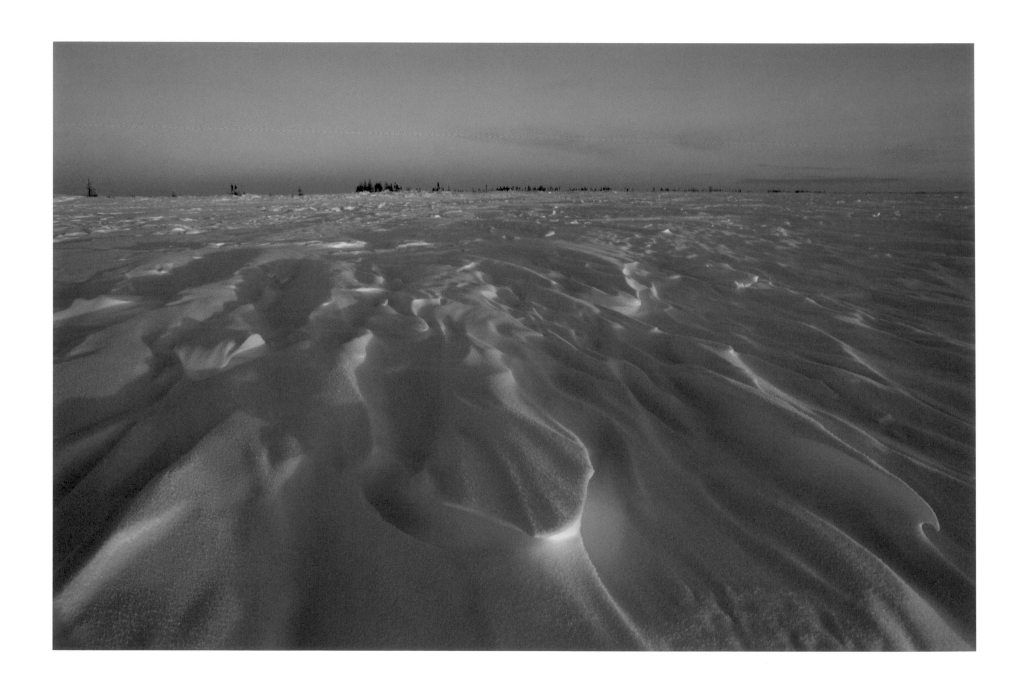

152

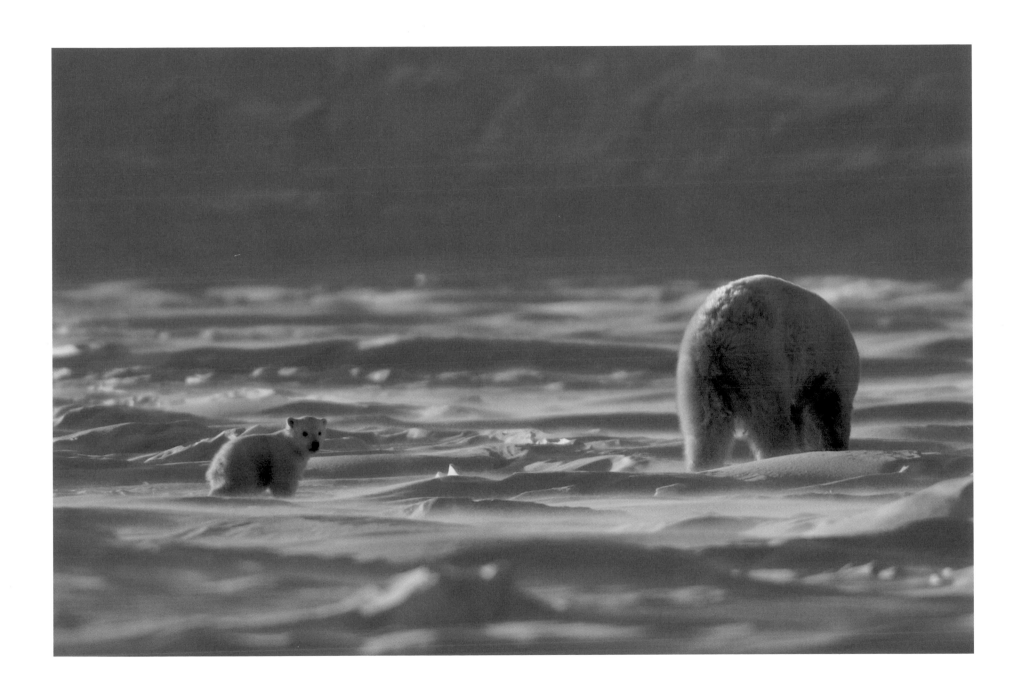

153

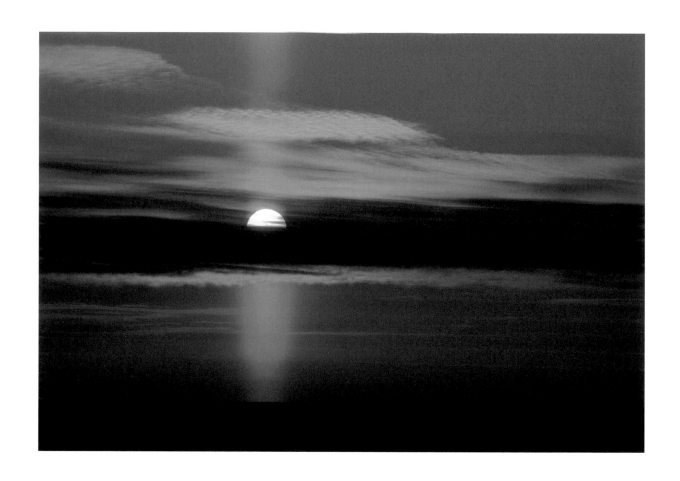

A successful day of photo shooting has come to an end – dinner is waiting at the lodge.

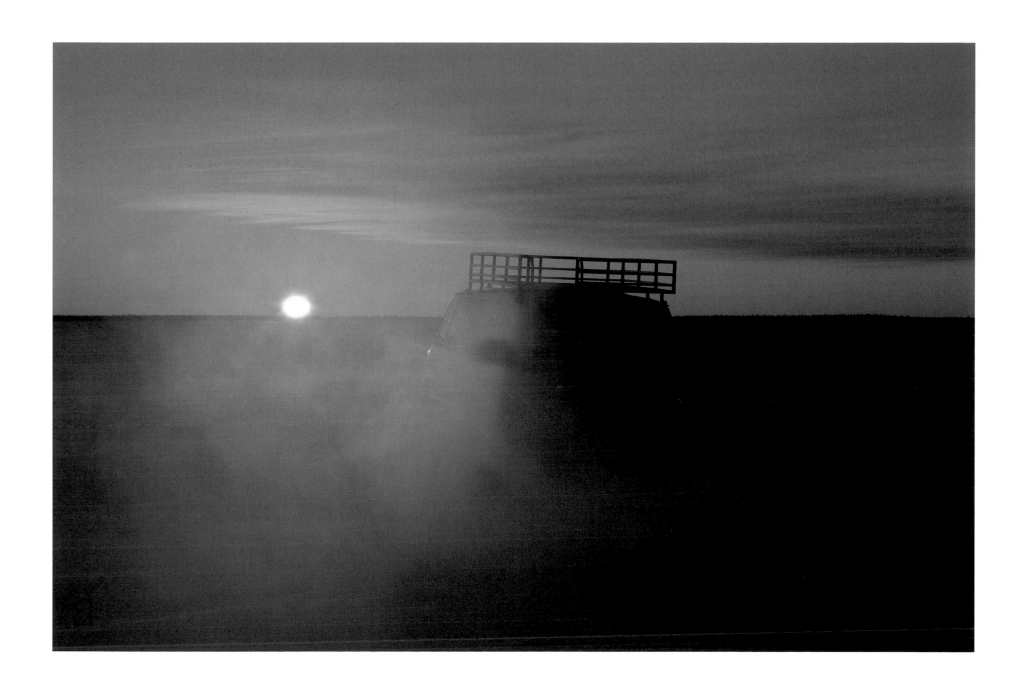

155

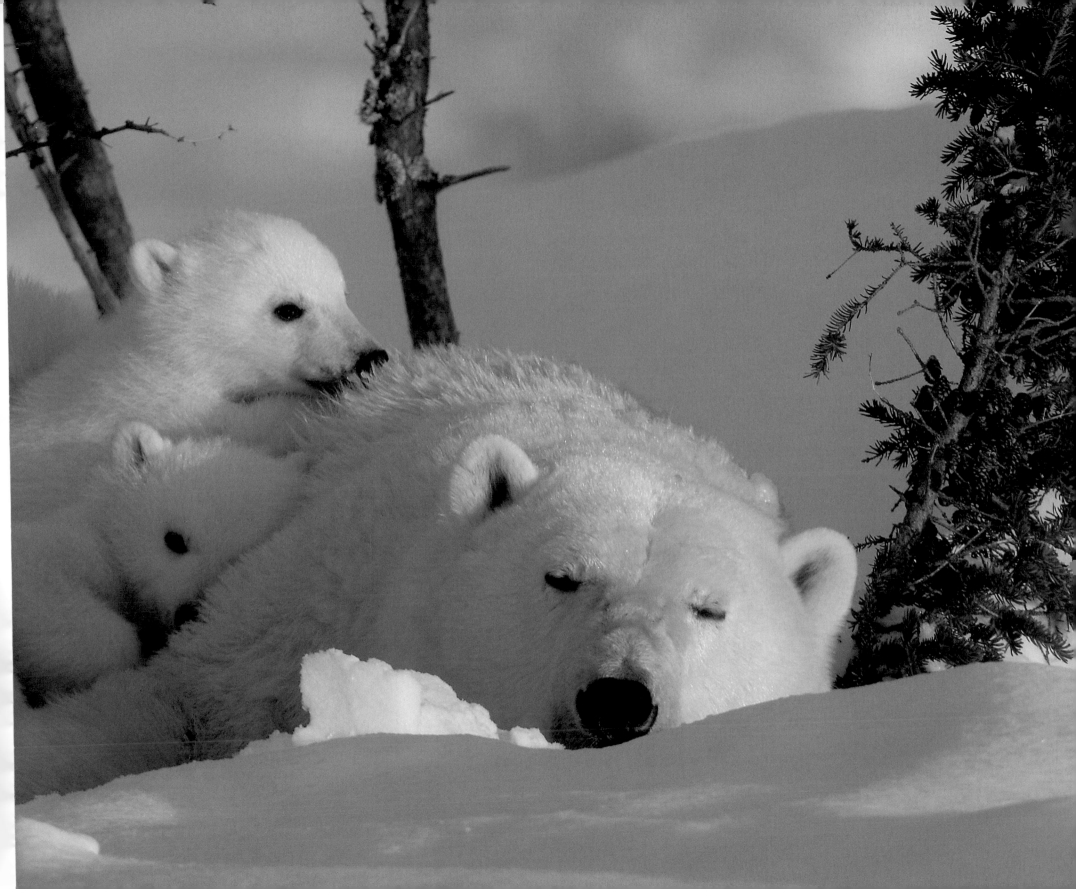

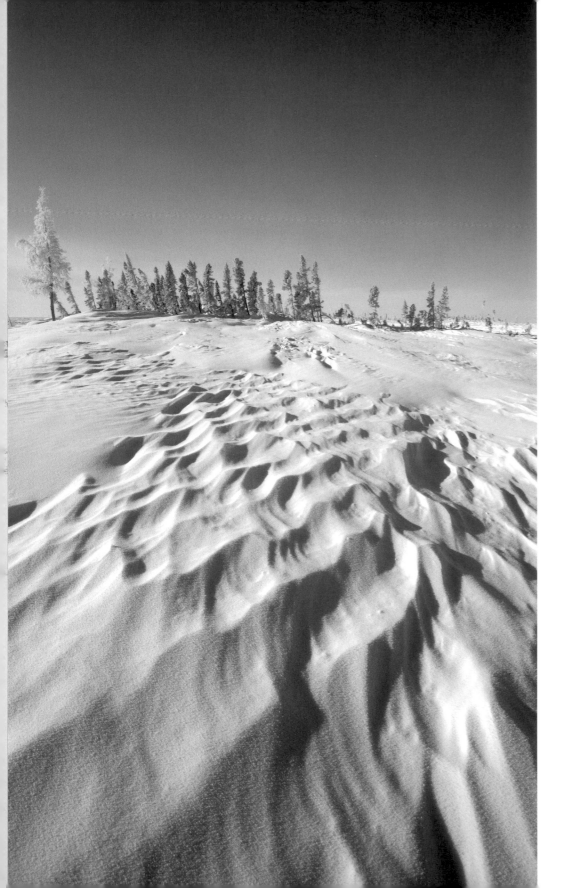

High ISO-values such as ISO 400 or ISO 800 are no problem with a 16.7 million pixel camera. The image quality allows for soft transitions without losing minute details, while at the same time allowing for a wide range of exposure settings. Small adjustments can be made afterwards with the help of special image processing software; the only prerequisite is that all exposures are taken in RAW format. To my mind, there is no viable alternative to this format if one wishes the finished photographs to be of the highest quality.

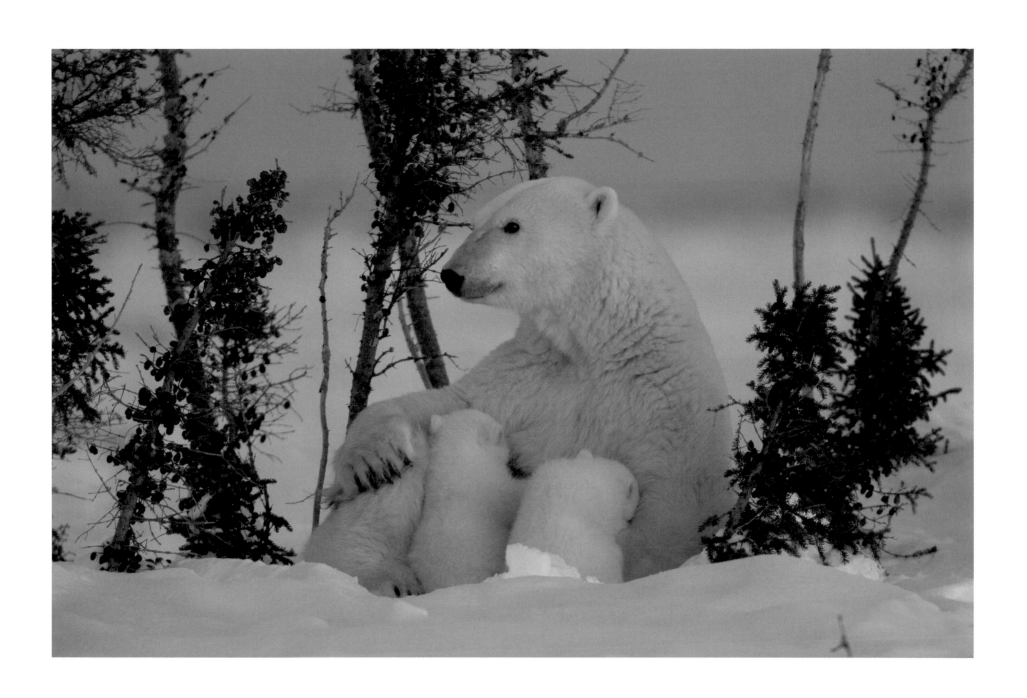

161

162

Over the past years, I have used a variety of different digital cameras. The following equipment has proven ideal for photographing polar bears:

Cameras Canon EOS: 1DS MKII, 1D MKII, 1DS, 10D

Lenses: EF 15 mm f/2.8 Fisheye, TS-E 24 mm f/3.5 L, EF 16-35 mm f/2.8 L, EF 24-70 mm f/2.8 L, EF 70-200 mm f/2.8 IS L, EF 100-400 mm f/4.5-5.6 IS L, EF 500 mm f/4.0 IS L, EF 600 mm f/4.0 IS L

Accessories: telephoto converter 1.4x and 2.0x, flash: 580EX, extension tube: EF 12 and EF 25

Memory cards: from 1 GB to 4 GB, a portable hard-disk storage device, laptop Apple PowerBook G4 and a waterproof camera case which is especially useful for temperature differences of more than 30 °C.

Since neither the camera nor the lenses have ever failed me, even when temperatures plunged to below –40 °C, I am very optimistic for the future of digital photography. It is important to recognize and utilize the advantages to ensure that wildlife photography will continue to be a special experience.

All images were generated digitally, but there was no digital manipulation. I simply made small adjustments to color, tint and focus and used the software to crop my images.

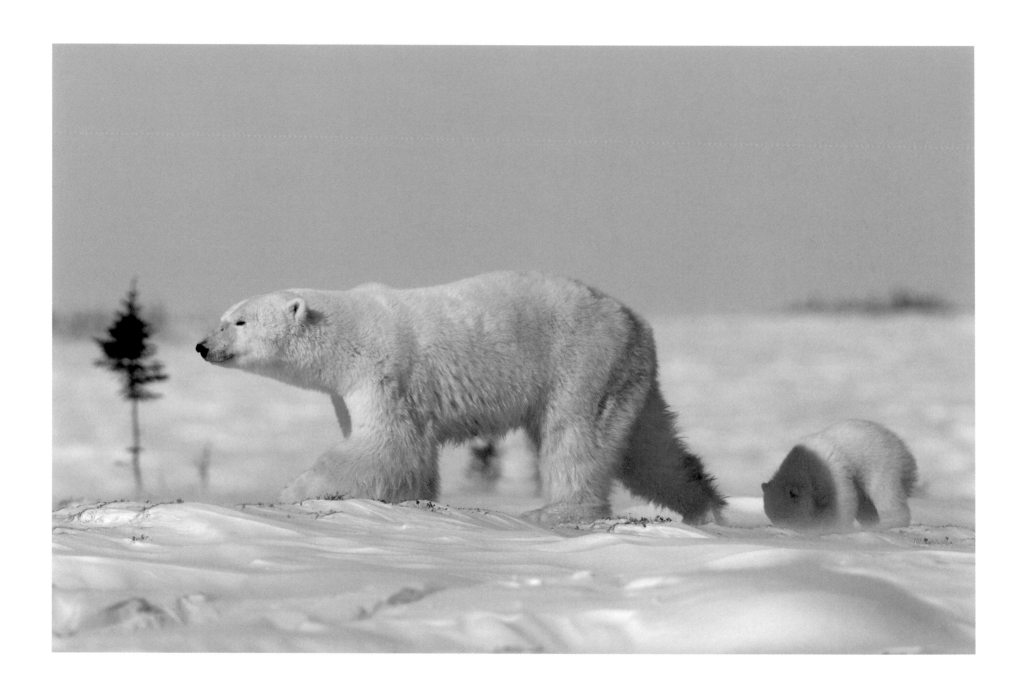

164

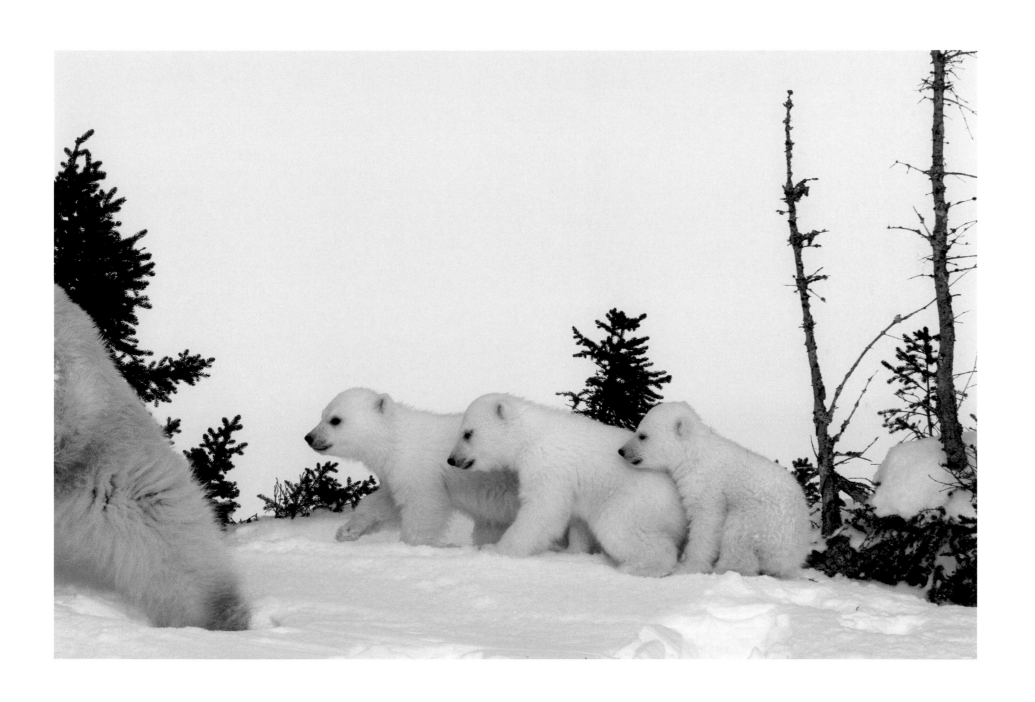

165

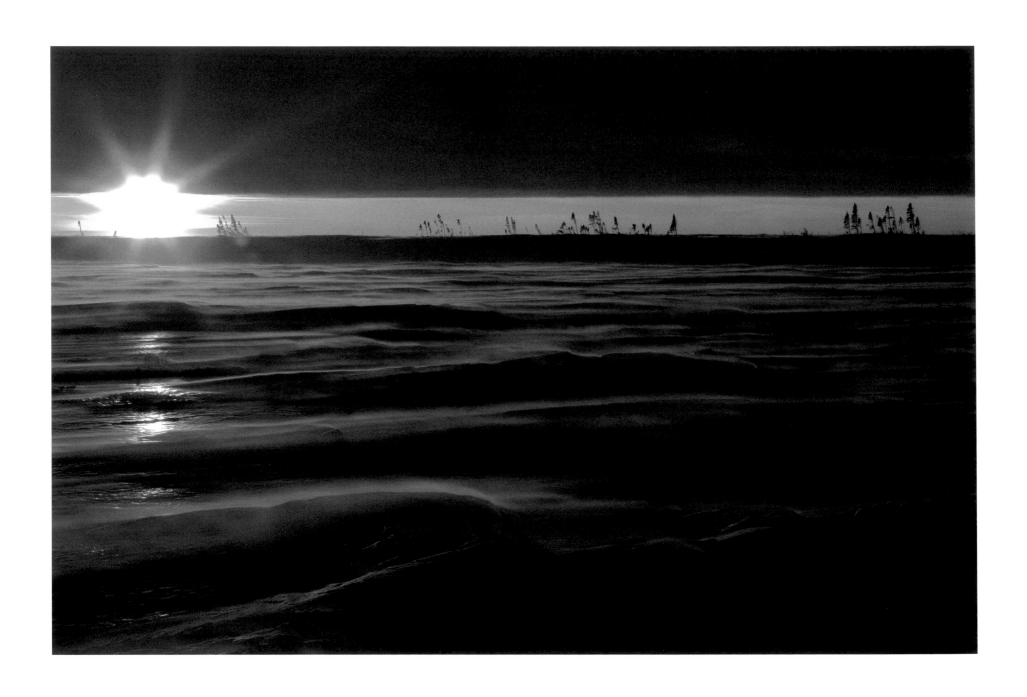

166

The sky in Canada's north changes constantly and the low sun creates stunning visions of light.

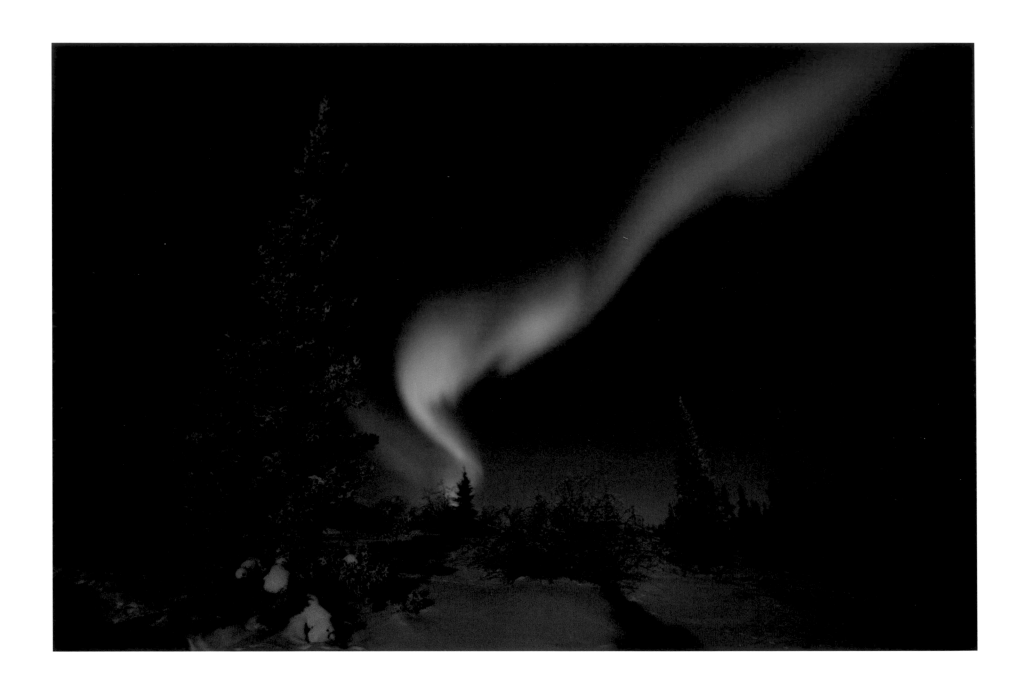

168

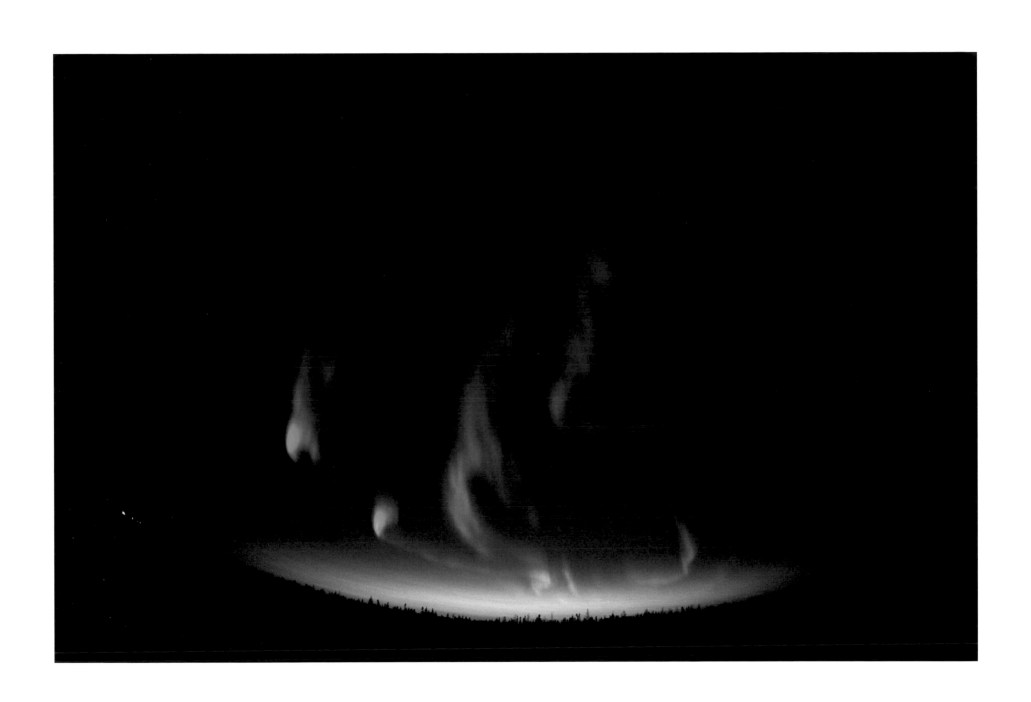

169

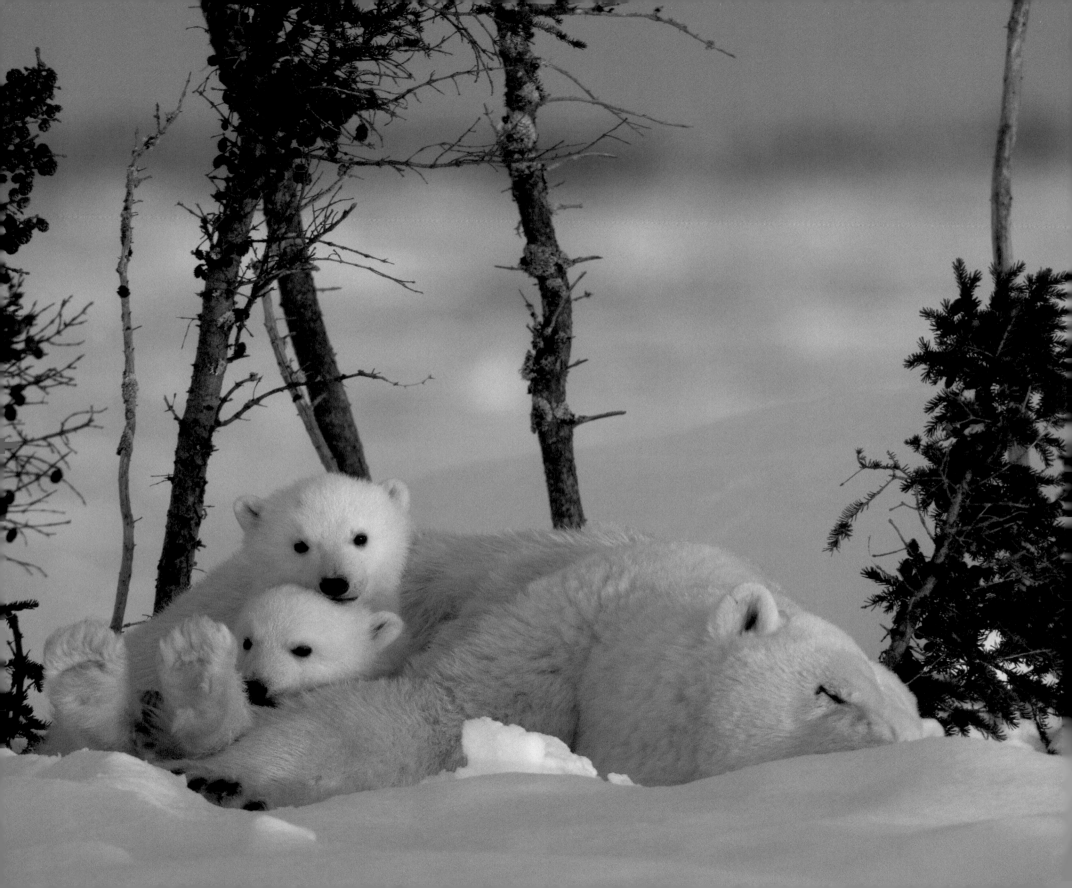

Acknowledgements

This book pays homage to an animal that is not only a predator but also a tender and playful creature with a strong sense of family. First and foremost, I would like to thank my girlfriend Steffi, who lends her support to all my projects, for her patience and practical assistance. Thanks also to my parents for their continued support. Thanks are also due to Morris Spence – the best guide, polar bear expert and friend – and to his family, my friends Michael Spence and Lawreen Reid for outstanding organization, logistical support and help, and to the entire trekking team at Wat'chee Lodge: James, Amuck, Gordon, Norman, Tommy, Ernest – and Darryl for the best meals in all of Canada.

I would also like to thank Cam Elliott, the superintendent at Wapusk National Park, for his professional advice and friendly support for this book project; Alex, with whom I could share my ideas and who realized many elements of this book on my behalf; Dr. Isolde Wrazidlo for her kind and professional editorial work; Dr. Ian Stirling for answering my questions and furnishing the biological facts; Tina for text design and, of course, the team at C.J. Bucher Verlag for their support and kind assistance, in particular Gerhard Grubbe, who offered his enthusiasm from the very beginning and whose advocacy at the publishing house made this book possible in the first place.

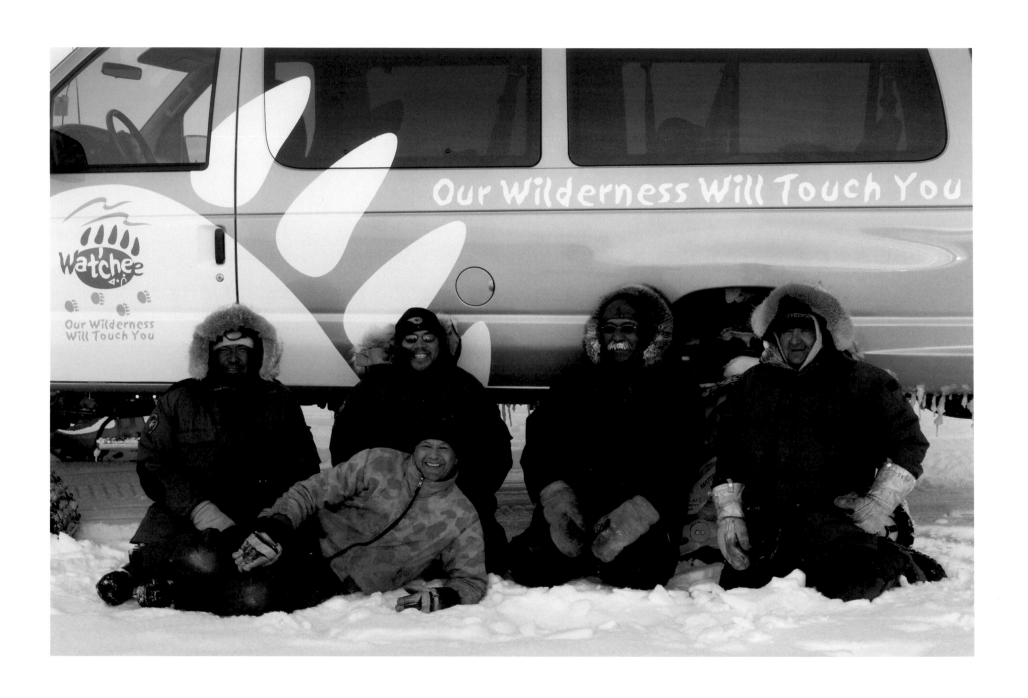

172

Thanks are also due to Julia Fuchshuber, without whose assistance this book would not exist; to Rosamund Kidman Cox for lending her support to this book project and for her professional comments; to Sophie Stafford and the entire BBC Wildlife Team; to Venita Kaleps and the GEO/GEOlino Team; to Lisbeth Brünnich and the team at Illustreret Videnskab, whose photo essays were excellent PR for polar bears.

Thank you also to Norbert Rosing, who became not only a good colleague but also a good friend over the course of many fascinating conversations; to the entire Canon CPS team for their friendly assistance and outstandingly fast and competent service whenever I ran into a glitch with the equipment.

And thanks to all others who lent their support to this project.

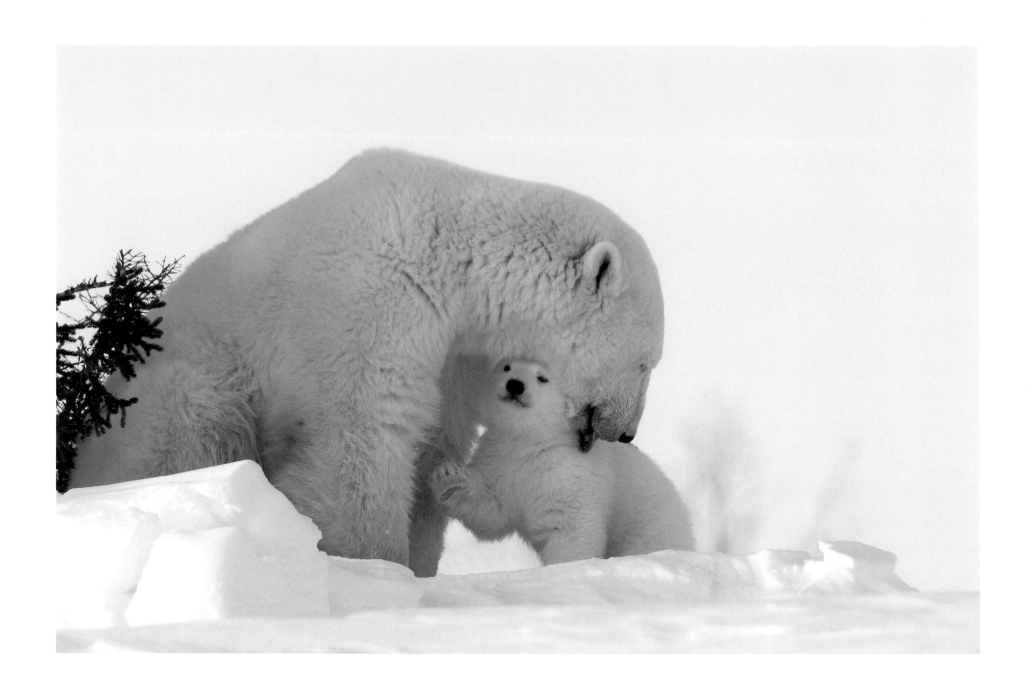

174

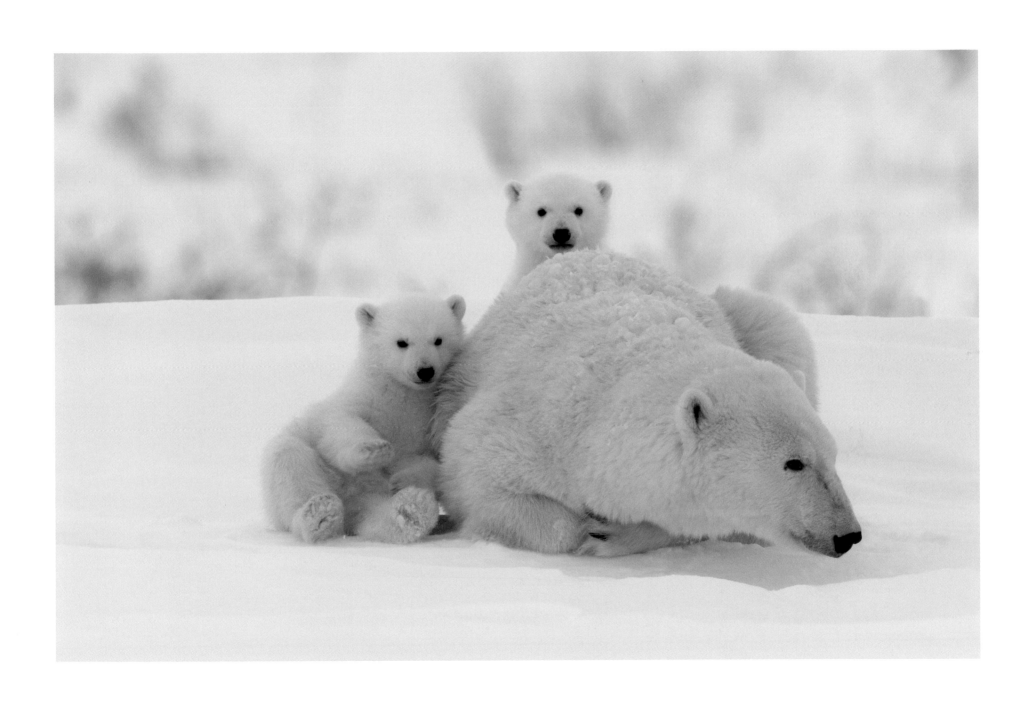

175

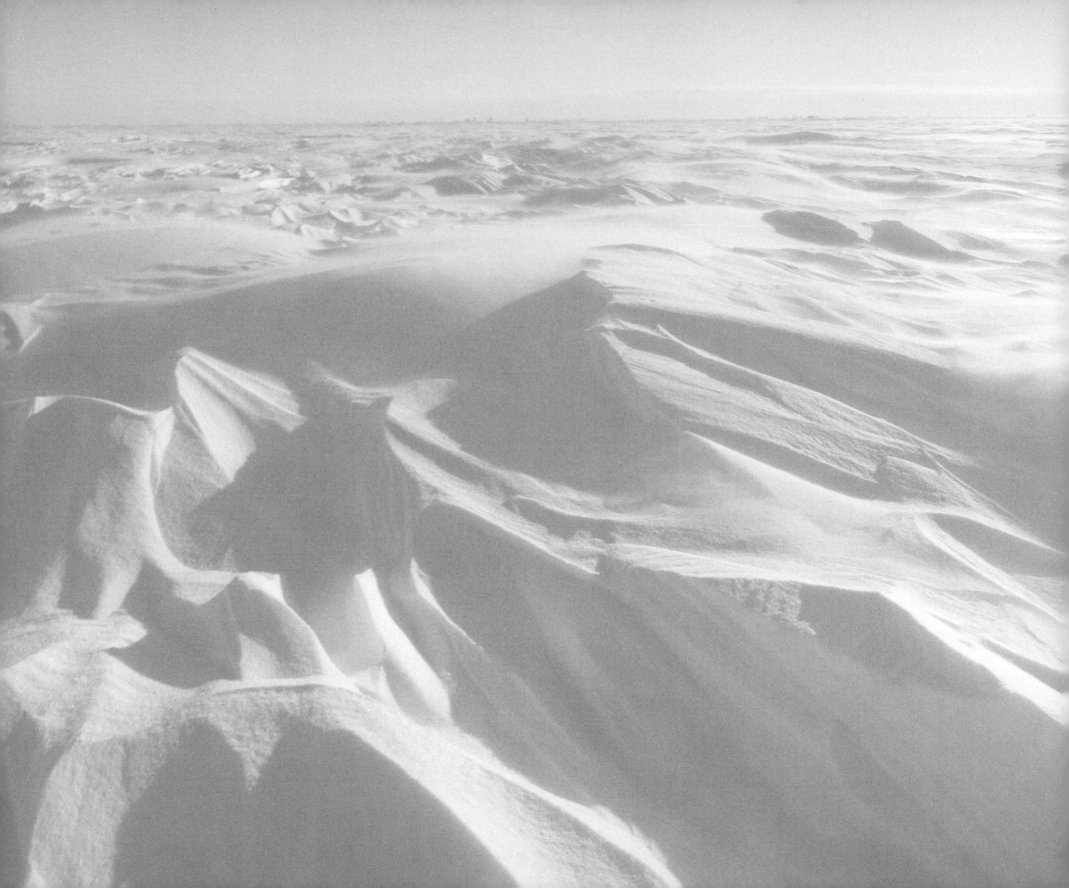